TIME LIFE BOOKS

PEOPLES OF THE WILD
THE EPIC OF FLIGHT
THE SEAFARERS
WORLD WAR II
THE GOOD COOK
THE TIME-LIFE ENCYCLOPAEDIA
OF GARDENING
HUMAN BEHAVIOUR
THE GREAT CITIES
THE ART OF SEWING
THE OLD WEST
THE WORLD'S WILD PLACES
THE EMERGENCE OF MAN
LIFE LIBRARY OF PHOTOGRAPHY
THIS FABULOUS CENTURY
TIME-LIFE LIBRARY OF ART
FOODS OF THE WORLD
GREAT AGES OF MAN
LIFE SCIENCE LIBRARY
LIFE NATURE LIBRARY
YOUNG READERS LIBRARY
LIFE WORLD LIBRARY
THE TIME-LIFE BOOK OF BOATING
TECHNIQUES OF PHOTOGRAPHY
LIFE AT WAR
LIFE GOES TO THE MOVIES
BEST OF LIFE

*This volume is one of a series devoted to the art and technology
of photography. The books present pictures by outstanding
photographers of today and the past, relate the history
of photography and provide practical instruction in the use of
equipment and materials.*

Light and Film

LIFE LIBRARY OF PHOTOGRAPHY

Light and Film

Revised Edition

BY THE EDITORS OF TIME-LIFE BOOKS

TIME-LIFE BOOKS, AMSTERDAM

ON THE COVER: Two essentials of the
photographic process are combined in
this composite photograph: light,
represented by the spectrum of colour in a
helium-selenium laser beam, and a
sensitive material, illustrated by the metal
and plastic holder for a single sheet of
film. The laser picture is a multiple
exposure that shows the laser beam
itself — yellowish-white — and then its
spectrum, which repeats five times,
spreading over an angle of more than
90°. Four sets of spectra appear to the
right of the main beam in the picture; one
appears to the left. The picture, which
was made by Fritz Goro, with the help of
William T. Silfvast at the Bell
Laboratories in Holmdel, New Jersey,
U.S.A., required the use of a special
camera and wide-angle lens that
captured the beams without distortion.

Contents

Introduction 7

1 Light and the Photographer 9

2 The Evolution of Film 47

3 Photographing the World 81

4 Modern Film 123

5 Exposure: Key to Image Quality 161

6 Taking Pictures by Artificial Light 187

Bibliography and Acknowledgements 235
Picture Credits 236
Index 237

LIFE LIBRARY OF PHOTOGRAPHY

EDITORIAL STAFF FOR THE
ORIGINAL EDITION OF
LIGHT AND FILM:

SERIES EDITOR: Richard L. Williams
Editor: Robert G. Mason
Assistant to the Editor: Simone Daro Gossner
Text Editors: James A. Maxwell, Peter Chaitin
Picture Editor: Carole Kismaric
Designer: Raymond Ripper
Staff Writer: Peter Wood
Chief Researcher: Peggy Bushong
Researchers: Maureen Benziger,
Rosemary Conefrey, Monica O. Horne,
Sigrid MacRae, Shirley Miller,
Don Nelson, Kathryn Ritchell
Art Assistant: Jean Held

EDITORIAL STAFF FOR
THE REVISED EDITION OF
LIGHT AND FILM:
EDITOR: Edward Brash
Picture Editor: Neil Kagan
Designer: Sally Collins
Chief Researcher: Jo Thomson
Text Editor: John Manners
Researchers: Diane Brimijoin, Elise Ritter Gibson,
Lois Gilman, Jean Strong
Assistant Designer: Kenneth E. Hancock
Art Assistant: Carol Pommer
Editorial Assistant: Jane H. Cody

Special Contributors:
Don Earnest, Gene Thornton (text);
Mel Ingber (technical research)

CORRESPONDENTS
Elisabeth Kraemer (Bonn); Margot Hapgood,
Dorothy Bacon, Lesley Coleman (London); Susan
Jonas, Lucy T. Voulgaris (New York); Maria Vincenza
Aloisi, Josephine du Brusle (Paris); Ann Natanson
(Rome). Valuable assistance was also provided by
Judy Aspinall, Stephanie Thompson, Martin Gregory,
Kate Cann (London); Carolyn T. Chubet, Miriam Hsia,
Christina Lieberman, Justina Voulgaris (New York);
Mimi Murphy (Rome); Katsuko Yamazaki (Tokyo).

The editors are indebted to the following individuals
of Time Inc.: George Karas, Chief, Time-Life Photo
Lab, New York City; Herbert Orth, Deputy Chief,
Time-Life Photo Lab, New York City; Melvin L. Scott,
Assistant Picture Editor, Life, New York City; Photo
Equipment Supervisor, Albert Schneider; Time-Life
Photo Lab Colour Technicians, Peter Christopoulos,
Luke Conlon, Henry Ehlbeck, Robert Hall.

Once a photographer has a camera in his hands, he encounters a formidable array of technical and aesthetic choices that arise from the two ingredients that make a picture: light and film. Should he use black-and-white film, or colour film? Should it be fast film, medium speed or slow? How should the scene be lit—with natural illumination, flash or floodlights? How should lighting angles be fixed in relation to the camera for pleasing results? What f-stop and shutter speed will adjust exposure to capture the minute detail and subtly shaded tones that a fine photograph requires?

Even an experienced photographer is often hard put to answer these questions confidently. The reason they seem so complex is that they are all interrelated. A decision on illumination invariably affects exposure, and the choice of film may change the other decisions. The questions also appear (or sometimes have been made to appear) mysterious because they all involve that remarkable physical quality, light, and its reactions with the more substantial materials of the world—and most particularly with certain light-sensitive compounds of silver on the surface of photographic film.

The aim of the original edition of this book was to unravel these mysteries by clearly explaining basic facts about light and how it acts. The aim of this revised edition is the same, and certain topics covered here appeared in the earlier edition. But advances in the sensitivity of colour films, in the popularity of cameras with built-in meters and in the sophistication of electronic flash units have required revision. In all, 100 pages were totally or largely re-done for this edition.

These topics are the basic ones a photographer must face before taking a picture. Once mastered, they provide him with a firmer grasp on the materials of his profession, his craft or his art. By exploring them in an orderly fashion, this book shows how the technical objectives can be combined with aesthetic aims to produce an outstanding picture.

The Editors

Light and the Photographer 1

How Light Acts 12

The Electromagnetic Spectrum 14

The Earth's Atmospheric Screen 16

Scattering: Key to the Sky's Palette 18

The Varieties of Reflection 20

Bending Waves by Refraction 22

Controlling Colours with Filters 24

How Photographers Exploit Light 26

Making the Source Unify the Picture 29

Setting a Mood 30

Capturing Atmosphere Indoors 33

Isolating the Image 34

Seeing Form and Texture 37

A Fresh View in Reflections 38

Rewards from a Rainy Day 41

Composition in Shadows 42

Patterns in Brightness 44

Managing Extremes 46

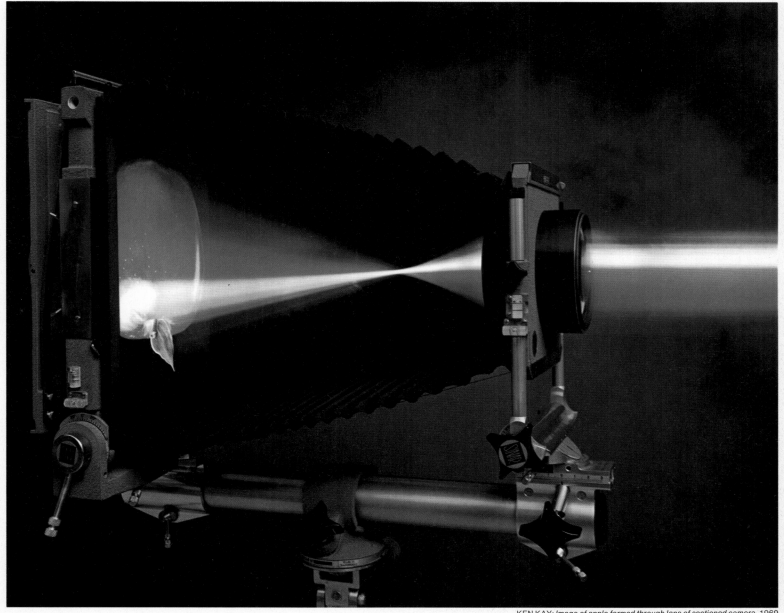

KEN KAY: *Image of apple formed through lens of sectioned camera,* 1969

How Light Acts

Anybody who is old enough to take pictures understands that photography depends on light. Obviously, the film is exposed by the light that enables the eyes to see. But the dependence of photography on light goes far deeper than that and takes forms that are not nearly so obvious, for the character and quality of a picture can be altered by the character and quality of the light. The source of the light matters—the sun makes different pictures from those made by incandescent bulbs (and fluorescent lights give results that are different yet again). The colour of the light—and all light is coloured even though the human eye seldom notices—affects not only colour pictures but black-and-white ones too. Material substances—clothing, walls, the surface of a lake—react with light and alter its reaction with photographic film. Even the very air we breathe, invisible though it is, may have marked effects on photographs—effects that vary with the time of day.

Many of these influences of light on photographs are at first surprising. What you see with your eyes is not what the camera reproduces. The explanation lies in the nature of photographic film. It does not work like the light-sensitive retina of the eye and, more important, it lacks the brain that interprets retinal signals to complete the act of "seeing". These discrepancies can ruin a picture for the unwary photographer—or create startling effects for the photographer who deliberately takes advantage of them. The most common example is the colour transparency shot indoors with "outdoor" type film; it comes out with an all-over red tinge. The reason: light from ordinary incandescent bulbs is redder than daylight and the colour film records it as it is while human sight does not (the brain automatically counterbalances the reddish colour of the illumination).

When black-and-white film is used, the influences of the quality of light are subtler. All ordinary black-and-white films are sensitive to some light the eye cannot see and they are also more sensitive to blue-coloured light and less sensitive to red-coloured light than the eye is. In a photograph of a landscape, for example, a deep blue sky can turn out a blank white and a pale red flower may have blossoms almost as dark as its leaves. These departures from what seems natural to the eye can be compensated for—or deliberately emphasized—if the photographer understands a few basic facts about light and its reactions with the material substances of the world.

Light is usually described as a form of energy, and it is indeed a kind of electromagnetic energy little different from radio waves, television signals, heat and X-rays. All are made up of waves that spread, bend, interfere with one another and react with obstacles much in the manner of waves in water. But if you ask a physicist what light is, he may answer that, together with all its electromagnetic relatives, it is really a form of matter, little different from substantial things such as houses. Like them, it is made up of individual par-

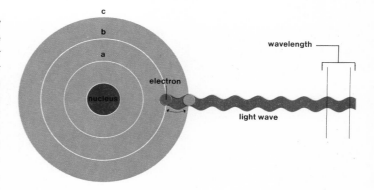

Light originates inside an atom such as the hydrogen atom in the diagram above, when one of the atom's components, an electron, oscillates in a way that is symbolized as a back and forth movement between two positions. This oscillation begins with the absorption of energy from outside the atom. Some absorbed energy goes to increase the energy content of the electron, a jump in energy that is represented as a shift of the electron from its location within the atom (orbit b) to another location (orbit c). But the higher energy levels—the orbits farther from the atom's nucleus—are less stable. The electron, like a ball lifted to a precarious spot on a narrow shelf, quickly drops back to a lower level (orbit b). The energy that is lost in this change appears as a light wave, and the wavelength of the light (marked off by parallel lines on the drawing of the waves) is established by the difference in energy between the two orbits. In the case of the hydrogen atom, the electron movement indicated produces light with a wavelength the eye senses as red.

ticles. The light particles, called photons, travel in streams in much the same way as droplets of water pouring from a hose; when a photon hits something it delivers a noticeable jolt, just as water droplets do.

There seems to be a paradox here. Can light be both energy and matter, wave and particle? The answer is yes and the reasons are not complicated. All energy is a form of matter; Einstein's famous equation $E=mc^2$ (E referring to energy and m to the mass of matter) is one indication of this fact. What is more, all matter has some characteristics of waves and some characteristics of particles. The wave characteristics of ordinary matter such as houses are rarely discernible and can generally be ignored; ordinary matter usually acts as if it were made up of particles. When it comes to the kind of matter we call light, however, the situation is quite different. Light's wave characteristics are predominant in many instances—and in yet other instances the particle characteristics reveal themselves. When light reacts with photographic film, for example, it acts like a particle: a photon strikes a molecule of silver bromide or silver iodide and partially disrupts it to make the exposure *(pages 128-129).* But in the majority of the phenomena involved in photography, light can be described as acting like a wave, and most discussions of light in this book will refer to light waves rather than to photons.

There are three major characteristics of a light wave that concern photographers: (1) its intensity, which is related to the height of the wave crests and indirectly determines brightness of the light; (2) the wavelength, which depends on the distance between crests and largely determines colour; and (3) its polarization, the angular orientation of the crests, which can be exploited for special photographic purposes. All three characteristics are influenced by what happens when light waves interact with ordinary substances: air, metal and glass surfaces, clouds, photographic filters. It is this light-matter reaction, beginning with the actual generation of a light wave inside an atom in the sun or a light bulb *(left),* that creates all the effects we see—and the sometimes quite different effects we photograph.

The Electromagnetic Spectrum

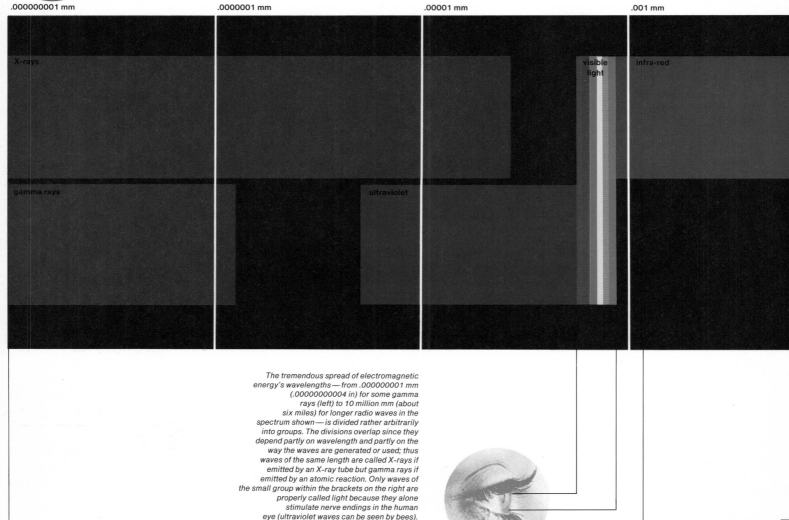

.000000001 mm .0000001 mm .00001 mm .001 mm

X-rays visible light infra-red

gamma rays ultraviolet

The tremendous spread of electromagnetic energy's wavelengths—from .000000001 mm (.00000000004 in) for some gamma rays (left) to 10 million mm (about six miles) for longer radio waves in the spectrum shown—is divided rather arbitrarily into groups. The divisions overlap since they depend partly on wavelength and partly on the way the waves are generated or used; thus waves of the same length are called X-rays if emitted by an X-ray tube but gamma rays if emitted by an atomic reaction. Only waves of the small group within the brackets on the right are properly called light because they alone stimulate nerve endings in the human eye (ultraviolet waves can be seen by bees). Photographic film, however, can be made sensitive to all waves from the shortest wavelengths (bracket on the left) to some in the infra-red group (bracket on the far right).

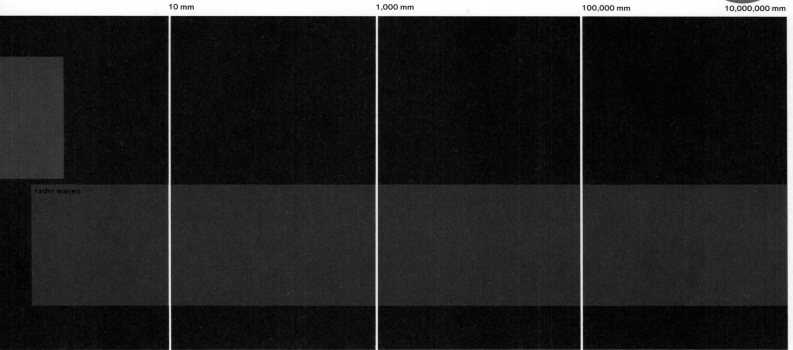

| 10 mm | 1,000 mm | 100,000 mm | 10,000,000 mm |

radio waves

It seems strange to think of light waves as being almost the same as radio waves, and yet the only physical difference between them is their length. Radio waves are the longest among the broad range of electromagnetic energy waves listed above, with wavelengths as great as 10 million mm (six miles). At the other extreme of the electromagnetic spectrum, gamma rays, produced by disintegrating atoms of radioactive elements, have wavelengths of less than approximately .0000001 mm (.000000004 in). The visible light waves are a very small group near the middle of the spectrum with wavelengths ranging from .0004 to .0007 mm (.000016 to .000028 in).

Within the narrow range of visible light,

each individual wavelength is emitted by the sun, but greenish wavelengths are emitted in greater intensity than are the others. This mixture registers in the brain as white. But other sources of light balance their wavelengths in different ways. Electronic flash tubes and fluorescent lamps emit light that may be made up of a relatively small number of distinct wavelengths—a mixture of a few distinct colours; unless these wavelengths combine to simulate sunlight (as they do in many flash units), they produce unnatural results in colour photographs. Incandescent bulbs emit a range of wavelengths, as the sun does, but the range is an unbalanced one, containing more of the long wavelengths (red colours) than it

does of the short ones (blue colours).

The wavelength balance is dependent on temperature; the temperature of the sun cannot be matched by incandescent filaments, and they cannot produce as many short wavelengths as the sun. The resulting reddish cast in their light must be counterbalanced for colour pictures and must be allowed for in black-and-white photographs.

But even sunlight is not always what it seems. It includes wavelengths that are not visible light, yet do affect film. And any of its wavelengths, visible or invisible, may be absorbed, separated, remixed and re-emitted on their way through the air to the earth—and to the film in the back of a camera.

The Earth's Atmospheric Screen

Before there was life on earth, nearly all the sun's electromagnetic waves managed to reach the surface of the earth at one time or another. With life came a new kind of atmosphere, which now screens out most of the solar wavelengths shorter than visible light (which is fortunate, since short waves can damage human tissue). The way and the degree to which the other wavelengths are able to get through depends on the atmosphere's content of carbon dioxide, smoke, dust, clouds, moisture and even on the time of day—with effects on photographic film that are sometimes annoying, sometimes surprising, sometimes beautiful.

The atmosphere screens out short wavelengths because of the way they react with matter. When short wavelengths strike molecules in air they release some of their energies, which are converted to another form. In many cases, they energize the molecules' electrons, causing them to jump to higher energy levels; when these electrons fall back they release energy that eventually takes the form of heat. Short wavelengths have then been converted into a different form of energy—they have been absorbed.

This happens only to the shortest of the wavelengths. Those that are not absorbed in this way include (a) a few too short to be seen, (b) all those in the visible spectrum and (c) many of those too long to be seen. The shortest of the in-visible rays that get through the atmosphere in any quantity are in the group called ultraviolet. These affect all ordinary films (colour as well as black and white) in the same way as visible light does. Among the longer wavelengths that are invisible is the group called the infra-red—they have wavelengths just longer than the deepest visible red. These infra-red rays are detected by special film and prove very useful in photography. Infra-red film can be used to take pictures through a layer of clouds, since many infra-red waves are not absorbed by cloud particles. Needing no visible light, such film—when exposed to infra-red waves—can take pictures in the dark (to trap a thief) or in dim light (to photograph a church wedding). And infra-red film records natural objects, which reflect infra-red in a different manner to the way they reflect visible light, in some quite unnatural but surprisingly beautiful tones *(pages 158-159)*.

Not all the waves that penetrate the atmosphere slip through unaffected. They, too, give up energy to molecules in air, but not in a way that causes energy-level jumps. When the energy is released, it is often altered in some way—in the direction of travel, the angle of undulation or in wavelengths. Since wavelength affects colour, it is this re-shaping of transmitted waves that gives sky, clouds and sunsets their colours.

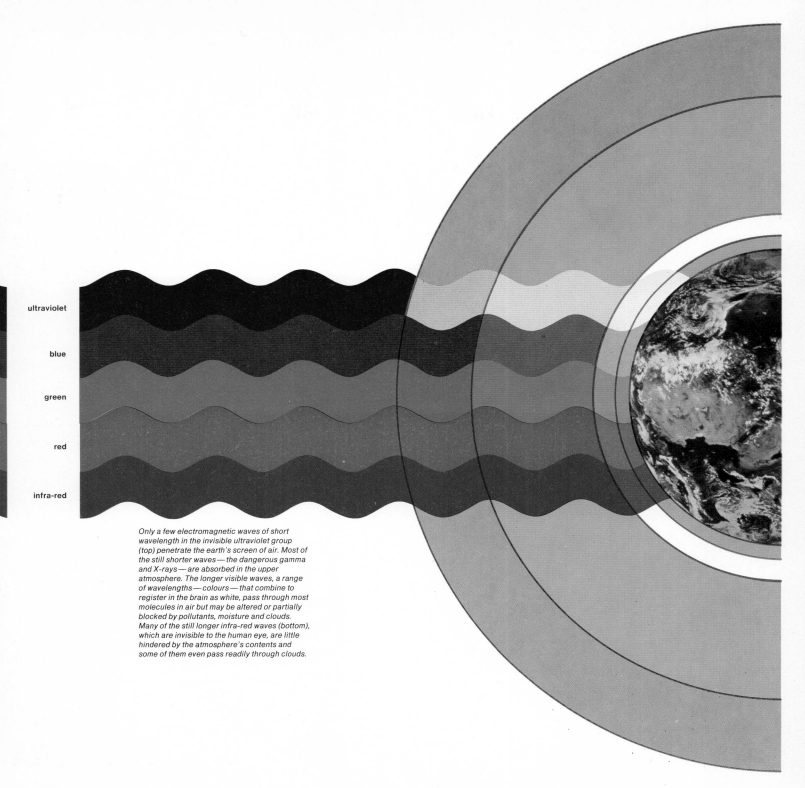

ultraviolet

blue

green

red

infra-red

Only a few electromagnetic waves of short
wavelength in the invisible ultraviolet group
(top) penetrate the earth's screen of air. Most of
the still shorter waves — the dangerous gamma
and X-rays — are absorbed in the upper
atmosphere. The longer visible waves, a range
of wavelengths — colours — that combine to
register in the brain as white, pass through most
molecules in air but may be altered or partially
blocked by pollutants, moisture and clouds.
Many of the still longer infra-red waves (bottom),
which are invisible to the human eye, are little
hindered by the atmosphere's contents and
some of them even pass readily through clouds.

Scattering: Key to the Sky's Palette

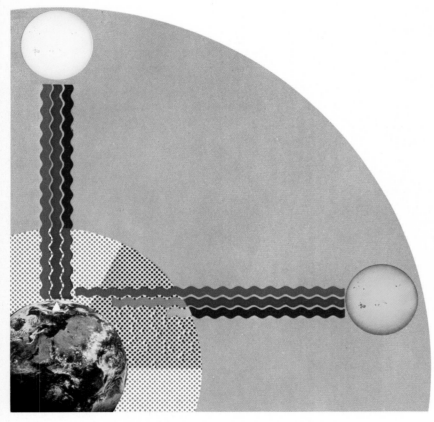

The distance the sun's light travels through the atmosphere, changing with the time of day, causes its alterations in hue. At noon the sun is directly over an observer standing at the point indicated by the arrow and its rays pierce the narrow band of atmosphere perpendicularly. The molecules in air scatter more of the short blue waves, but less of the longer green or the still longer red ones, which pass through. The sun then appears yellow (because a

combination of green and red waves looks yellow) and the sky is blue. At sunset, the light reaches the observer obliquely, travelling through much more atmosphere. It has encountered more molecules and more scattering takes place—so reducing the proportion of short (blue and green) wavelengths that the longer reddish ones predominate; the sky then takes on a red tinge and the sun looks a bright yellow-orange.

The spectacular colour of the sunset on the right is caused by the same phenomenon that makes the sky blue: the selective scattering of light waves by molecules of air (and very small dust and water particles). When these molecules react with light waves passing by, they affect the shorter wavelengths (bluish colours) more than the longer ones (yellow and red), bouncing them around and giving the sky its bluish tinge.

When to an observer on earth the sun appears low in the sky, near the horizon —as at sunrise and at sunset—its light travels a greater distance through the atmosphere than when it is overhead *(diagram on the left).* Traversing more air molecules, the light waves undergo more scattering. So many of the shorter waves are scattered that relatively few get straight through to an observer; the waves that do get through are mostly the longer yellow and red wavelengths and, therefore, the sun appears yellow-orange. Sunsets in a clear, cloudless sky are generally unimpressive, but when a beam of this reddish light paints the clouds it produces spectacular displays like the one on the right.

Not only is the colour of the sun when it is low in the sky different from its appearance during the rest of the day, but the quality of the overall illumination is different, too. Because more of the rays from the sun are scattered around through the atmosphere at sunrise and sunset, the balance between the brightness of sky light and of direct sun rays becomes more even than it is at midday. The sky light brightens shadows and softens the contrast between light and dark areas to create the delicate illumination photographers prize.

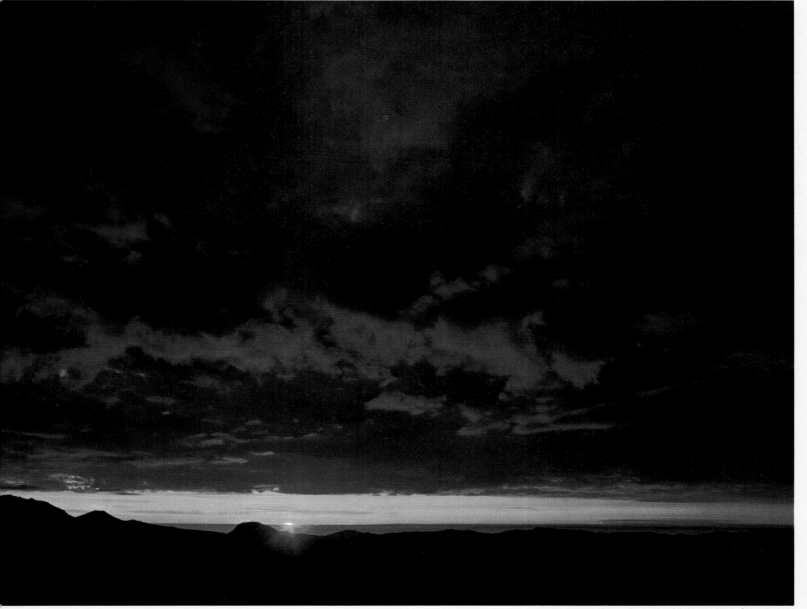

HARALD SUND: *Sunset, Rocky Mountain National Park, Colorado,* 1969

The Varieties of Reflection

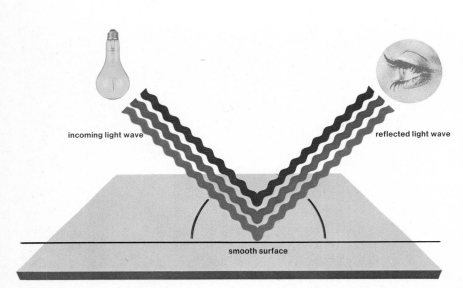

incoming light wave

reflected light wave

smooth surface

Light waves bounce off a smooth surface as a ball bounces off a wall: the angle of incidence equals the angle of reflection. All the reflected waves remain organized like the incoming ones, and the eye sees the light bulb as a reflected image. If the surface is rough, however, some waves hit and bounce at one angle, others at different angles; the reflected waves become disorganized and no image can be seen.

Light coming from the sun is unpolarized—the waves undulate at all angles, as indicated by the light and dark red waves below. They can be polarized—made to undulate at one angle, as indicated by the single pale red wave. This can happen when light waves are reflected at certain angles by such non-metallic substances as glass and water. The part of the light that continues through the substance remains essentially unpolarized. Metals are different—their electrons have a different arrangement that does not cause reflected light waves to be polarized.

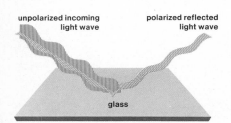

unpolarized incoming
light wave

polarized reflected
light wave

glass

Any smooth surface—polished metal or a still pool *(right)*—bounces light waves to create a reflected image *(diagram, above)*. Metals send the incoming waves back virtually unchanged, which is why they make good mirrors.

Certain non-metallic substances, however, such as diamonds, glass and water have a different electron arrangement, and reflect differently in ways that are important to photographers. Their electrons are interrelated, each layer with the one behind, so that light energy striking the surface electrons is partially passed along to those behind; the result is a dim reflection. When a non-metal's electrons are so closely interrelated, the waves that they release can undulate at the same angle *(left)*.

Even this dim reflection can be killed by a thin coating of another material—the anti-reflection coating used on camera lenses. The electrons in the coating reverse the reflected waves and pass them, too, to electrons in the rear.

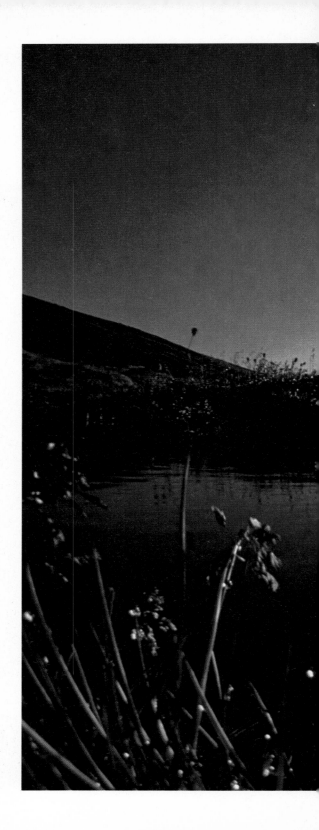

HARALD SUND: *Sunrise over Highland Pool, Mount Evans, Colorado,* 1969

Bending Waves by Refraction

A substance composed of transparent particles —such as clouds or sugar—is diffusely luminous instead of transparent because of the way light is reflected at the particle surfaces and refracted, or bent, inside the particles. If the light reaching the particles (top) is a mixture of wavelengths—which gives white light—a similar mixture emerges (bottom) with the directions of its waves altered (hence the diffusion).

Clouds are transparent water droplets— yet they usually appear as they do on the right, a diffuse white instead of transparent. Refraction, the bending of light, is one reason for this.

When the light waves enter or leave a droplet they bend so that they zigzag through the cloud and emerge in many directions. Reflections at the droplet surfaces also change waves' directions, adding to the disorganization and giving the cloud a diffuse white look.

Glass also bends light by refraction, but does not look white—unless it is finely powdered. When it is solid, as in a camera lens, it produces only a few controlled changes of direction and the light waves remain organized.

HARALD SUND: *Landscape with Clouds, Vicinity of Hartsel, Colorado,* 1969

Controlling Colours with Filters

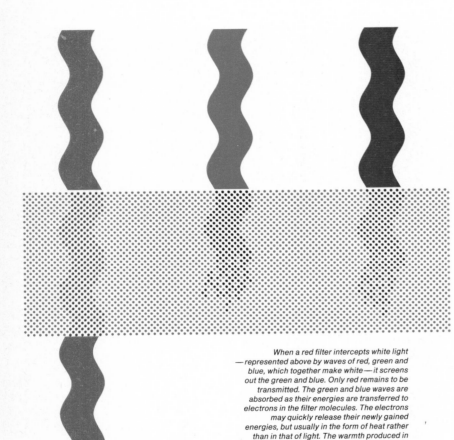

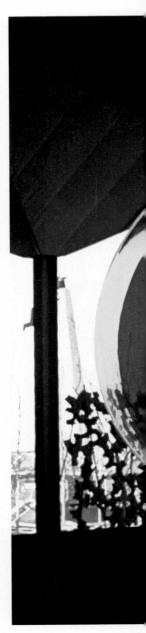

When a red filter intercepts white light
—represented above by waves of red, green and
blue, which together make white—it screens
out the green and blue. Only red remains to be
transmitted. The green and blue waves are
absorbed as their energies are transferred to
electrons in the filter molecules. The electrons
may quickly release their newly gained
energies, but usually in the form of heat rather
than in that of light. The warmth produced in
this manner can actually be felt after such a filter
has been exposed to white light for a time.

The man-sized glass discs on the right, which are components of a piece of modern sculpture, work just like the filters a photographer places over the lens of his camera to control the film's rendition of coloured objects *(pages 184-185)*. The discs achieve their multicoloured effect by allowing certain wavelengths of light to pass through them while absorbing others *(diagram on the left)*. Daylight—the mixture of all colours forming white light—from outside the gallery window appears variously yellow, red, blue or black, depending on which filter, or combination of filters, it is seen through.

A segment of the edge of the blue disc on the right looks black because it overlaps the red behind it. Between them they absorb all colours and allow no light to pass. Yet the yellow disc, a thin sliver of which shows on the left of the picture, does not affect the colour of the overlapping red disc—the red disc still looks red. Their absorption provides the explanation. Yellow glass absorbs mainly blue and transmits yellow, green and red (a combination that the brain registers as yellow). Since little red is absorbed by the yellow disc, it does not alter the appearance of the red disc in front of it.

Which wavelengths a filter absorbs are determined by molecular structure. If an orbit exists that an electron can jump to when it is struck by light of a particular wavelength, that wavelength is usually absorbed. Energy levels can be matched to almost any wavelength by applying modern chemical methods, and filters can be compounded to absorb a few wavelengths, a broad range of wavelengths or even several separate wavelengths in the spectrum. □

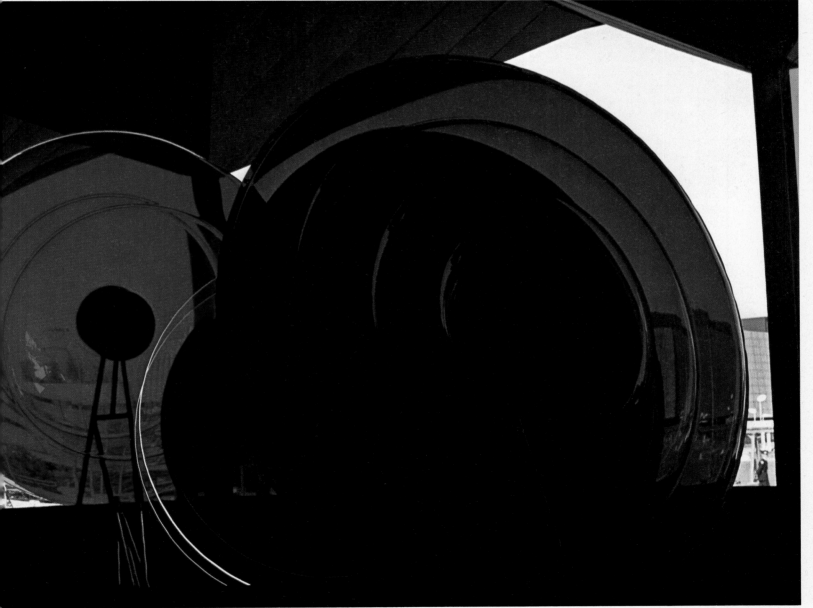

JAN LUKAS: *Sculpture, Expo '67, Montreal,* 1967

How Photographers Exploit Light

The hard, vertical line of white light that is piercing the shadows in Charles Harbutt's photograph on the right demands attention. It draws the eye directly into the picture and like an arrow points to a young boy's hands pressed flat against a wall. The light and the hands convey the photographer's thought: the boy is blind and he has discovered light in the only way he can, through touch.

This picture is one of a series Harbutt made of children at The Lighthouse in New York City, an institution for the blind. Harbutt had noticed, after observing him for several days, that this painfully deprived boy used his hands to feel for the warmth created by the rays of the sunlight that threaded the narrow space between two buildings each afternoon at about the same time. It was the only light needed for the exposure, and it made Harbutt's picture.

Like Harbutt, the photographers who took the pictures on the pages that follow used the physical characteristics of light to dramatize reality: direct sunlight for a hard, graphic image, hazily diffused daylight for a mysterious, romantic quality, directional light to accent a figure or emphasize form. They employed its qualities deliberately; no photograph shown is a lucky shot. Each one results from a conscious awareness of what light can do in a photograph.

It is common for a serious photographer to spend a great deal of time at this, experimenting with light just as he does with cameras and film. George Krause, like several other outstanding professionals, spent the early part of his career making all of his photographs on overcast days, when the illumination was diffuse. When he felt he had mastered the use of such lighting he turned to scenes that involved harsher contrasts of shadow and brightness—with the stunning results shown on page 43.

Such concentration on one particular aspect of light helps a photographer to learn to "see" light—i.e., to visualize the differences that changes in illumination will make. With this educated and heightened sense of perception he can make a picture live up to the original Greek meaning of the word photography: "light writing". Shadows, reflections, patterns of light, even the light source itself may become the heart of a composition in which solid objects are incidental and light is the theme.

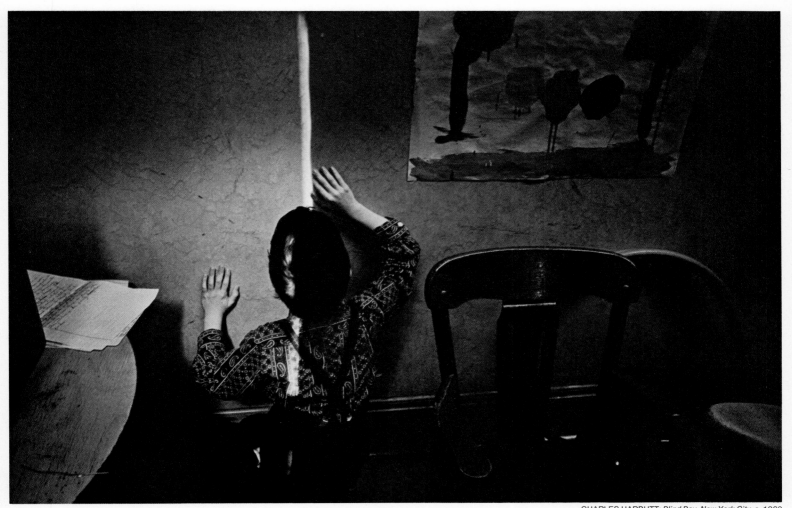

CHARLES HARBUTT: *Blind Boy, New York City*, c. 1960

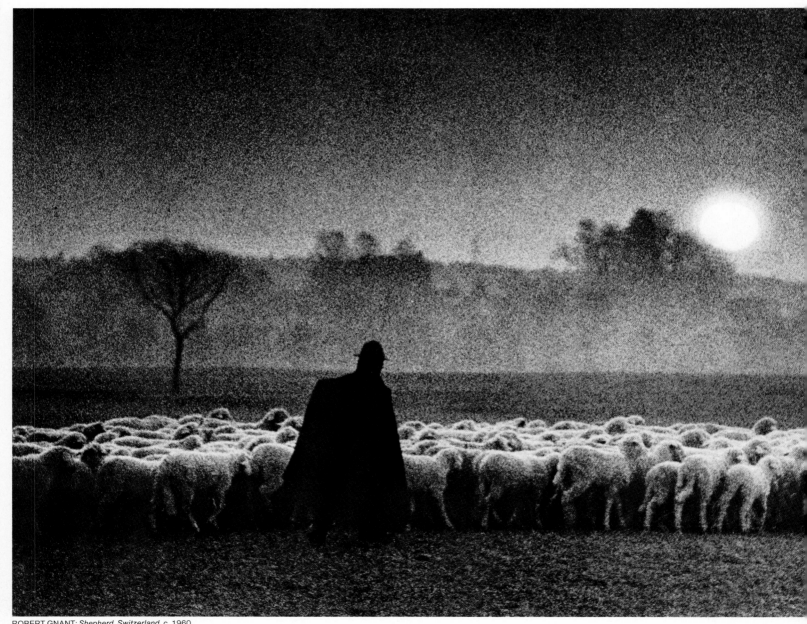

ROBERT GNANT: *Shepherd, Switzerland,* c. 1960

28

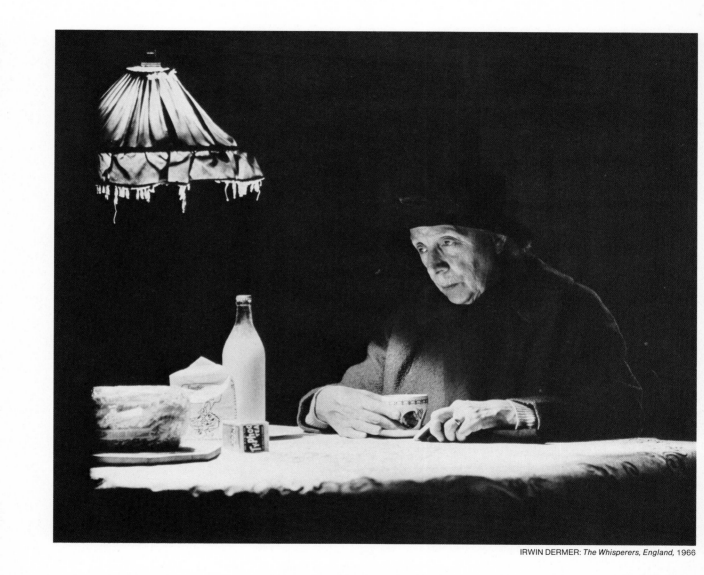

IRWIN DERMER: *The Whisperers, England,* 1966

Just as the sun blinds us if we look directly into it, any light source included in a composition tends to overwhelm the subject it illuminates. But when a balance can be struck, the picture acquires a special sense of completeness. We not only see the view but understand why it looks that way, as in Robert Gnant's photograph of a Swiss shepherd with his flock by moonlight *(opposite),* or in Irwin Dermer's portrait of the English actress Dame Edith Evans as a lonely old woman in the film *The Whisperers,* her world encompassed by a tea table, her sun an electric light bulb.

Setting a Mood

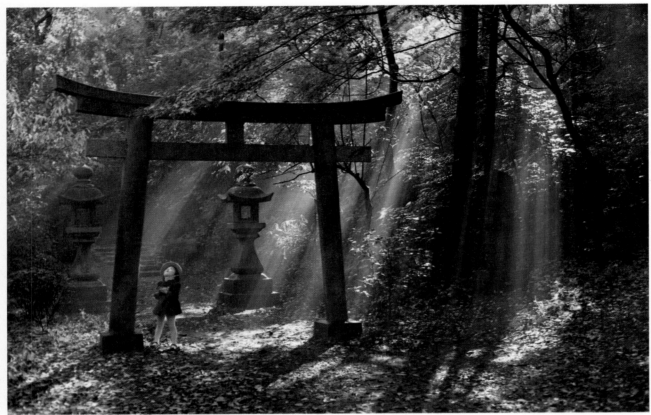

HARALD SUND: *Torii Light, Tokyo,* 1975

Light that comes directly from a single source—the sun or a spotlight—can create dramatic, often magical, effects. But strong light can also wash out details in highlights or lose them from shadows. A successful compromise was struck in the photograph above of a child gazing at a *torii,* the ritual gateway found at shrines devoted to Japan's ancient Shinto faith. By exposing for the shadows in this sun-dappled museum garden, the photographer was able to bring out detail in most of the scene although the sun filtering through the trees causes some loss of detail in the highlights.

Reflected or diffused light—from the walls of a room, from the sky on an overcast day—is soft. It fills in shadows and plays down contours. Neal Slavin's study of an amusement park in winter, with all the people and excitement gone, shows a scene almost faded from view; the soft light filtering through a snowstorm seems to come from everywhere and nowhere.

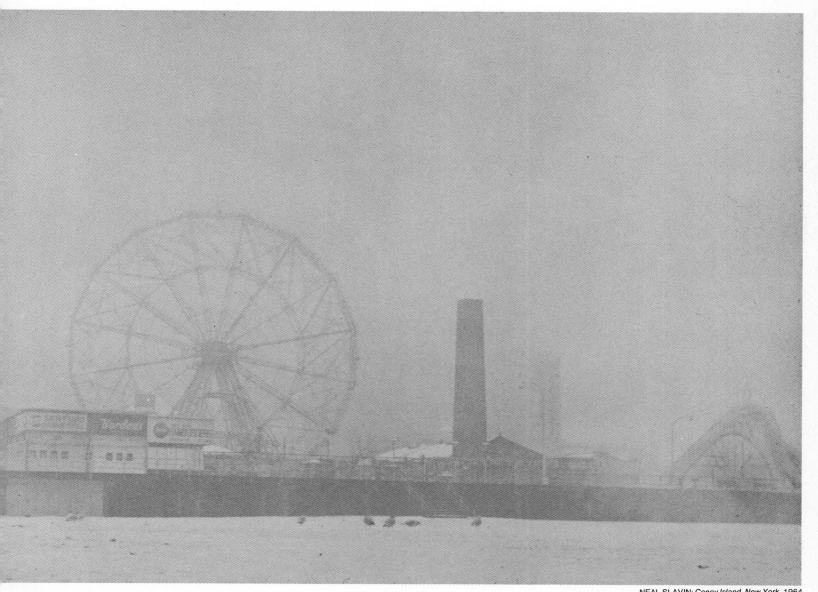

NEAL SLAVIN: *Coney Island, New York,* 1964

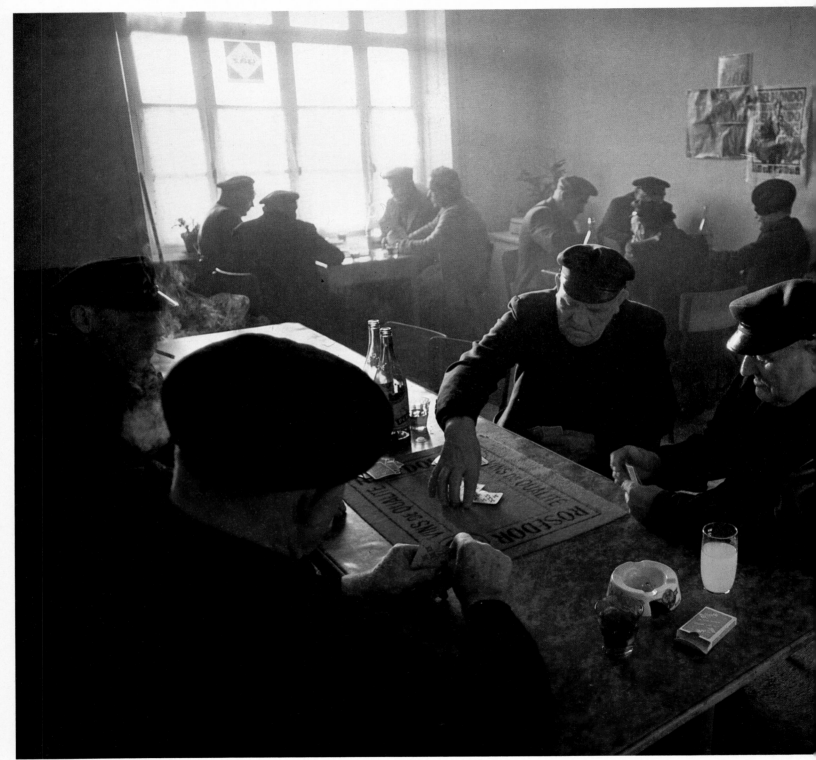

MICHEL THERSIQUEL: *Buvette, Keritz, France*, 1975

Capturing Atmosphere Indoors

Afternoon sunlight, spilling through a curtained window and spreading across a fisherman's café in Brittany, enhances the atmosphere of relaxed activity that makes this picture special. To reproduce the light indoors and show how it shades parts of some figures while illuminating others, without using flash or floodlights that would disturb the mood, the photographer was confronted with a delicate exposure problem: he had to expose sufficiently to record detail in the faces of the fishermen in the foreground without permitting the window light to obliterate the figures at the far end of the room.

The exposure he selected — 1/60 second at f/2 with ISO 50/18° film — yielded a clear view of the men nearest the camera, and left the others gently silhouetted in the hazy window light.

Isolating the Image

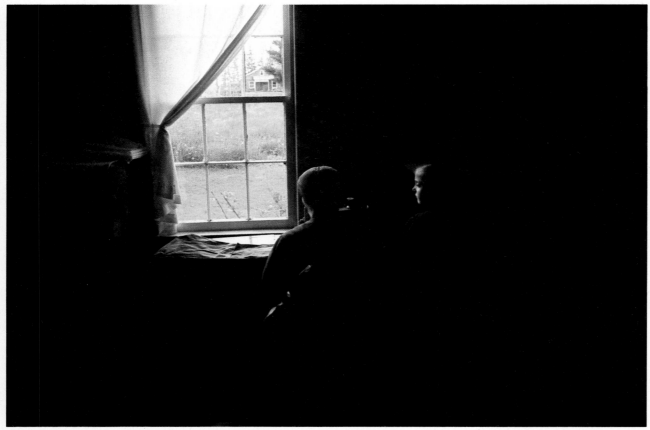

ROBERT W. MADDEN: *Mother and Daughter, Pleasant Valley, Maryland,* 1973

There is nothing wrong with the old rule of standing with your back to the sun when making a snapshot. It ensures maximum illumination of the subject. But the directional characteristics of light can also be exploited in subtler ways.

For the scene of an Amish woman and her daughter at work *(above),* the photographer shot directly into the source of light—the window light by which they were sewing. This surrounded the figures with a halo, which is made even more delicate by the contrast of the deep shadows that fill the room.

In the picture of Hasidic Jews at a wedding party *(right),* the interest lies in the expression on each man's face and in the placement of his hands—the very elements emphasized by the bright light that floods in horizontally from the left.

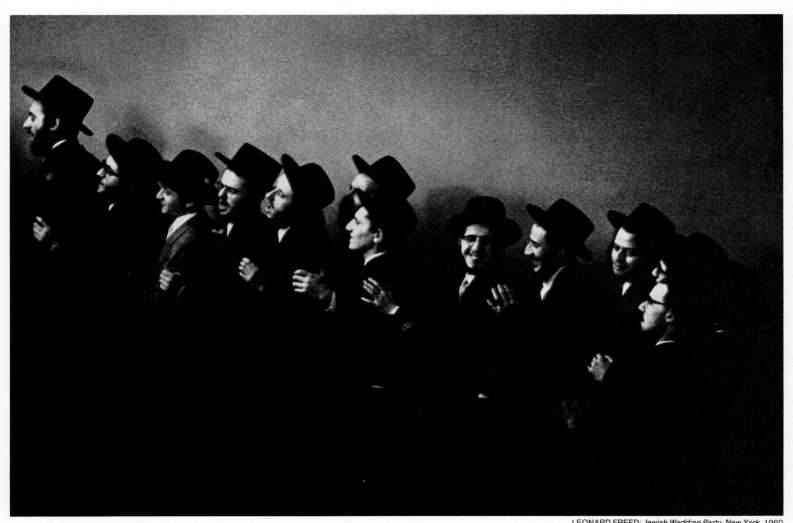

LEONARD FREED: *Jewish Wedding Party, New York,* 1960

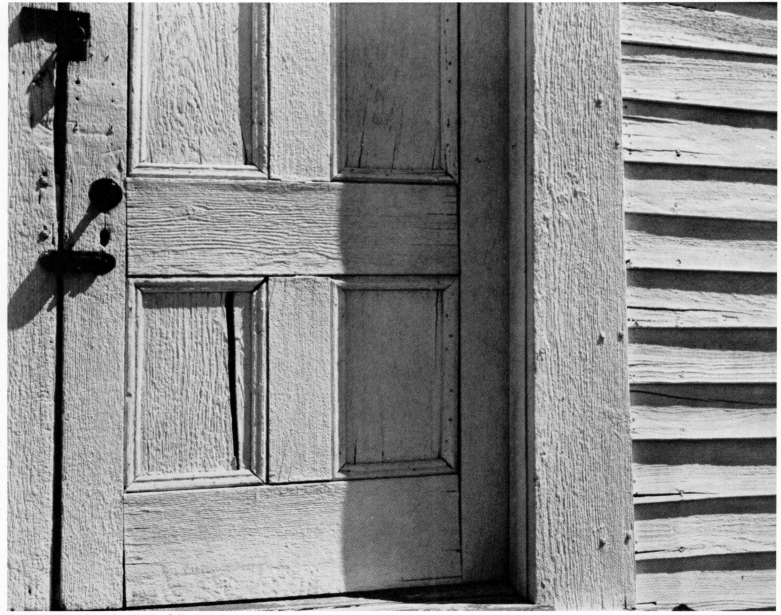

EDWARD WESTON: *Church Door, Hornitos, California,* 1940

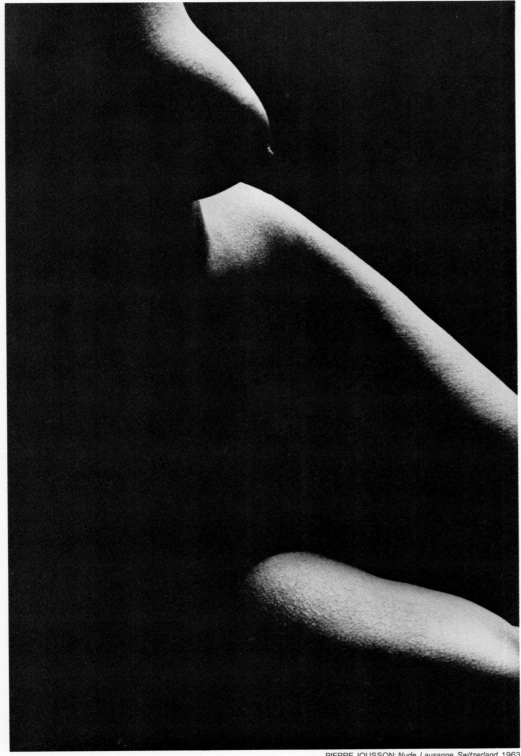

PIERRE JOUSSON: *Nude, Lausanne, Switzerland,* 1963

Seeing Form and Texture

Light falling obliquely across the front of an old church celebrates the natural texture of weatherbeaten wood in Edward Weston's photograph on the opposite page. Weston, who invariably relied on natural light for illumination, waited for hours on several occasions for the exact balancing of quality, direction and intensity that achieved the effect he sought. The problem is more easily solved in the studio, where oblique light can be precisely controlled to convey the reality of surfaces and shapes. On the left, Pierre Jousson has aimed a single spotlight to brush the surface of a nude model, creating a contrasting pattern of lights and darks that gently defines the female form.

A Fresh View in Reflections

The interplay between real and reflected images can turn the normal view of the world topsy-turvy, especially in a photograph taken from an unconventional angle. In the aerial view of Buena Vista Lake in southern California *(right),* the relationship between the sun and a sunlit flock of flying snow geese is puzzling. The heavy, bold image of the sun is seen mirrored in the lake surface. But the flight of snow geese is not reflected.

In reality, the birds are pictured directly, flying beneath the camera plane and above the sun image, reversing the normal view of them. The pattern is multiplied in complexity by shadows of the birds visible on the lake surface, and again as ghostly echoes off the shallow lake bottom. The faint, blurred dots in the upper left-hand corner of the picture are shadows cast by another flock of birds flying at a much higher altitude.

In a picture of the lily pond at Impressionist painter Claude Monet's estate 64 km (40 miles) from Paris *(opposite),* the relationship between objects and their reflections, recorded from a more familiar perspective, is easier to make out. The photographer's intention was to recapture, on film, some of the luminous effects of light striking water that the Impressionists achieved in their paintings.

The light areas at the bottom of the picture are reflections of the sky. The rounded shapes above them are lily pads glistening in the sunlight against a shadowy background of reflected trees. The lilies appear to be floating above the sky —an illusion that Monet, who designed the pond, often painted during the 43 years he lived on the estate.

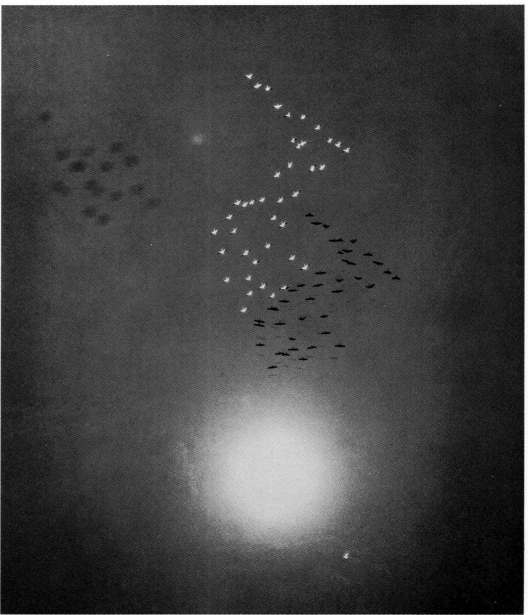

WILLIAM GARNETT: *Snow Geese over Water, Buena Vista Lake, California,* c. 1953

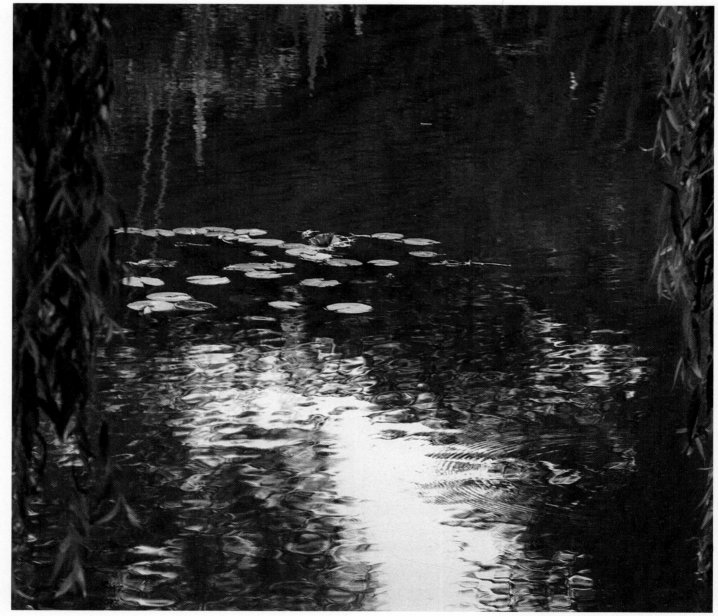

DMITRI KESSEL: *Water Lilies, Giverny, France,* 1979

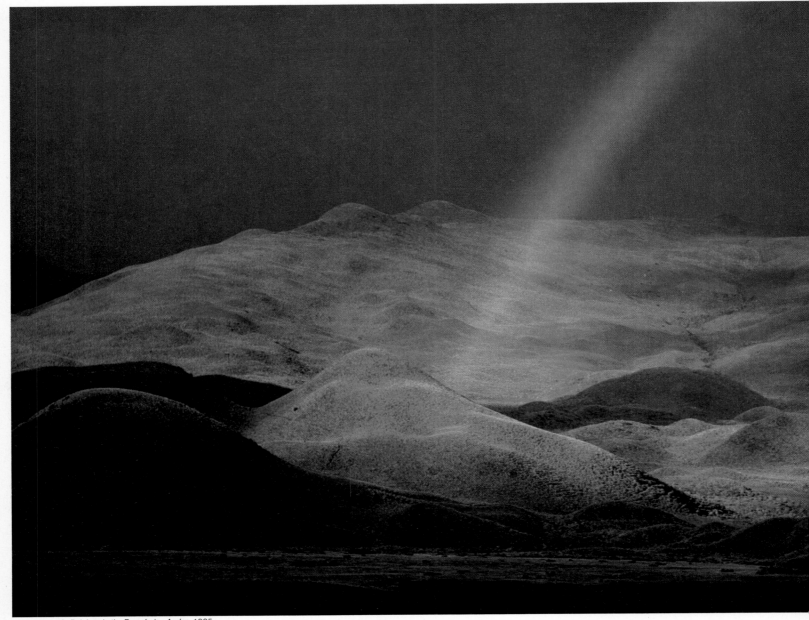

ERNST HAAS: *Rainbow in the Ecuadorian Andes,* 1965

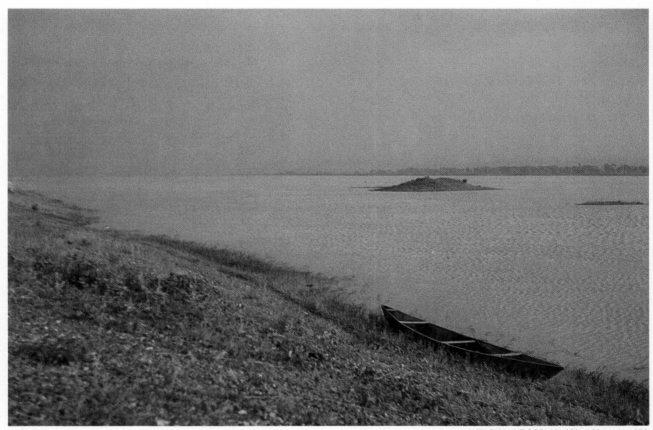

ANNI-SIRANNE COPLAN: *African Monsoon,* 1978

When light is refracted or filtered through rain or water vapour, it can reduce a tropical landscape to moody monotones or spread a rainbow across the sky. In the photographs shown here, the remarkable colours created by refracted light have been as accurately reproduced as colour film permits; no filters or special processing were used to exaggerate the effect.

Ernst Haas's breathtaking photograph of a rainbow arching over the Ecuadorian Andes *(left)* reminded him of "the first cycle of the seasons and the colours of flowers to come". It appeared in the first section of his 1971 book, *The Creation,* devoted to the Biblical story of the creation of the elements.

Above, a French photographer's delicate view of the Niger River in West Africa was taken during the monsoon-like rains that occur every afternoon in the summer. The whole picture glows with a single unifying element—harsh tropical sunlight softened by rainfall.

Composition in Shadows

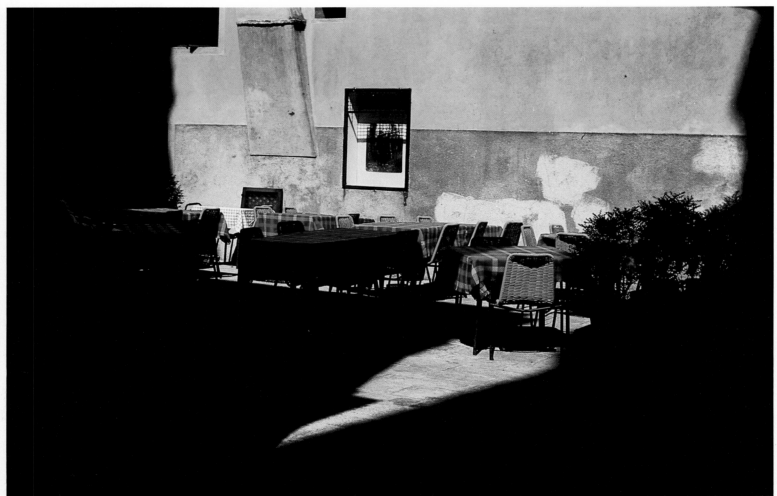

HARRY CALLAHAN: *Café in Venice, Italy,* 1978

Shadows carry the weight of these two pictures. In the photograph above, the buildings behind the camera throw jagged shadows across a pavement café in Venice. Compared to the strong pattern formed by shadows and wall, the café itself becomes almost incidental to the composition. The photographer capitalized on a characteristic of colour film to achieve this effect: colour film normally yields higher contrast in a strongly lit scene than black-and-white film.

In a picture taken at dawn in Seville *(right),* horizontal light casts a looming, sinister shadow. The photographer captured what seems to be the image of a dark secret following the woman, its foreboding enhanced by her bent carriage.

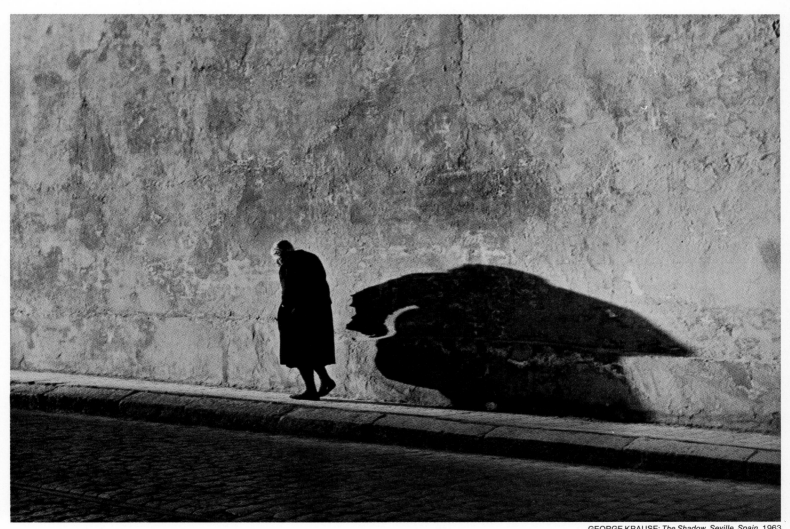

GEORGE KRAUSE: *The Shadow, Seville, Spain,* 1963

Patterns in Brightness

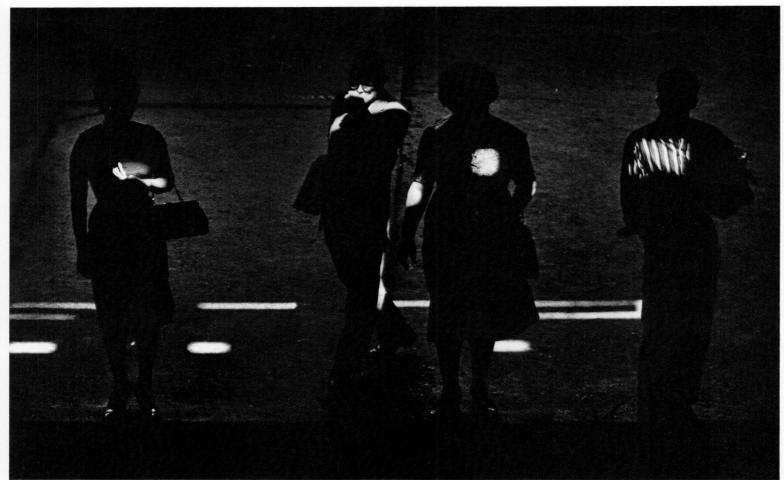

KENNETH JOSEPHSON: *Chicago,* 1961

Shadows made the pictures on the two previous pages. Here, light reverses roles: its presence rather than absence paints the patterns that the eye seizes upon. Kenneth Josephson snapped his shutter at the exact moment that four pedestrians were spotlighted by the random shafts of sunlight penetrating the gloom under an elevated railway in Chicago *(above).* In Lars Werner Thieme's unusual photograph of a German organ grinder *(opposite),* the pattern of sunlight infiltrating a Munich street arcade provides the picture's substance, more solid seeming than the pavement and the wall it presses against.

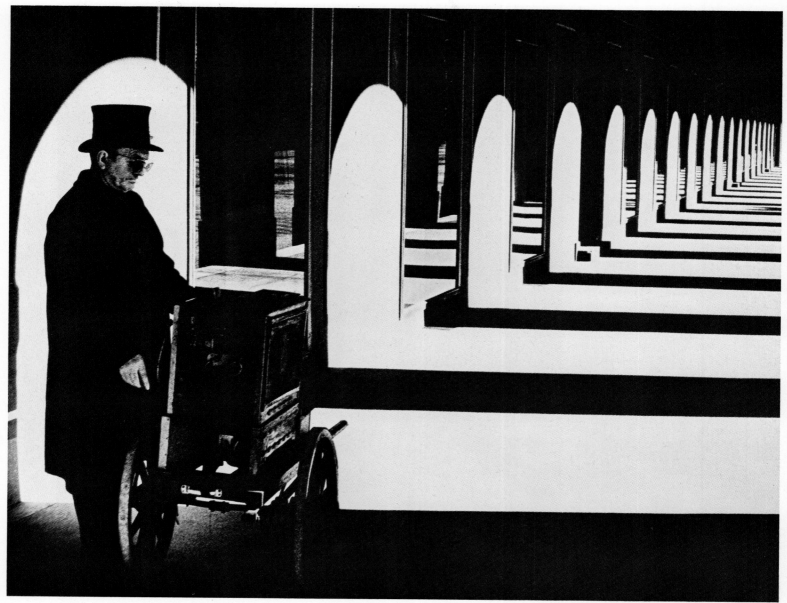

LARS WERNER THIEME: *Ash Wednesday, Munich, Germany,* 1967

Managing Extremes

Scenes with highly contrasting lights and darks, such as the night-time street scene on the right, present unusual obstacles—especially if shot in colour. It is difficult to choose an exposure that will produce sufficient illumination to show details in the shadows but will not over-expose the highlight areas. Colour distortions are also troublesome during night-time shooting. They can occur when certain colour films are used under artificial light, and when dim illumination requires exposure times of 1 second or more.

By selecting colour print film—rather than slide film—Jan Staller was able to overcome these difficulties in this photograph of a bus stop opposite New York City's Flatiron Building. Because he was able to correct colour distortions with filters during printing, snow that has accumulated on the pavements was rendered with perfect fidelity in the final print. If he had used colour slide film, which involves no printing stage and thus offers no opportunity to make colour corrections, the snow would have appeared orange. With falling snow and a well-placed tree to screen the intensity of the street lights, his long, 60-second exposure recorded detail in the darkness above the street without over-exposing areas near the street lights.

This picture was inspired by a celebrated photograph that was taken from about the same spot by Edward Steichen in 1904. It shares some of the original's tranquil tone despite the passage of a hectic three quarters of a century.

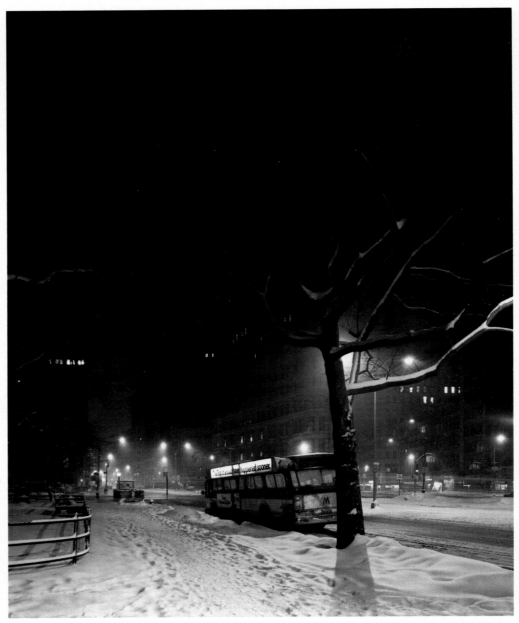

JAN STALLER: *A Tribute to Steichen, New York City,* 1978

The Evolution of Film **2**

The Inventors of Photography 50

Old-Time Processes, Clumsy but Beautiful 62
The Art of Making a Daguerreotype 64
The Several Faces of Daguerreotype 66
A Clear View of the World in Daguerreotypes 68
Calotype Prints from a Paper Negative 70
The Soft Look of the Calotype 72
Making a Wet Plate 76
The Wet Plate: De Luxe and Economy Models 78
A Picture While You Wait 80

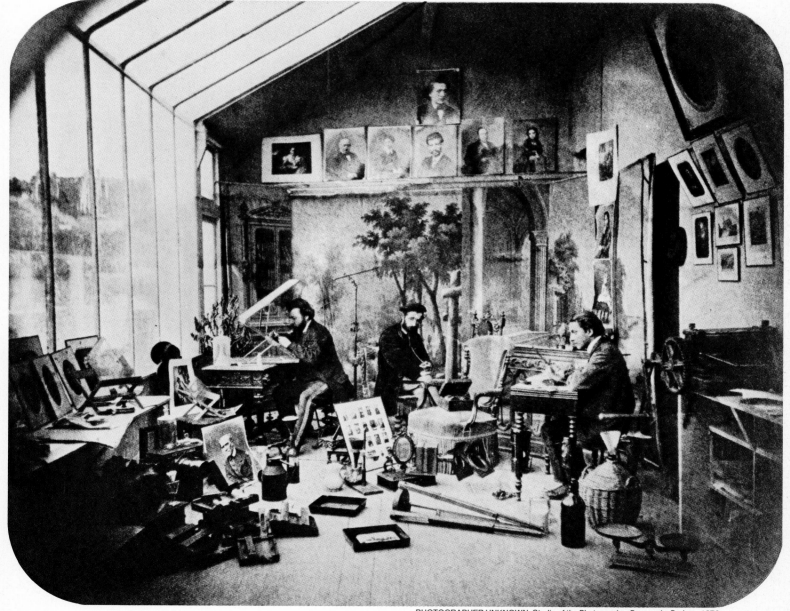

PHOTOGRAPHER UNKNOWN: *Studio of the Photographer Bourgeois, Paris*, c. 1870

49

The Inventors of Photography

After completing a lecture at the Sorbonne one day in 1827, Jean Dumas, an outstanding chemist of the period, was approached by a perturbed woman who told him she was "the wife of Daguerre, the painter". Her husband, she said, was "possessed". He was convinced he could make permanent pictures from the fleeting images produced by a lens. "I'm afraid he is out of his mind," she said. "Do you, as a man of science, think it can be done, or is he mad?"

"In our present state of knowledge, it cannot be done," Dumas replied, "but I cannot say it will always remain impossible, nor set the man down as mad who seeks to do it."

Dumas was not merely pacifying a worried woman; he had good reason not to dismiss the idea of recording permanent images with light. As a chemist, he undoubtedly knew that certain silver compounds were reactive to light — as early as the 17th century, an Italian scientist, Angelo Sala, had reported that "when you expose powdered silver nitrate to the sun, it turns black as ink" — and that short-lived pictures had already been recorded with these compounds. The unsolved and difficult problem was how to "fix" the recorded image, halting the reaction with light so that the picture would not fade away.

In 1727, a hundred years before Madame Daguerre talked with Dumas, Johann Heinrich Schulze, a professor of medicine at the University of Altdorf in Germany, made the first of these ephemeral pictures. One day, as part of an experiment that had nothing to do with light images, he stood a flask containing a silver nitrate mixture in sunlight; when he inspected it a few minutes later, he found the part of the solution that had received the direct rays of the sun had turned a dark violet, while the remainder of the mixture retained its original whitish colour. When he shook the bottle, the violet disappeared.

Intrigued by this, Schulze pasted paper stencils on the flask and faced them directly towards the sun. When he later removed the stencils, there, outlined by the surrounding darkened sediment, were the whitish patterns — i.e., negative silhouettes — of the light-blocking slips of paper. But was it the sun's light or its heat that caused the unshaded chemicals to darken? To answer that question, Schulze put another container of the mixture in a hot, dark oven. It was not affected; obviously light had caused the change. The silhouettes were soon gone, however. Within a short time, just the reflected daylight in the room darkened them to the same shade as the surrounding sediment.

In the early 19th century, Thomas Wedgwood, the youngest son of the famous British pottery manufacturer Josiah Wedgwood, made similar experiments with similarly tantalizing results. He made some attempts to record the natural images created by a lens in a camera obscura, the ancient device that artists used to cast a picture of a scene on a glass viewing screen. The results, however, were so poor that he concentrated on making silhouettes like Schulze's, placing leaves and insect wings on silver-sensitized white paper or

white leather and exposing them to the sun. Like Schulze, he achieved negative images. Wedgwood tried many ways to make these silhouettes permanent, but nothing worked. As soon as light, however subdued, struck the images, they began to darken like the rest of the coating.

Schulze and Wedgwood were on the right track. The silver atom's unique properties enable it to form compounds and crystals that respond in delicate, controllable ways to the energy of light waves *(pages 128-129)*. Over the following century and a half, many men from a variety of callings, not only scientists but artists, printers, soldiers, musicians, country squires, even clergymen, helped to develop silver-based materials into the practical roll film that made photography—in black-and-white or full colour—Everyman's art form. Black-and-white pictures are made up of deposits of silver metal that look black, instead of the familiar silvery grey, because the particles of metal are so finely divided. Even colour photographs start out as black-and-white negatives—each one a record, in silver, of the amount of each primary colour in the subject. Black-and-white film, of course, had to come first; its story, told here, is one of technical discovery combined with business enterprise; how it led to a practical system of colour photography is described in *Colour,* another volume of the LIFE Library of Photography.

Oddly enough, although silver is the basis of all modern photography, it played no part at all in the first permanent pictures that can be called true photographs, made in about 1824 by Joseph-Nicéphore Niepce, a gentleman inventor and lithographer living in Chalon-sur-Saône in central France. They were produced with, of all things, asphalt.

Niepce began his experiments partly because of a business need. In the lithographic printing process as it was then practised, copies were produced from a flat stone surface that had a design transferred on to it, much as in printing from woodcuts or engravings. To get lithographs of a line drawing, for example, the drawing had first to be copied (in reverse) on the stone surface. Niepce's son, Isidore, had done this work, but he had left for his tour of army duty. Niepce had no talent for draughtsmanship and he decided to devise an automatic method of copying line drawings on to his lithographic stones.

Niepce knew that a certain kind of asphalt, called bitumen of Judea, hardened when exposed to light. He dissolved this asphalt in lavender oil, a solvent used in varnishes, and coated a sheet of pewter with the mixture. Face down on the coated surface he placed a line drawing that had been oiled to make it translucent and then exposed the plate and illustration to sunlight. The sun hardened the asphalt wherever the blank areas of the drawing allowed light to shine through on to the plate, but the coating that was shielded by the black lines of the drawing remained soft and soluble. After removing the oiled drawing, Niepce washed the plate with lavender oil. This removed the soft, soluble

asphalt that had not been struck by light. The parts of the plate that duplicated the black sections of the original drawing were cleaned down to the pewter base and etched with acid to make an incised copy. The incised lines held the ink to make the print. Niepce called his new process heliogravure—from the Greek *helios* for "sun" and the French *gravure* for "engraving". He made heliographic plates of drawings of the Virgin, the Infant Jesus, Saint Joseph and other subjects, but a more exciting use soon occurred to him: why not put one of his asphalt-coated plates inside a camera obscura and make pictures directly from nature? Placing a plate at the back of the camera, he aimed its lens through an open window at his courtyard and left it there all day. When the plate was removed and washed in lavender oil, it bore a barely decipherable view of roofs and chimneys. To get a better image and reduce the impracticably long exposure time, Niepce tried other light-sensitive materials, including a plate of silver-coated copper. The results, however, were not encouraging.

Word of Niepce's work filtered through France and one day he received a letter from a stranger, a Parisian named Louis Daguerre. Daguerre wrote that he, too, was experimenting with the recording of images and suggested an exchange of information. Niepce's reply was guarded. Darkly suspicious, he wrote to a business associate in Paris in February 1827 to inquire about Daguerre: "This gentleman, having been informed, I do not know to what extent, of the object of my researches, wrote to me last year to let me know that for a long time he had occupied himself with the same object and he asked me if I had been more fortunate in my results. However, if he is to be believed, he has already obtained very astonishing results; notwithstanding this, he requested me to tell him first whether I thought the matter was possible at all. I do not want to deceive you, Monsieur, that a seeming incoherence of his ideas has caused me not to tell him too much. Will you be good enough to send me your personal information on Daguerre and your opinion of him."

The reply was moderately reassuring. "I believe," wrote Niepce's associate, "he has a rare intelligence for the things that deal with machines and lighting effects; I know he has occupied himself for a long time with perfecting the camera obscura, but I do not know the object of his work."

In August of that year, Niepce was in Paris and met Daguerre for the first time. Except for their mutual interest in recording images with the camera obscura, the men seemingly had little in common. Niepce, then 64, had been born into the French aristocracy and was a quiet, reserved man with a classical education and an excellent background in science. The French Revolution had sharply reduced his wealth, but he continued to receive enough money from the family estate to enable him to devote most of his time to scientific pursuits. Before he became interested in his photographic process, he and his brother, Claude, had spent some years dabbling with other inventions, including a

method for extracting indigo dye and an internal combustion engine. Although they were successful in propelling a boat up and down the Seine and Saône rivers with the engine, neither invention ever proved commercially feasible.

Daguerre, who was Niepce's junior by 22 years, came from a middle-class family, was largely self-educated and knew almost nothing of science but was a remarkably talented and energetic man. Because of his skill at drawing, Daguerre had been apprenticed at 16 to an architect, but he left after three years to become a painter and a stage designer for the Paris Opera. He was also one of the inventors of the enormously popular Diorama. In this spectacle, usually staged in a specially built exhibition hall, famous scenes, such as the interior of Canterbury Cathedral or panoramas of the Swiss Alps, were re-created with three-dimensional effects through the use of translucent paintings and sophisticated lighting. Among his other talents, Daguerre danced well enough to appear occasionally with the corps de ballet at the Opera and was an amateur acrobat with professional competence—tight-rope walking was his speciality.

Despite the dissimilarity in their backgrounds and characters, Niepce and Daguerre apparently liked each other at first meeting. During the next two years, they corresponded about their work and met from time to time to discuss their progress. (The ever-cautious Niepce, however, disclosed few details of his actual methods.) Then, in 1829, Niepce proposed that Daguerre become his partner and engage "in mutual work in the improvement of my heliographic process, and the various ways of applying it, taking a share in the profits that its improvements will permit us to hope for".

Daguerre quickly accepted and then visited Niepce in Chalon to learn about heliogravure and to make plans for the joint project. After Daguerre returned to Paris, the partners never saw each other again. For the next four years they worked separately and reported on their experiments by post. Much of their research during this period was focused on the application of iodine, the reddish non-metallic element that had been discovered in 1811 and was found to form a very light-sensitive compound with silver. But Niepce did not live to enjoy the eventual success of their work. He died of a stroke in 1833, leaving his partner to carry on alone.

On January 7, 1839, Daguerre was finally satisfied with his new photographic process and arranged to announce it before the French Academy of Sciences. Aware of his own lack of scientific training and reluctant to submit himself to questions that might be asked by the Academy members, Daguerre requested a scientist friend to make the actual presentation for him. It was a triumph. The photographs, which the inventor called "daguerreotypes", were examined with awe and enthusiastically praised.

Reporting on the pictures, the prestigious *Journal of the Franklin Institute* of Philadelphia said that the Academy members "were particularly struck

with the marvellous minuteness of detail. . . . In one representing the Pont Marie, all the minutest indentations and divisions of the ground, of the buildings, the goods lying on the wharf, even the small stones under the water, were all shown with incredible accuracy. The use of a magnifying glass revealed an infinity of other details quite undistinguishable by the naked eye.''

Daguerre did not reveal details of his process for some months after its announcement and during this interval some chose to consider his pictures a fraud. A German publication, *Leipziger Stadtanzeiger,* found that Daguerre's claims affronted both German science and God, in that order: ''The wish to capture evanescent reflections is not only impossible, as has been shown by thorough German investigation, but the mere desire alone, the will to do so, is blasphemy. God created man in His own image, and no man-made machine may fix the image of God.'' The *Stadtanzeiger* held that if such wise men of the past as Archimedes and Moses ''knew nothing of mirror pictures made permanent, then one can straightway call the Frenchman Daguerre, who boasts of such unheard of things, the fool of fools.''

The teacup tempest subsided when the mechanics of the process were revealed in August 1839. Daguerre had perfected a very sophisticated photographic method. His light-sensitive material was silver iodide, similar to but more effective than the compounds used by Schulze and Wedgwood. And somehow (the record is vague on this point) he had hit upon the solution to the centuries-old problem of ''fixing'' the picture into a permanent, fade-proof image. Daguerre discovered that a chemical now known as sodium thiosulphate—photographer's ''hypo''—dissolved light-sensitive silver compounds before they had been transformed into a visible image but not afterwards. Thus he could make an exposure and before any other light struck the picture bathe it in hypo to halt further action by light.

Except for the fixing step, Daguerre's process was totally different from modern photography. The daguerreotype was made on a highly polished surface of silver, plated on a copper sheet *(pages 64-65)*. It was sensitized by placing it, silver side down, over a container of iodine crystals inside a box. Rising vapour from the iodine reacted with the silver, producing the light-sensitive compound silver iodide. During exposure in the camera, the plate recorded an image that at this state was latent—a chemical change had taken place but no evidence of it was visible. To develop the image, the plate was placed, again silver side down, in another box, this one containing a dish of heated mercury at the bottom. Vapour from the mercury reacted with the exposed grains of silver iodide on the plate. Wherever light had struck the plate, mercury formed an amalgam, or alloy, with silver. This brilliantly shiny amalgam thus made up the bright areas of the image. Where no light had struck, no amalgam was formed; the unchanged silver iodide was dissolved

away in sodium thiosulphate fixer, leaving there the bare metal plate, which looked black, to form the dark areas of the picture.

The sharpness and tonal range of the daguerreotype continues to be among the wonders of photography. Anyone who has examined at close range one of the many small, velvet-framed pictures exhibited in historical collections cannot help but marvel at their life-like appearance, precisely detailed, delicately shaded and naturally luminous. The image is literally a bas-relief created by the mercury. The amount of the mercury amalgamated with silver at each point in the image varies directly with the amount of light that has struck that point on the plate and it is this very gradual build-up of amalgam that creates a seemingly infinite range of greys. The amalgam is mirror-like in reflectivity, so that highlighted areas are unusually brilliant, while the deep, rich black of the dark sections is simply the polished silver plate, which when viewed from the proper angle reflects almost no light.

The French government quickly recognized the value of the new process and just seven months after Daguerre's announcement to the Academy, he and Niepce's son, Isidore, were awarded pensions for life. Soon the daguerreotype became an adjunct to historical functions. "At the opening of the railroad to Courtrai, Belgium," the British *Mining Journal* reported in 1840, " . . . the camera obscura is to be placed on an eminence commanding the royal pavilion, the locomotive engine, the train of wagons, and the major part of the cortège, and is to be brought into action exactly at the time of the delivery of the inauguration speech. A discharge of cannon is to be the signal for a general immobility, which is to last the seven minutes necessary for obtaining a good representation of all the personages present."

There was, however, criticism of the new process. While praising it as an invention "little short of miraculous", a British publication, *The Penny Cyclopedia,* complained that the highly polished surface of the daguerreotype produced a "glare offensive to the eye". The journal also found fault with the curious tendency of the plates to appear as negatives unless viewed from exactly the right angle. This meant the pictures could not be hung in frames, since "it would be necessary to take them down to look at them".

But there were other, more important disadvantages that made the daguerreotype a technological dead end in spite of its superb quality. The plate required artful polishing, sensitizing and developing, and the image was extremely delicate and required elaborate protection from abrasion. The most serious drawback of the daguerreotype process, however, was that each plate was unique; there was no way of producing multiple copies except by photographing the original.

Although the daguerreotype would continue to be made for about a decade, the process was actually obsolete when it was introduced. Photography's

time had come and in England a gentleman scientist had already invented the modern photographic process. On January 25, 1839, less than three weeks after Daguerre's announcement to the French Academy, William Henry Fox Talbot appeared before the Royal Institution of Great Britain to present his negative-positive system. Talbot was a disappointed man when he gave his hastily prepared report. Daguerre's prior announcement, Talbot admitted later, ". . . frustrated the hope with which I had pursued, during nearly five years, this long and complicated series of experiments—the hope, namely, of being the first to announce to the world the existence of the New Art—which has since been named Photography." Although Talbot could not be the first, he was determined to establish, as soon as possible, that his process was wholly independent of Daguerre's.

Talbot was fairly typical of a number of amateur scientists who graced the gentry of the early 19th century. Born in the south of England in 1800 to an upper-class family—his mother was the daughter of an earl, his father an officer in the Dragoons—Talbot was educated at Harrow and Trinity College, Cambridge, elected a Fellow of the Royal Society for his contributions to mathematics and served briefly as a Member of Parliament. He sometimes used a camera obscura to help him in sketching, one of his hobbies, and he recalled that in 1833 "the idea occurred to me—how charming it would be if it were possible to cause these natural images to imprint themselves durably and remain fixed on paper". He soon began his experiments.

Talbot's first attempts were silhouettes, produced by placing objects on light-sensitive paper and exposing them to the sun—the technique used earlier by Wedgwood. Talbot sensitized a fine grade of writing paper by dipping it into a weak mixture of salt and water, waiting for it to dry and then brushing the sheet with a silver nitrate solution. This operation was repeated several times with each sheet. But, unlike Wedgwood, Talbot soon learned how to retard, if not halt completely, the fading of the image. In his experiments, he observed that sensitivity was nearly eliminated in areas of the paper where the salt concentration was excessive. He applied this discovery by dipping the exposed sheet in a concentrated salt solution. (Soon he was led to the permanent fixative that Daguerre had independently discovered, sodium thiosulphate, by his friend and fellow scientist, Sir John Herschel.)

Now Talbot carried the making of a silhouette a step further: he made a positive paper print of it. The negative silhouette—i.e., a white image of, say, a leaf, outlined by the surrounding dark areas—was placed face down on a second piece of sensitized paper. Then the two were pressed together under a pane of glass and exposed to sunlight, a procedure now known as contact printing. Light could pass through the leaf's white image on the negative and thereby create a dark image on the second sheet; meanwhile the dark areas

of the negative blocked light so that the corresponding sections of the second sheet remained white. The result was a positive resembling the natural original, a dark leaf against a white background. This was the foundation for the negative-positive system of modern photography. The most important test came when Talbot applied the technique to an image recorded in a camera. After exposing a negative to an outdoor scene, he made a positive print: a recognizable picture of the scene.

With the light-sensitive coating used in these early experiments, the image could be seen forming during the exposure. Talbot simply looked at the paper under the pane of glass if he was making a silhouette, or peered through a hole in the camera if he was taking a picture, and when the negative image was sufficiently pronounced, halted the exposure. But in June 1840, about a year and a half after his appearance before the Royal Institution, Talbot announced a revolutionary advance: a new, highly sensitive negative material that recorded a latent image on paper. Nothing could be seen on this new coating after exposure, he said, but he "found that the picture existed there, although invisible; and by a chemical process...it was made to appear in all its perfection." Talbot called the process "calotype" from the Greek words *kalos* for "beautiful" and *typos* for "impression". (It was Talbot's friend, Sir John Herschel, who later coined the name by which the process is now known, from the Greek words *photos* for "light" and *graphos* for "drawing". Sir John was also the first to employ the words "negative" and "positive" to describe Talbot's system.)

Talbot made a number of improvements in the calotype over the next several years. By increasing the sensitivity of the coating, he was able to reduce the required exposure time, enabling him to photograph people. But there was one flaw in the paper negative, and Talbot never eliminated it completely. The fibres in the paper blocked some light during the printing operation and thus produced a soft, slightly fuzzy photograph. When the inventor began waxing his negatives to increase translucency, this distortion was almost eradicated, but the calotype's sharpness never quite matched that of the daguerreotype.

The problems of the paper negative became academic in October 1847 when Abel Niepce de Saint-Victor, an army officer and cousin of Nicéphore Niepce, appeared before the Academy of Sciences in Paris to announce his new process, one that used glass plates coated with an emulsion of a silver compound suspended in egg white. The advantages of glass over paper as a base had been apparent for some time to other experimenters; glass presented no texture problems, was uniformly transparent and chemically inert. But until Niepce de Saint-Victor used egg white, no one had found an emulsion that would hold a light-sensitive material on glass, although many

sticky substances, including the slime exuded by snails, had been tried.

To prepare his emulsion, Niepce de Saint-Victor functioned as part chef and part chemist. To the egg white he added a bit of potassium iodide and then whipped the mixture until it was stiff. This froth was spread evenly on the glass plate, permitted to dry and was then made light-sensitive by being dipped into a bath of acidified silver nitrate.

Photographers were not unanimously enthusiastic about the new process, however. Although it could produce pictures with excellent detail, thanks to the textureless base, the early egg white plate was easily damaged and was no faster than the calotype, image quality varied with the relative freshness of the eggs and the plates were heavy, clumsy to manipulate and fragile. But the demonstration of the practicality of glass as a base was to prove of enormous importance to photography. With the discovery of a far better emulsion a few years later, photographers quickly learned to live with the inconveniences and shortcomings of glass plates.

Probably nothing could have been more remote than photography in the mind of Louis Ménard, a French chemist, when he discovered in 1846 that gun-cotton (cellulose nitrate) would dissolve in a mixture of ether and alcohol to produce a highly viscous liquid that dried into a hard, colourless, transparent film. He called the substance "collodion". He could find no use for this odd fluid but physicians soon adopted it as a dressing for minor wounds. Applied as a liquid, collodion dried into a tough, waterproof covering that protected the damaged area and kept it clean. The idea of using collodion as a photographic emulsion was first advanced by Robert Bingham, a British chemist, in January 1850.

Coating a plate required nimble fingers, flexible wrists and practised timing. After pouring collodion in the middle of the plate, the photographer held the glass on the edges with his fingertips and tilted it back and forth and from side to side until the surface was evenly covered. The excess collodion was poured back into its container. After being sensitized in silver nitrate, the plate was exposed while still damp and then developed immediately, for Bingham had learned that the collodion emulsion became less sensitive as it dried. Thus the process became known as "wet-plate photography".

When wet collodion plates were developed in pyrogallic acid (pyrogallol), introduced in 1851, exposure time could be reduced to as little as five seconds. Because this high speed permitted the taking of pictures never before possible, photographers were willing to put up with the tedious business of preparing the plates and the need to complete the exposure-to-development cycle while the emulsion was still wet. It was with cumbersome wet plates that Mathew Brady and his men documented the Civil War *(pages 101-107)* and William Henry Jackson photographed the American West *(pages 90-93)*.

Professional and amateur experimenters in large numbers kept busy trying to improve the process. Some of the proposals made in photographic publications must have startled even the most unorthodox readers. In the mid-1850s, for example, the London *Journal of the Photographic Society* recommended dipping the sensitized plate into pure honey. This procedure, the *Journal* stated, would preserve sensitivity for at least four weeks before exposure, and for 12 hours between exposure and development. The British *Photographic News* prescribed raspberry syrup for the same purpose. Although there is no evidence that any sizeable body of photographers followed these suggestions, the concept was not without some merit. Sugary substances, such as honey and syrup, absorbed atmospheric dampness and did help to keep the plates moist and sensitive.

The need for moisture to sustain sensitivity became less important, however, as gradual improvements in formulation of the silver compounds led to faster emulsions. But in the 1880s two separate though related innovations not only made a fast dry plate but also eliminated the need for the clumsy, fragile glass plate itself. The first development was an emulsion based on gelatine—the jelly-like substance that is processed from cattle bones and hides. (Bingham had actually described the process in 1850.) It retained its speed when dry and, perhaps more important, could be applied on a flexible backing—rolls of film—instead of glass. While glass plates coated with gelatine emulsion continued to be used by professional photographers for many decades (astronomers still use them sometimes), roll film revolutionized photography by making it simple enough for millions of amateurs to enjoy.

Most of the credit for bringing photography to the millions goes to one imaginative, hard-driving man, George Eastman, who contributed several of the basic inventions himself, financed research for others and appropriated at least one key development from its originator. A prototype for America's rags-to-riches tradition, he began as an almost penniless bank clerk in Rochester, New York, built one of the country's foremost industrial enterprises, became a millionaire and gave over $100 million away to the arts and education (the University of Rochester and the Eastman School of Music, Tuskegee and Hampton Institutes). Yet he was not a tycoon in the standard mould; he never married, he kept much of his philanthropy anonymous (the several millions he gave to the Massachusetts Institute of Technology were for many years credited to a mysterious "Mr. Smith"), and at the age of 78, after a long illness, he shot himself.

Almost from the day Eastman bought his first camera in 1877, he took a jaundiced view of the wet plate. "I bought an outfit," he said, "and learned that it took not only a strong but also a dauntless man to be an outdoor photographer." Soon he was reading all the photographic literature he could find

in search of a less burdensome means of taking pictures. "It seemed," he said, "that one ought to be able to carry less than a pack-horse load." An article in a British publication about a gelatine emulsion that could be used when dry, he said, "started me in the right direction".

Although Eastman knew nothing of chemistry—he had left school when he was 14 to help support his widowed mother—he began to experiment with his own gelatine emulsion. "My first results did not amount to much," he said, "but finally I came upon a coating of gelatine and silver bromide that had all the necessary photographic qualities. . . . At first I wanted to make photography simpler merely for my own convenience, but soon I thought of the possibilities of commercial production." Working at night, often forgoing sleep, he began devising a machine to mass produce dry plates.

By 1880 he had rented space in Rochester, had trained three assistants and had begun selling his plates to various photographic supply houses. He kept his job at the bank, however, until 1881, when he went into partnership with Henry Strong, one of the lodgers in his mother's boarding house, and formed the Eastman Dry Plate Company. Each man put up $1,000. But Eastman was aware that photography would never become a popular hobby as long as pictures were taken on awkward glass plates. What was needed was something light, inexpensive and flexible enough to put on rollers—in short, film. His goal became obvious when the firm incorporated in 1884 under the name The Eastman Dry Plate and Film Company.

There was nothing new about the concept of roll film. Almost from Daguerre's time, a number of men had tried with varying degrees of success to make it, but no one was able to produce it commercially until Eastman invented the equipment to manufacture film on a mass basis. The result was Eastman's "American Film", a roll of paper coated with a thin gelatine emulsion. After the film was developed, the emulsion had to be stripped from the opaque paper backing to provide a negative that light could shine through for making prints. Most photographers had trouble with this operation—the negative often stretched when removed from the paper—so the film was usually sent back to the company for processing.

The new film created a great stir among photographers, but it had little immediate meaning for the general public since the heavy, expensive view camera was still commonly used to take pictures. But roll film made possible a new kind of camera—inexpensive, light and simple to operate—that made everyone a potential photographer. In June 1888, Eastman introduced the Kodak. It came loaded with enough film for 100 pictures. When the roll was used up, the owner merely sent the camera with the exposed film still in it back to the Eastman company in Rochester. Soon the developed and printed photographs and the camera, reloaded with film, were returned to the owner.

The roll-film Kodak became an international sensation almost overnight.

In the midst of all the excitement that followed the introduction of American Film and the Kodak, few people paid any attention to a patent application filed in May 1887 by a New Jersey clergyman named Hannibal Goodwin. Yet Goodwin was the inventor of truly modern roll film: a transparent flexible plastic coated with a thin emulsion and sturdy enough to be used without a paper support (as it is in most modern films).

Goodwin's starting point was a material developed in 1863 from the very substance that had served as the wet plate's emulsion base: collodion. Mixed with camphor, collodion became the versatile plastic, celluloid, which could be rolled, moulded and extruded into many different forms and was used for handles on combs and brushes and for gentlemen's detachable collars. But commercially produced celluloid had severe shortcomings for Goodwin's purposes; it was not uniformly transparent and it became brittle after a short time. Goodwin modified celluloid with solvents and finally was able to produce this base at "two one-thousandths of an inch, more or less, in thickness". At first the film tended to curl because the base was coated on only one side. Goodwin eliminated the problem by coating the other side with non-sensitized gelatine.

But Goodwin's patent was not granted until September 1898, more than 11 years after he had made application. The reason for the delay was a condition common to parsons, a lack of funds. Goodwin could not afford to make the tests the Patent Office required. Meanwhile, in April 1889 the Eastman company filed an application for a similar film and was granted it in December of that year. Marketing of the film had begun four months earlier.

By 1900, about two years after his patent had been granted, Goodwin managed to raise enough money to begin manufacturing his film. Before his newly organized firm, the Goodwin Film and Camera Company, could begin operations, however, Goodwin died. Not long after his death, the Goodwin company filed a suit against Eastman for patent infringement, claiming that the Eastman company had departed from its own formula and was using Goodwin's. Litigation dragged on for 12 years before the United States Circuit Court of Appeals finally ruled that Goodwin's patent application of 1887 had "disclosed for the first time the fundamental and essential features of a successful rollable film". By then ownership of the Goodwin patent had changed hands several times and the court award—$5 million—went to one of Kodak's early rivals, The Ansco Film Company.

Financial circles may have been interested in the judgment but it meant little to the man in the street. For him the new era in photography had begun with the simple, light camera and roll film. He was too busy taking pictures to be concerned with who received credit for what. □

Old-Time Processes, Clumsy but Beautiful

In terms of the quality of a picture—in the sharpness of detail captured and the great breadth of shading reproduced—black-and-white photography was born full bloom when Louis Daguerre introduced the first practical process early in 1839. "A good daguerreotype," said Edward Steichen, one of the modern era's leading photographers, "was as perfect a kind of photograph as was ever made." Daguerreotypes, such as the portrait of President John Quincy Adams shown on the right, represented a major technological triumph, rather as if the first phonograph had been able to reproduce music as naturally as a fine modern sound system.

Other early processes that came after the daguerreotype were remarkable in different ways. The calotype, the first picture that could be printed from a negative, had its own distinct look: a soft rich warmth deriving partly from the fibres of the paper on which the negative was made. A third process—the glass plate coated with a wet collodion emulsion—was capable of a wide range of effects: sharpness approximating to that of the daguerreotype, unusual softness in tones of grey and an almost grainless clarity.

The great range of possibilities offered by these old processes, along with a growing interest in the history of photography, has led a number of modern photographers to experiment with them, difficult as they are to use. Joel Snyder, a Chicago photographer, founded a company that revived 19th-century printing methods to produce stunning new prints from old negatives. Beginning in 1964, Snyder tried no less than 15 different processes, using the soft, flattering qualities of the calotype for portraits, and the clear yet faintly old-fashioned appearance of the wet plate to create advertisements (in one, for a gourmet seasoning, he arranged a still life of food to capture the nostalgic look of "chicken like great-grandmother used to make").

Snyder, who demonstrated the three major 19th-century processes on the following pages, found them to be fascinating but highly exacting and—in the case of the daguerreotype and wet plate—dangerous because of the materials employed. One of the old instruction books that he used warns: "Ventilate your mercury—its fume is loaded with rheumatism, sciatica, lumbago, toothache, neuralgia and decrepitude."

Mercury can actually, over a long period of time, cause worse harm—partial paralysis—but even the temporary effects are extremely unpleasant, as Snyder learned: he suffered severe chest pains and shortness of breath for days after standing too close to the fumes from heated mercury. While working with the wet-plate process, he once lost consciousness as a result of inhaling vapours from the ether and alcohol in collodion.

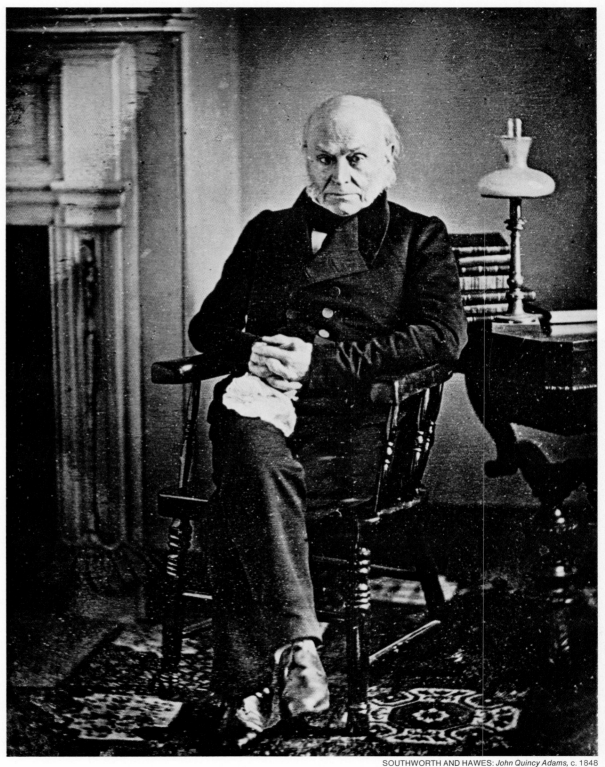

SOUTHWORTH AND HAWES: *John Quincy Adams,* c. 1848

The Art of Making a Daguerreotype

1 cleaning the plate

2 polishing with a soft cloth

3 preparing iodine crystals for sensitizing

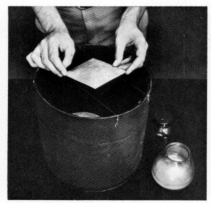

4 sensitizing the plate

5 taking the picture

NOTE: Because of the hazardous materials involved, readers are warned not to attempt the daguerreotype process shown here or the wet-plate process (pages 76-77). Even the calotype process (pages 70-71) requires care to avoid silver-nitrate burns.

When Joel Snyder begins to make a daguerreotype, he remembers the advice of the inventor of the process: for good results, the plate of silver-coated copper must be spotlessly clean and highly polished. He soaks a wad of cotton in a mixture of pumice and alcohol and thoroughly cleans the surface (1). Next, he buffs the plate to a high gloss (2), using soft lamb's-wool.

Now Snyder prepares to sensitize the plate by placing a bowl of iodine crystals (3) at the bottom of an airtight cylinder. With only a candle for illumination—the light level must be low during this stage—Snyder suspends the plate, silver side down, on the two wires inside the top of the cylinder (4). He leaves the plate in place for about 10 minutes, while fumes

from the iodine crystals rise to the silver coating on the plate and combine with it to form the light-sensitive compound, silver iodide. To increase sensitivity, Snyder exposes the plate to fumes from a bromine-lime mixture for two minutes, then returns to the iodine for two more minutes. Finally he puts the plate into the camera and poses the model (5), his wife.

After the exposure has been made, Snyder returns to the candlelit darkroom to prepare for developing. This process is carried out inside an airtight box to

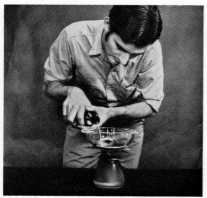

6 preparing mercury for developing

In making the daguerreotype of his wife on the right, Joel Snyder used a 10.2 x 12.7 cm (4 x 5 in) Sinar view camera with a plate holder adapted to accept the relatively thick silver-surfaced metal plate. The exposure was 7 seconds at f/4.5.

9 the finished daguerreotype

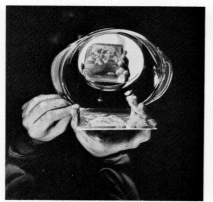

7 the developed image

8 fixing the image

avoid harm from mercury fumes, but in the picture above, the box has been removed to show the steps. Snyder first pours mercury into a bowl supported above a spirit lamp (6). After putting a thermometer in the mercury and lighting the lamp, he quickly lowers it into the box and fastens the top.

He looks through a window in the box and when the thermometer shows that the mercury has reached a temperature of between 60° and 82° C (140° and 180° F), he places the exposed plate in a holder, unseals a slot near the top of the box and inserts the holder so that the silver side of the plate is exposed to the rising mercury fumes. The forming image can be watched by looking through the window of the box—the picture is reflected in the bowl of mercury (7). Finally Snyder pours photographic fixer (sodium thiosulphate) on the plate (8) to make the image permanent. Then he washes the plate in distilled water. The result is a sharply defined daguerreotype (9).

The Several Faces of Daguerreotype

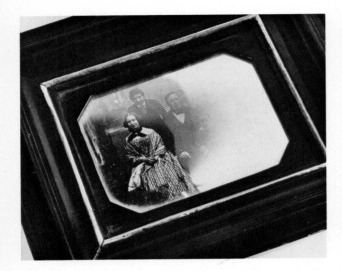

Brilliantly life-like though the daguerreotype was, it suffered one technical drawback that could not be overcome: when someone looked at the picture, he saw a negative image, a positive image or a combination of the two, depending on his angle of view and the direction of the light striking the photograph. Therefore a daguerreotype, unlike a painting, was not suitable for hanging on a wall.

If, for example, three visitors were looking at this family portrait hanging above the mantlepiece in the parlour, the person on the right side of the room might see the picture as shown above left—half positive and half negative. To the guest standing directly in front of the photograph, it might appear as shown above right—all negative. Only the third person, seated on the left side of the room, might see a wholly positive image, as shown opposite.

The simplest way for someone to look at the daguerreotype was to hold it in his hands and shift it slightly until the positive image became visible. This inconvenience, however, seemed insignificant to the thousands of people who thronged to newly opened studios in the 1840s to have their portraits made quickly and inexpensively.

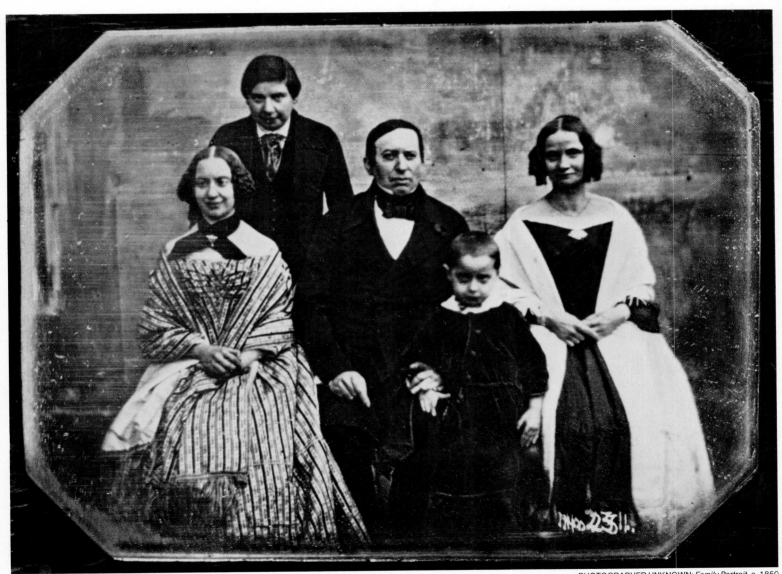

PHOTOGRAPHER UNKNOWN: *Family Portrait*, c. 1850

A Clear View of the World in Daguerreotypes

Some people, particularly the middle-aged and elderly ones, found the detail in their daguerreotype portaits somewhat distressing; a little less honesty would have been appreciated. However, it was this quality of superb definition that made the daguerreotype ideal for recording the wonders of nature and the works of man. The photographs conveyed a sense of reality and immediacy that no artist was able to match.

Shortly after the mechanics of Daguerre's invention were revealed, photographers all over the globe began to take pictures of everything from the Egyptian Pyramids or Niagara Falls *(right)* to the busy Cincinnati waterfront *(below)*.

The Cincinnati photograph—actually two photographs carefully fitted together—is an especially good example of the daguerreotype's impressive sharpness: signs on buildings a considerable distance from the water's edge are legible. Even today the picture's fine detail could be matched only by the best modern equipment expertly used.

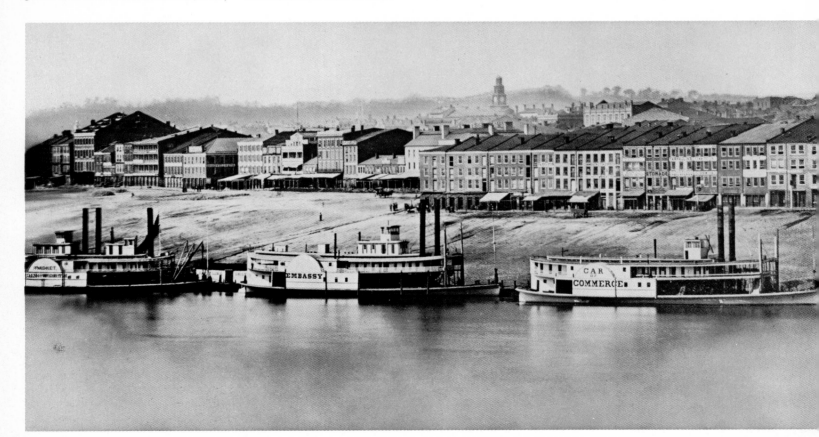

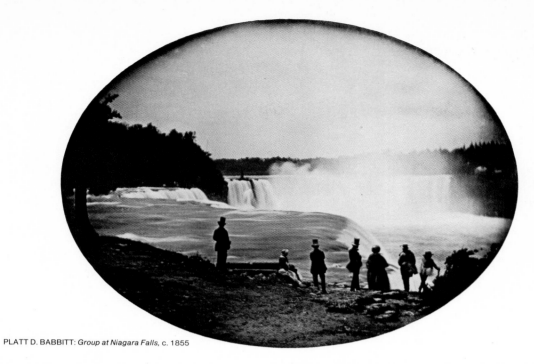

Niagara Falls (left) was already a world-famous tourist attraction when Platt Babbitt made a daguerreotype of it in about 1855. Despite the long exposure required, the visitors in the foreground and the rushing water are recorded with remarkable clarity. In 1848, when Charles Fontayne and William Southgate Porter took their daguerreotypes of the Cincinnati waterfront (below), they used eight plates — two of which are shown here — to encompass the city's entire dockland area along the Ohio River.

PLATT D. BABBITT: *Group at Niagara Falls*, c. 1855

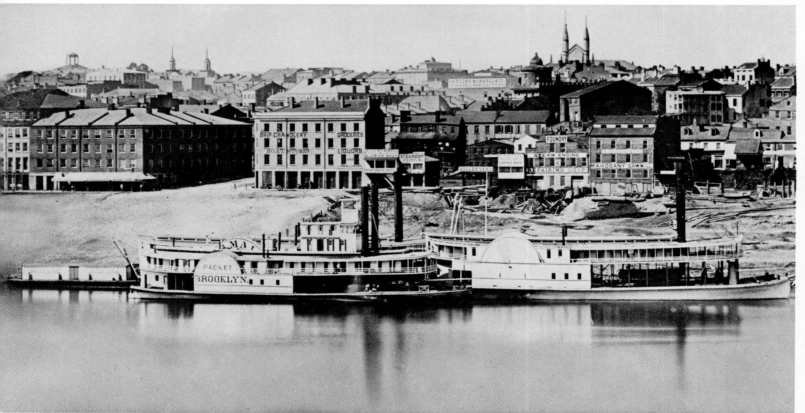

WILLIAM SOUTHGATE PORTER AND CHARLES FONTAYNE: *Cincinnati Waterfront*, 1848

Calotype Prints from a Paper Negative

A calotype is not only somewhat simpler to make than a daguerreotype, the process is also more familiar: the camera produces a negative that can be printed in more or less the normal way.

Joel Snyder carefully selects the paper for the negative—a vellum tracing paper, 100 per cent rag content, free of bleaching agents and mineral impurities and as thin as possible. After washing and drying the paper to remove sizing (which might interfere with absorption of chemicals), he works by candlelight as he sensitizes the sheet, coating it on one side by floating it for about three minutes on a 4 per cent solution of silver nitrate in distilled water (1). He lets this coating dry and then floats the paper on a 7 per cent potassium iodide solution for one to two minutes; the two chemicals react to form a coating of silver iodide. He then washes the paper in distilled water (2) to remove excess chemicals and again dries the paper.

Now Snyder, still working by candlelight, inspects the paper for imperfections (3). If there are any air bubbles, or blue or green specks, which indicate mineral deposits in the paper or a residue from the water, he discards the sheet and starts again. If none of these flaws are present, he brushes the paper with a solution of gallic acid, silver nitrate and acetic acid to increase sensitivity (4). The wet paper is now ready for use in the camera.

After the picture is taken (5), he develops the negative by brushing it a second time with the solution of gallic acid, silver nitrate and acetic acid (6). Development may take anywhere from one to three

1 coating the paper with silver nitrate

2 washing the paper

3 inspecting for imperfections

4 increasing sensitivity

5 preparing to make the exposure

minutes depending on how long the paper was exposed in the camera (if the exposure is long enough the image may be visible when the negative comes out of the camera). The negative is then washed, fixed and dried in the normal way. To increase the translucency of the paper for printmaking and to minimize the shadows cast by its fibres, Snyder places the negative on a slightly heated surface, such as a baking sheet, and applies beeswax to one side (7). Now the negative goes into a standard printing frame (8), the blank back of the paper against the glass. A sheet of good bond paper, coated with silver chloride by floating it on a 2½ per cent ammonium chloride solution and a 10 per cent solution of silver nitrate, is placed sensitized surface down on top of the negative.

In the printing process (9), which takes about 10 minutes, light passes through the glass and paper negative to the printing paper. No developing is necessary—the image is formed directly by the exposure—but fixing and washing are required. Then the print is ready (10).

6 developing the negative

7 waxing the negative

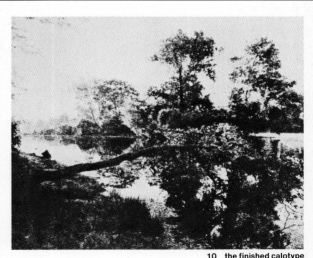

10 the finished calotype

8 placing the negative in a printing frame

9 making a contact print

In making a calotype of the wooded scene above—a small inlet in Chicago's Jackson Park—Snyder used his Sinar view camera and an exposure of 2 seconds at f/5.6.

The Soft Look of the Calotype

Because of the texture in both paper negative and printing paper, the calotype process produces a much softer picture than the shiny silver surface of the daguerreotype. Details become hazy and lose their distinct edges.

Although most mid-19th century photographers preferred the sharply defined daguerreotype, many used the calotype exclusively. None exploited its characteristic softness more successfully than the calotype's British inventor, William Henry Fox Talbot. It was Talbot's interest in art, and the unhappy discovery of his lack of the draughtsman's skill, that led him to the invention of photography. He became a sensitive, careful photographer with an instinct for composition.

The calotype's quality suggests an artist's charcoal drawing, and Talbot skilfully exploited this effect in portraits, such as the one on the right of his half-sister (both the negative and the positive are reproduced here), as well as in still lifes, landscapes, scenes from everyday life and picturesque views of architecture such as those on pages 74 to 75.

Although Talbot was the inventor of the negative-positive system of photography that is now in use, he never received the recognition and financial rewards that Daguerre enjoyed—despite the fact that he was only a few days behind Daguerre in publicly announcing his process for recording photographic images.

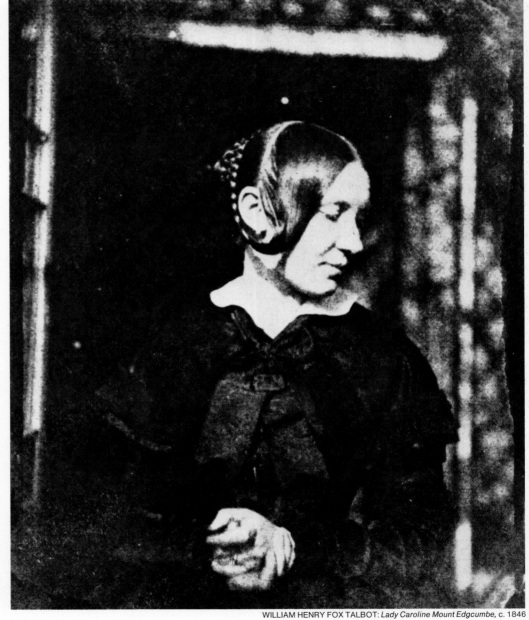

WILLIAM HENRY FOX TALBOT: *Lady Caroline Mount Edgcumbe*, c. 1846

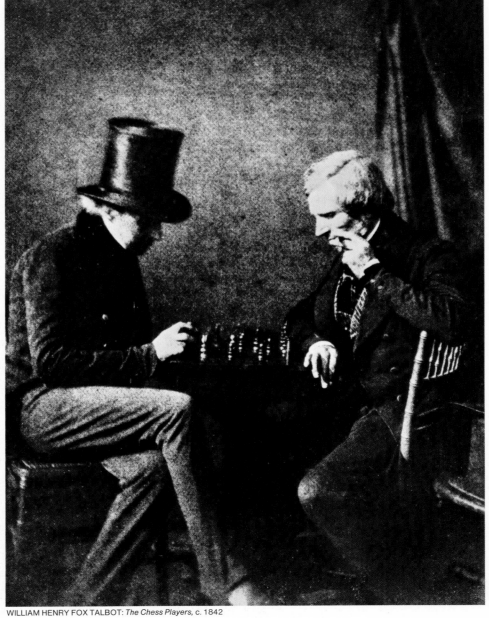

WILLIAM HENRY FOX TALBOT: *The Chess Players,* c. 1842

WILLIAM HENRY FOX TALBOT: *Wind Street in Swansea, Wales,* 1845

Making a Wet Plate

1 cleaning the plate

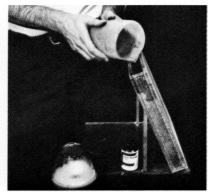

2 filling the sensitizing bath

3 coating the plate with collodion

4 sensitizing the plate

5 checking the sensitizing

6 preparing to make the exposure

When Joel Snyder sets out to use the wet-plate process, he starts with a piece of ordinary window glass. To protect his hands from cuts, he sands the edges and a border on the surface of about 3 mm (⅛ in) with emery paper. This also improves the bond between the glass and the viscous emulsion that will coat it. Then he washes the glass with a mixture of powdered pumice and alcohol (1).

The next step is to fill a sensitizing bath—a rectangular glass tank—nearly to the top with a solution of one part of silver nitrate to 12 parts of water (2). Now he pours collodion containing potassium iodide on the plate (3) and tilts it back and forth until the entire surface is evenly covered.

Working with only a candle for illumination, he uses glass hooks to lower the collodion-coated plate into the sensitizing bath (4), where he leaves it for four to six minutes. When he pulls the plate out (5), Snyder examines it to see if it is properly sensitized. It should be creamy white. If it looks waxy, more time in the bath is needed. When the plate is ready, Snyder places it, still wet, in a holder and inserts the holder in his camera. Now he is ready to pose his subject (6).

After taking the picture, Snyder returns to the darkroom while the plate is still wet and develops it with pyrogallic acid (7). Then the plate is washed, fixed and washed again. After it has dried, Snyder prints it (8) on paper he sensitizes himself with silver chloride.

7 developing the plate

To make the collodion wet-plate portrait on the right, Snyder posed an actor-director friend in a window, set his view camera at an aperture of f/5.6 and made an exposure of 9 seconds.

8 the finished portrait

The Wet Plate: De Luxe and Economy Models

Some of the finest portraits in the annals of photography were taken with collodion wet plates. Under studio conditions and in the hands of a skilled photographer, the wet plate could capture mood, the sophisticated interplay of highlights and shadows, textures and details as effectively as the finest modern film. Only romantic poses and old-fashioned dress set apart a number of 19th-century photographs, such as the one of Sarah Bernhardt on the right, for example, from the best of today's portraits.

For actresses, politicians and others in the public eye, the existence of a negative, and thus the means of securing an unlimited number of prints, was important. But there was a large public to whom this advantage was of little interest. The average man was likely to want only a single picture of himself or members of his family to place on the piano or tuck away in a photo album. In order to meet the demands of this market, the ambrotype *(far right)*—from the Greek *ambrotos* for "immortal" and *typos* for "image"—came into being.

This process depended on the wet plate but used it in a special way. Photographers had noticed that when a negative was placed emulsion side up against a dark background, a positive image could be seen. This phenomenon was exploited by glueing black cloth to the back of the negative or coating the back with a dark varnish. Copies could no longer be made from the negative, but the elimination of the need for making a print saved money and time. The customer paid less for his photograph—and, by waiting a short time for the backing to be applied to the negative, he could take his picture away with him.

NADAR: *Sarah Bernhardt,* 1859

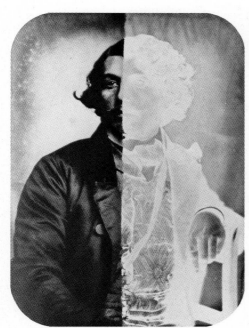

PHOTOGRAPHER UNKNOWN: *The Riding Master*, c. 1860

*The ambrotype is simply a collodion wet-plate
negative with a dark backing of either cloth
or varnish. The right half of the plate shown
above is not backed and therefore looks like an
ordinary negative. With backing on the left
side, the positive image appears. A completely
backed plate is shown on the right.*

PHOTOGRAPHER UNKNOWN: *Soldier*, c. 1860

A Picture While You Wait

In 1856, soon after the introduction of the economical ambrotype, Hannibal L. Smith, a professor of chemistry at Kenyon College, Ohio, patented the still cheaper, quick-service tintype, which delivered a finished picture even faster than the ambrotype did. The quick delivery came from new, rapid processing solutions, the low cost from the tintype's materials. Like the ambrotype, the tintype was a collodion wet-plate negative on a dark background, which resulted in a positive image. But, instead of a glass plate backed with dark cloth or varnish, Hannibal used a metal sheet, usually thin iron enamelled black or brown, to support the collodion.

The inexpensive tintypes quickly became the rage of the era. Enterprising tintypists appeared everywhere, taking pictures of children in parks, of families at company picnics, of newly married couples outside churches. And thousands of young men, self-conscious in their new uniforms, sat stiffly for the tintype camera before going off to the Civil War. The results were generally crude, but in the hands of a talented photographer the tintype process could produce striking portraits such as the one on the right.

Although no copies could be made of tintypes, many photographers used special multi-lensed cameras to take several pictures at once and accommodate anyone who wanted extra photographs of himself. Even after roll film and the simple box camera made every man his own photographer, the purveyors of tintypes prospered. They were fairly common in the United States as late as the 1930s and a number of practitioners are still to be found in other parts of the world. Today, however, metal is no longer used to support the collodion: cardboard is used instead. □

PHOTOGRAPHER UNKNOWN: *Portrait of an Indian*, c. 1860

Photographing the World **3**

Recording an Era 84

A Famous Chronicle of War 100

Pomp and Boredom in Camp 102

The Grim Truths of Combat 104

The Aftermath of Battle 106

The Grand Tour in Pictures 108

Romantic Vistas from Far Away 110

Views of Worlds Left Behind 112

Wondrous Journeys up the Nile 114

Documenting a Way of Life 116

Catching the Subtleties of a Vanished Society 118

Men at Work in Old Persia 120

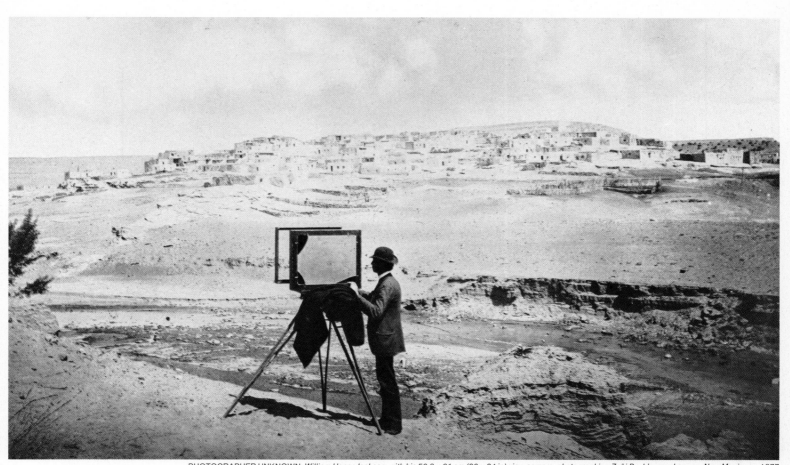

PHOTOGRAPHER UNKNOWN: *William Henry Jackson, with his 50.8 x 61 cm (20 x 24 in) view camera, photographing Zuñi Pueblo near Laguna, New Mexico,* c. 1877

Recording an Era

In May 1842, a gigantic fire swept through Hamburg, Germany, killing 100 persons, destroying more than 4,000 buildings and rendering a fifth of the population homeless. Almost before the embers were cold, two photographers, Carl F. Stelzner and Hermann Biow, were picking their way through the rubble of the gutted city. Loaded down with a heavy camera, silvered plates, dark tent, chemicals and sensitizing and development equipment, they made 40 daguerreotypes of the aftermath of the tragedy *(opposite page)*. Their pictures, taken only three years after the birth of photography, were probably the first news photographs in history.

Stelzner and Biow were among a rapidly growing body of photographers who saw their role as basically that of reporters, conveyors of information about the world and times in which they lived. To them, immediacy and reality were the major strengths of photography, not its ability to render "art" in painting-like landscapes, still lifes or contrived allegorical tableaux. During the first half-century or so after Daguerre had startled the world with his invention, these pioneers blazed the trail of what we now call documentary photography. Their subjects were as varied as the world itself: heads of state juggling the destiny of nations and housewives haggling with street vendors; bloody conflicts and placid scenes in village squares; the ruins of ancient civilizations and the growth of new ones; faraway places and familiar cities. Weighed down with their cumbersome paraphernalia, these photographers climbed mountains and descended into mines, went aloft in balloons, crossed deserts, navigated unexplored rivers and risked their lives on battlefields to bring back pictures people wanted to see.

Although there were no means of reproducing these pictures directly in newspapers and magazines until the half-tone mechanical process for making engravings from photographs was developed late in the 19th century, they enjoyed a surprisingly wide audience. Many people bought prints singly for their private collections. Others acquired books—*Egypt, Sinai and Palestine; Mont Blanc and its Glaciers*—with the photographs painstakingly pasted to the pages. Eventually, weekly news journals began copying photographs and printing the results in the form of wood engravings. But the greatest popularity of documentary photographs came in mid-century with the invention of the stereoscopic camera, which made a pair of views that were printed together, side by side, on one card. Looked at through a special viewer, or stereoscope—one of the most popular was designed by the Boston humorist, physician and photography buff, Oliver Wendell Holmes—the two pictures merged to create a scene with three-dimensional depth. The oak-trimmed stereoscope and its stack of 3-D picture cards became a standard adjunct to the Victorian parlour, providing millions of people with a new and exciting concept of their world.

CARL F. STELZNER: *Hamburg,* 1842

Making the world's first news photographs, Carl F. Stelzner took this daguerreotype of the 1842 Hamburg fire from a rooftop near the Elbe River to show the ruins in the Alster district. In the foreground the banks of a canal are strewn with the rubble of buildings, docks and a bridge.

Although portraits and travel photographs were what most people wanted to buy, men like Stelzner and Biow quickly recognized the unique ability of the camera to freeze a moment in time, to record an important happening with such authenticity that anyone looking at the photograph felt almost as though he were witnessing the event. For the first time, through photography, a clerk in London, a mechanic in Boston or a waiter in Paris could be present, at least vicariously, at such historic occasions as the coronation of King Wilhelm of Prussia, the great gathering assembled in St. Peter's Square to hear Pope Pius IX proclaim the doctrine of papal infallibility or the signing of a peace treaty in China by mandarins and British representatives.

Such early news photography probably had its greatest public impact in the reporting of war. When the United States and Mexico fought in the late 1840s, photographers were on hand to take pictures of the troops on both sides. At about the same time, a photographer recorded a Russian army of occupation that had come to help the Austro-Hungarian Empire control rebellious Hungarians. But these ventures produced only a few stilted pictures of soldiers in formation. Modern reportage of war was born and matured in the decade between 1855 and 1865, the years when photographers went to the battlefields of the Crimean War and the United States Civil War. The ways in which the two conflicts were documented differ enormously, as can be seen in the work of the photographer most closely connected with each war: Roger Fenton, who was with the British, French and Turkish forces in the Crimea, and Mathew Brady, who headed the photographic teams that accompanied the Union armies fighting the Confederacy.

Fenton's war was fought in the hills and valleys of the Crimean borderland between Russia and Turkey. Russian expansionist pressures had led Turkey to declare war in October 1853; the following March, England and France became allies of the Turks. Shortly before England entered the conflict, a British publication, *The Practical Mechanics' Journal,* proposed that photography be used "to obtain undeniably accurate representations of the realities of war and its contingent scenery, its struggles, its failures and its triumphs". Combat artists had illustrated battle scenes before, but the work of the painter, the *Journal* said, "is powerless in attempting to describe what occurs in such operations, whilst a photographic picture brings the thing itself before us". In its enthusiasm for the essential "truth" of photography, the *Journal* overlooked the fact that the photographer chooses which "truths" will be his subjects.

England had been at war for about a year when Roger Fenton, a 35-year-old lawyer and amateur artist-photographer, was personally selected by Queen Victoria and Prince Albert to go to the Crimea (the venture was financed by the Manchester publishing house of Thomas Agnew & Sons).

The royal couple had little, if any, interest in Fenton's photographing "the realities of war" and certainly none in his recording "its failures". On the contrary, he may have received explicit instructions to avoid that sort of thing; the home-front populace was already getting too much of it from newspaper reporters on the scene.

During the autumn of 1854 and the winter that followed, the British press was filled with stories about the dreadful conditions under which the troops lived and the almost criminal maladministration of the war. William Howard Russell of *The Times* was especially vehement. In late November he wrote that the men were in the midst of a winter campaign without warm, waterproof clothing and that "not a soul seems to care for their comfort, or even for their lives". In a December dispatch he wrote: "The dead, laid out as they died, are lying side by side with the living. . . . The commonest accessories of a hospital are wanting . . . for all I can observe, these men die without the least effort being made to save them." Casualty lists bore out such grisly accounts. Of the men who died in the Crimea, seven eighths were victims of cholera and exposure; only one eighth died in battle. Just before Fenton was to leave for the war, in early February 1855, popular outrage forced the resignation of the incumbent prime minister, Lord Aberdeen. In this highly volatile political situation, the Queen almost surely ordered Fenton to take no pictures that would further arouse the anger of the citizens.

Fenton and his two assistants arrived at Balaclava in the Crimea on March 8, 1855. With them they brought a horse-drawn van that had been converted into a combination darkroom and living quarters, and 36 large cases containing five cameras, a number of lenses of different focal lengths, some 700 unsensitized glass plates, chemicals, a still for purifying water, printing frames, a stove, food, wine, harnesses for four horses and a set of carpenter's tools. Fenton would be using the relatively new wet plates, which had to be prepared immediately before use but permitted considerably shorter exposures than earlier materials.

In Balaclava, Fenton was shocked by the indifference to even elementary sanitation. "The whole place is one great pigsty," he wrote. "At present eighty sheep are slaughtered every day in the vessels in harbour alone, and the entrails thrown into the water alongside. All over the camp, animals wanted for food are killed close to the tents, and the parts not used are rotting for days." However, such scenes, which would have offended Victorian tastes as well as Victoria herself, were not subjects for Fenton's camera.

In contrast to the soldiers, Fenton lived fairly well during the months he was in the Crimea. He was welcomed into the top military circles, where good food, vintage wines and other amenities were routine. But in his work he shared the danger and hardship of the front. His van, painted a light colour

ROGER FENTON: *Field Kitchen of the Eighth Hussars, the Crimea,* 1855

The war in the Crimea appeared comfortable enough in Roger Fenton's pictures of nattily uniformed soldiers being served a meal in the field and the neat encampment of an artillery unit (opposite). What they failed to record was the other face of the conflict: men in inadequate clothing shivering in the cold and rain, abominable sanitary conditions that led to cholera epidemics — and the theatrical military bumbling, pain and wholesale death that marked this "last of the gentlemen's wars".

ROGER FENTON: *Encampment of Horse Artillery, the Crimea,* 1855

to reflect heat, could be seen far across the battlefield; it frequently became the target of Russian artillerymen, who probably thought it was an ammunition wagon. On one occasion, a shell tore off its roof. Fortunately Fenton and his assistants were not injured. A far worse trial for the photographer and his helpers was the intense, dry heat of early summer and the accompanying dust and swarms of flies. The van became an oven that cooked the men and their materials. "When my van door is closed before the plate is prepared," Fenton wrote, "perspiration is running down my face, and dropping like tears. . . . The developing water is so hot I can hardly bear my hands in it." All the darkroom work became extremely difficult. Cleaning plates became a major problem. Minute foreign substances on the glass,

which created no difficulties in more moderate temperatures, now reacted chemically to the heat and caused spots and streaks on the negative. Coating large plates with their emulsion was a maddening task. Even though the collodion was thinned, it often dried where it was first poured before the edges were covered. And when a plate was properly prepared, the collodion would frequently dry —drastically reducing its sensitivity —within the few minutes required to insert the plate in a frame, get it to the camera, take the picture and return to the darkroom for development.

Despite such handicaps, Fenton took many excellent pictures *(pages 86-87)*. He was unable to capture action because of the relatively long exposure required even by wet plates, but his photographs of officers and men look remarkably spontaneous and unposed. They reveal, however, a highly selective view of war —a war without death or destruction, without horror or suffering or fear. We see an officer about to enjoy a glass of wine after a hard day in the field, a group of soldiers teaching a dog to sit up, gunners taking a siesta near a mortar. Only a few pictures, such as *The Tombs of Cathcarts Hill* (a half dozen or so headstones and men raising a flag) and *The Valley of the Shadow of Death* (a deserted road strewn with cannon-balls) offer even a slight reminder that war is a lethal business.

Although men who had served in the Crimea may have had reservations about Fenton's one-sided portrayal of the war, Queen Victoria, her government and the British public apparently had none. When Fenton returned to England in July 1855, he was warmly received by the royal family and arrangements were made to exhibit his several hundred pictures in London and other English cities. Portfolios of prints were published and single pictures were also put on the market. In terms of counteracting, at least partially, the effects of the grim reporting and casualty lists from the Crimea, Fenton's mission was a success.

In the early summer of 1861, just six years after Fenton had returned to London, President Abraham Lincoln, deeply immersed in plans for the first major battles of the Civil War, took time to listen to the request of a photographer and then to scribble a two-word note: "Pass Brady." By granting the famous portrait photographer, Mathew Brady, permission to travel anywhere with the Union armies, Lincoln cleared the way for a kind of photographic recording of war never seen before *(pages 101-107)*.

Pictures of wars and other news events brought the realities of life home to millions for the first time. But, once over, such grim realities were soon forgotten; Brady, for one, could hardly sell a war picture after the conflict came to an end. People were far more fascinated with photographs of such wonders as Death Valley.

True, there had always been artists' drawings that portrayed unfamiliar places. But looking at drawings meant seeing things through another person's

TIMOTHY H. O'SULLIVAN: *The Photographer's Wagon and Mules in the Nevada Desert,* 1868

To capture the lonely vastness of the desert north of Death Valley, Timothy H. O'Sullivan climbed a sand dune and made this picture of the ambulance that served as his photographic van.

eyes and never quite believing them. The camera somehow seemed an extension of one's own vision; a photograph was accepted as real, a faithful image created by a mechanical process.

Through photography, the stay-at-home of the 19th century could travel by proxy to almost any part of the world. Some of the finest photographers of the era served as his guides. In 1856, Francis Frith, a British photographer and publisher, struggled 960 km (600 miles) up the Nile to the Second Cataract, bringing back pictures of the Pyramids, the Sphinx and ancient temples along the route *(pages 114-115)*. The Bisson brothers, Louis Auguste and Auguste Rosalie, hauled their equipment to altitudes of 4,880 metres (16,000 ft) in the French Alps to photograph the peaks, while Carlo Ponti and James Anderson portrayed the watery wonders of Venice and the ruins of ancient Rome.

Strangely enough, one of the most spectacular landscapes of all, on the western frontier of the United States, remained largely unphotographed until the decade following the end of the Civil War. Explorers and artists had been in the Rocky Mountain area long before this time, but the wondrous tales they had told of the region and the sketches they had made were often discounted. Most of these doubts were dispelled when photographers made the western trek. One of the first to go was Timothy H. O'Sullivan, who had worked with Brady before and during the Civil War *(page 102)*.

The hardships and dangers of the Civil War—on two occasions O'Sullivan's camera was toppled by shell fragments while he was taking pictures—proved excellent schooling for his work with government surveying teams in the West. On his first expedition to the Rockies in 1867, the party faced passes blocked with snow-drifts of 9 metres (30 ft) or more, capable of swallowing men and mules without a trace. To lessen the hazard, the group moved at night when the bitter cold froze the snow into somewhat firmer footing. One night, O'Sullivan later recounted, 13 gruelling hours were required to cross a 4 km (2½ mile) divide. Hauling mules out of holes in the snow consumed much of the time.

On that same trip, the rapids of the Truckee River in what is now Nevada almost cost O'Sullivan his life. Fortunately he escaped with only a financial loss. The small boat in which he and several other men were travelling was driven off course by the swift current and wedged between two rocks. The men tried to shove off with their oars and succeeded only in losing them. Stripping to his underwear, the photographer dived into the stream to free the boat and was immediately swept under the swirling water. He finally surfaced some distance downstream, managed to swim ashore and yelled to his companions to throw him a line. They did—weighting the end of it with O'Sullivan's purse containing $300 in $20 gold pieces. The line reached O'Sullivan but not the purse, which fell off and disappeared into the

WILLIAM HENRY JACKSON: *Cathedral Spires in the Garden of the Gods, Colorado,* 1873

Views of the American West, such as this one of the spectacularly eroded sandstone pinnacles in the foothills of the Rockies, drew streams of tourists when they were seen in the East.

water. "I prospected a long time, barefooted, for it," he sadly reported later.

Photographically, O'Sullivan's trip was more successful. He photographed part of the California desert on that first expedition and expressed his fascination with its brilliant mounds of snow-like sand in both pictures *(page 89)* and words. "The contour of the mounds was undulating and graceful," he recalled, "it being continually broken into the sharp edges by the falling away of some of the portions of the mound, which had been undermined by the keen winds that spring up during the last hours of daylight and continue through the night."

O'Sullivan went on five expeditions to the West and brought back some of the finest pictures ever taken of the region. His work, however, attracted little public attention at the time, and when he died of tuberculosis at the age of 42 he was buried in an unmarked grave on Staten Island in New York.

But not all the early photographers who went west were unappreciated. Probably the most celebrated was William Henry Jackson. Born in Keeseville, New York, in 1843, Jackson had become familiar with cameras during his boyhood, thanks to a father who experimented with daguerreotypes. Young Jackson's first interest was painting and when he was 15 years old he left school to earn his living by painting portraits and landscapes, and by hand-colouring photographs. Later he settled in Vermont and took a steady job as a photographer's assistant.

When the Civil War began, he volunteered for the Union Army, served out his enlistment without seeing combat and then returned to Vermont and photography. He was doing well financially, but an unhappy love affair caused him to leave in 1866 and he was soon working his way towards the West Coast, part of the time as a "bullwhacker", or driver, with a wagon train. He finally ended up in Omaha running a photographic studio.

Jackson soon became bored with routine studio work, so he fitted out a wagon as a photographic van and set off to take pictures of Indians. It was not an undertaking for a nervous man. The Union Pacific and Central Pacific railway companies were then laying tracks westwards for the first transcontinental railroad and the Indians around Omaha were forcibly resisting the technological invasion. There were a number of attacks on work crews.

But on his first trip, a six-day excursion from Omaha to Cheyenne and back, Jackson managed to persuade the local tribesmen not only to leave his scalp in place but to pose for his camera. The prints sold readily. Encouraged by his success, he took even longer journeys and returned with pictures of such sights as the Salt Lake Valley, the Wasatch Mountains and Echo and Weber Canyons.

In the summer of 1870, Jackson accompanied Dr. Ferdinand V. Hayden, a geologist and physician, on a United States government survey along the

Oregon Trail through Wyoming. This relationship with Hayden was to lead to Jackson's most significant work a year later: pictures that would play a crucial role in preserving for future generations the beauty of the western wilderness. Hayden, fascinated by what he heard in a lecture about the marvels of Yellowstone, persuaded Congress to underwrite an expedition there in 1871; as soon as he had an appropriation to pay a photographer, he recruited Jackson to join the party.

The expedition left Ogden, Utah, in early June. Most of Jackson's photographic gear was transported in a converted ambulance that also served as a darkroom. When Jackson was working in mountainous areas where the wagon could not go, a sturdy mule called "Hypo" assumed the burden and a specially fitted tent became the darkroom. "When hard pressed for time," Jackson reported later, "I had to make a negative in fifteen minutes from the time the first rope was thrown from the pack to the final repacking."

Photographing Yellowstone was a difficult and often risky business, but Jackson was caught up in the excitement of seeing the area for the first time and being the first to record its wonders with a camera. His earlier photographic experience in the wilderness served him well. He was especially adept at what army men refer to as "field expedients", making do with whatever is at hand. When he photographed Mammoth Hot Springs, for example, he employed the subject itself in his photographic processing. After taking and developing his pictures, he used the 49° C (120° F) water that tumbled down the series of semicircular basins to wash the plates, knowing they would dry more quickly because of the heat of the water.

Fortunately, Jackson was a strong man as well as a resourceful one. Once, after taking a number of pictures at the top of Yellowstone's 60 metre (200 ft) Tower Falls, he decided to take some from the bottom without moving all his heavy equipment. He carried only his camera and a few plates, exposed them, climbed back to the summit, developed them, prepared more plates and went down again. To keep the prepared plates moist and sensitive during the ascent and descent, Jackson backed them with wet blotting paper, inserted them in holders, wrapped the holders in a wet towel and then covered the entire package with a black cloth. The first climb down to the bottom and the last up were the most difficult because he had to carry the camera as well as the plates, but the intervening round trips were not easy; four per day was the maximum possible. Even Jackson admitted he paid "a stiff price in labour for one subject".

The results Jackson achieved were worth the effort. He made about 400 negatives of some of the most magnificent scenery on earth. Great canyons, waterfalls, geysers shooting towers of boiling water into the air, placid lakes, lush forests and forbidding sulphur flats — all were part of his photographic

Three Shoshone women and a well-wrapped papoose pose for William Henry Jackson's camera inside the entrance to a tepee. In his travels in the West, Jackson took hundreds of such pictures — of Indian tepee villages and pueblos, of men doing tribal dances and women grinding corn, of proud chiefs sitting for their portraits in full-feathered dress. The photographs constitute one of the few authentic records of the American Indians as they lived before they were confined to reservations.

WILLIAM HENRY JACKSON: *Shoshone Tepee*, c. 1870

report. Many of the earlier explorers had been labelled as liars because of the stories they brought back about Yellowstone; Jackson and his cameras provided incontrovertible evidence that the descriptions had been accurate.

Early in the 1871-1872 session in Congress, Senator S. C. Pomeroy of Kansas had introduced a bill calling for the establishment of America's first national park at Yellowstone. Because of the Senate's reluctance to accept the verbal accounts of the area, he had had considerable difficulty in getting consideration of the measure. But the atmosphere changed completely on the day Pomeroy could say to his colleagues: "There are photographs of the valley and of the curiosities, which the senators can see." Once they had seen Jackson's pictures, the Senate and then the House quickly passed the bill and, on March 1, 1872, President Ulysses S. Grant signed it into law. Yellowstone was now set apart "for the benefit and enjoyment of the public". Jackson's photographs, especially his stereoscopic slides, which were sold in great quantities, also helped start Yellowstone's first tourist boom. Wealthy sportsmen, adventurers and even respectable Eastern ladies and their families journeyed to the West to see at first hand the sights Jackson had captured with his camera.

During the next six years, Jackson accompanied Hayden on other expeditions, photographing the Grand Tetons in Wyoming, the Rocky Mountains in the Pikes Peak area and the ruins of the pre-Columbian cliff dwellings of the Mesa Verde in Colorado's San Juan mountains. (In 1906 Mesa Verde also became a national park.) After Jackson's job with the United States Geological Survey was eliminated in an economy move in 1878, he struck out on his own and made a modest fortune photographing various parts of the United States, Canada and Mexico.

When the half-tone printing process came into use in the 1880s he went into the business of engraving photographs for reproduction in newspapers and magazines; once again he prospered. In 1924, at 81, he moved to Washington, D.C., and resumed his career as a painter, which he had never fully given up. When he was 93, he painted a series of oils of the Old West that have hung ever since in the Department of the Interior. He maintained his interest in photography until his death in 1942, just months before he would have celebrated his 100th birthday.

His name is not likely to be forgotten. Jackson's Canyon along the Oregon-Mormon Trail on the North Platte River, Jackson's Lake in the Grand Teton Mountains and Jackson's Butte in the Mesa Verde are permanent memorials to a great photographer and his work.

In the same decades in which the camera was documenting the events and places of the world, it was also recording the lives of the people of the world. A number of 19th-century photographers made pictures of influential

GIUSEPPE PRIMOLI: *A Reception at the Quirinal Palace,* 1893

GIUSEPPE PRIMOLI: *Attendants at the Wedding of Vittorio Emanuele III,* 1896

*As a member of the European aristocracy, Count
Giuseppe Napoleone Primoli had ready access
to stylish events. One was the silver wedding
anniversary of King Umberto I and Queen
Margherita at the King's palace in Rome in
1893, whose grand sweep he captured in the
photograph opposite. Another was the wedding
of King Vittorio Emanuele III to Princess
Helena of Montenegro in 1896, the fringe
details of which he recorded in the picture above.*

personages that were not portraits intended for private use but were meant
to be sold to the public. In 1850, Mathew Brady published *The Gallery of Illus-
trious Americans,* "containing portraits of twelve of the most eminent citizens
of the American Republic since the days of Washington. . . ." The citizens
then so eminent included Henry Clay, John James Audubon and Daniel Web-
ster as well as the now half-forgotten President, Millard Fillmore, and mid-
western politician Lewis Cass. Brady also photographed all but one of the 17
men who had held the office of President of the United States in the years
between 1833 and 1897. (The exception was William Henry Harrison, who
died in 1841, before Brady became a practising photographer.)

Late in the century, Giuseppe Primoli, an Italian count and intimate of the
aristocracy of France and Italy, provided an extensive photographic record of
the rarefied world of European nobility. His pictures of the upper classes at
work and play, some of which are shown on these and the following two pages,
constitute one of the best single portrayals of the period known as *la Belle
Époque.* Primoli, an extraordinarily energetic man, travelled from one end of
Europe to the other, recording its sovereigns attending receptions, riding
horseback and in carriages, participating in hunting expeditions and military
exercises. He was often followed by a small caravan of servants to help him
haul his cameras, his darkroom equipment and his hundreds of glass plates.

Like a modern photojournalist, he was not content until he had exhausted
a subject, taking many pictures from different angles, documenting all the
details of an event. (It is hardly surprising that in his first three years as a
photographer he exposed some 10,000 plates.) And, like a modern reporter,
he often sought to reveal a situation not by showing the action itself but by
recording people's reactions to it; when he went to a local racetrack, for ex-
ample, he turned his back on the horses and caught instead the richly
changing expressions of the spectators in the stands. Anything and every-
thing interested Primoli. When Buffalo Bill and his road company came to
Rome, Primoli was there pitching his photographic tent next to those of the
Indians and persuading them to allow their picture to be taken. Yet, enthu-
siastic as he was about photography, Primoli was no dilettante. He was
acutely aware of the realities of life; among his best pictures are photo-
graphs that show policemen at work, a woman fixing her hair *(pages 96-97),*
even beggars and children sleeping in the streets, and prisoners in chains.

Perhaps the most penetrating photographic study of urban life, however,
was undertaken by John Thomson in London. He focused on the slums of the
English capital and became the first photographer to use pictures deliber-
ately for pointed social comment. His reputation as a photographer was
established well before he made London's poor his personal cause. Born in
Scotland in 1837, he attended the University of Edinburgh and read chemistry,

95

but photography soon became his primary interest. In 1862 he boarded a steamer with his cameras and wet-plate equipment and headed for the Far East. His travels to Siam, Cambodia, Formosa, the Malay Peninsula and China—and his revealing photographs of the peoples, cities and landscapes of those countries—became the basis of a four-volume work, written by Thomson and illustrated with lithographs, of a special type called collotypes, made from his photographs. The books made Thomson one of the best-known photographers in Great Britain.

In the 1870s, Thomson met a journalist named Adolphe Smith, who suggested that they collaborate on a book about the London slums. Thomson and Smith were soon at work with camera and notebook. The result was *Street Life in London,* consisting of 36 case histories, each of them illustrated with a Thomson photograph reproduced by a method similar to collotype. The book was published in 1877 and, given its subject matter, the timing could not have been better.

Britain was going through a period of extensive self-examination and social change, a period when, in the words of biographer and critic Lytton Strachey, "Victoria found herself condemned to live in an agitating atmosphere of interminable reform. . . ." One of the troublesome questions being asked has a familiar ring today: why are so many citizens of a progressive and wealthy society forced to live in abject poverty?

Apparently aware that earlier, non-photographic treatises on the slums had sometimes been dismissed as hyperbole, Thomson and Smith pointed out in their introduction that they were "bringing to bear the precision of photography in illustration of our subject. The unquestionable accuracy of this testimony will enable us to present true types of the London Poor and shield us from the accusation of either underrating or exaggerating individual peculiarities of appearance."

Thomson did achieve a remarkable balance with his photographs *(page 99).* The filth, the ragged clothes, the dismal surroundings, the degradation and despair are all there, but he also shows that warmth, humour and spirit can continue to flourish even under the worst conditions. A picture such as *The Crawlers*—one of several pictures of middle-aged women who can barely drag themselves from one place to another—is in itself a photographic essay on the indifference of society. The text comments: "Huddled together on the workhouse steps in Shorts Gardens, these wrecks of humanity, the Crawlers of St. Giles, may be seen both day and night seeking mutual warmth and mutual consolation in their extreme misery. As a rule, they are old women reduced by vice and poverty to that degree of wretchedness which destroys even the energy to beg." The same atmosphere of defeat is also present in other photographs such as *London Nomads,* in which two men

GIUSEPPE PRIMOLI: *Girl Fixing Her Hair*, c. 1895

Like all gifted reporters, Giuseppe Primoli took pains to catch the small, human moments that occur in the lives of ordinary people, such as the policemen on the left, posing with their boss amidst barricades set up for a carnival horse-race in the streets of Rome, and the girl above, standing on a stool to primp in a mirror while a very attentive admirer looks on.

GIUSEPPE PRIMOLI: *Rome Commissioner of Public Safety and Carabinieri*, c. 1884

and two women, dirty, tired and seemingly devoid of interest in anything, are shown outside a battered, gypsy-like wagon, while two children with already ageing faces peer out from the wagon's door.

In contrast to such scenes are others of grinning youngsters buying ices from a man with a pushcart, a family posing self-consciously in a park for a street photographer, a young Italian street musician playing a harp for a small but attentive audience. Many of the photographs simply show the day-to-day activities and haunts of the slum dwellers: a second-hand dress shop in which soiled garments hang as limply as sails on an airless sea; a pavement "doctor" selling a "cough preventative", a locksmith working in his street stall; a shoeshine boy; a water cart flushing the streets; a woman buying strawberries from a vendor; boys looking hungrily through the window of a dingy restaurant while the owner stands in the doorway. Several of these pictures appear on the opposite page.

In *Street Life in London,* Thomson was doing with his camera what Charles Dickens had done earlier with a number of his novels: assaulting the British conscience with the hope of improving the lot of the poor. The use of photography as an editorial weapon became more and more common in the decades that followed as photographers lashed out at shameful conditions either ignored or treated with apathy by society. In the 1890s, Jacob A. Riis focused on the slums of New York and produced his memorable book of text and pictures, *How the Other Half Lives,* a damning commentary on indifference to poverty in one of the world's richest cities. A decade later, Lewis W. Hine, employing what he called "photo-interpretations", expressed his indignation over the heartless exploitation of child labour in sweatshop factories; his report was a major factor in the passage of child labour laws in the United States. During the depression of the 1930s, *Life* and *Fortune* photographer Margaret Bourke-White and novelist Erskine Caldwell collaborated on the powerful *You Have Seen Their Faces,* a photographic essay on the bitter human suffering in the south of the United States. Today this tradition of photographic reportage and commentary has become an integral part of modern communications and a major force behind communal action, from the newspaper story on alienated youth to the magazine picture essay on environmental pollution. □

The first known use of photography as a tool of social commentary was a book called Street Life in London, published in 1877, a collection of essays, as the preface puts it, on the "various means by which our unfortunate fellow-creatures endeavour to earn, beg or steal their daily bread". The photographs, some of which are shown here, were taken by John Thomson, who had established a reputation with perceptive portraits as well as with several books of photographs recording Far Eastern cultures. Street Life was sold on London news-stands in 12 instalments of three photographs and essays each, and added to the growing awareness of urban poverty.

Three Men in a Pub

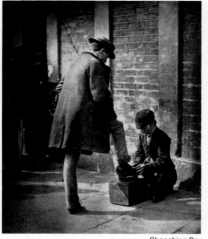
Shoeshine Boy

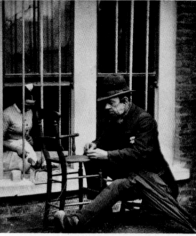
"Caney the Clown", Recaning a Chair

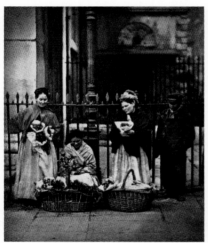
Flower Sellers at Covent Garden

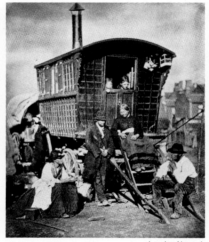
London Nomads

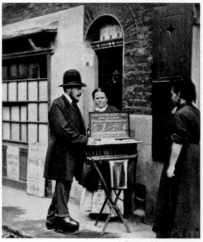
A Patent-Medicine Man

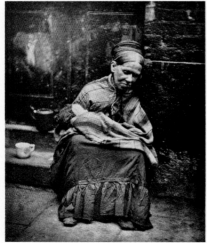
One of the "Crawlers", Minding a Child

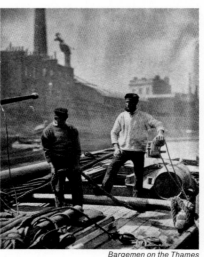
Bargemen on the Thames

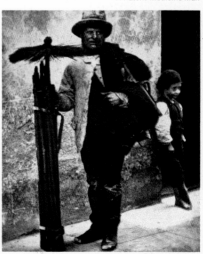
Chimney Sweep

A Famous Chronicle of War

When the Civil War split America, hundreds of men took cameras to the battlefields and brought back a record that, with the honesty only photography can achieve, revealed the tragic truth of combat to people at home. But today it is the name of one man, Mathew Brady, that is almost synonymous with Civil War photography. Even the newspapers of the time had to struggle to find words adequate enough to convey their admiration of his work. The *New York World* wrote that Brady and his assistants "have hung on the skirts of every battle scene; have caught the compassion of the hospital, the romance of the bivouac, the pomp and panoply of the field-review—aye, even the cloud of conflict, the flash of the battery, the after-wreck and anguish of the hard-won field."

Brady, in fact, may not have taken a single picture of the war. Many pictures attributed to him were actually taken by aides, and notable photographs were made independently by such men as Alexander Gardner, who took the picture on page 104 after leaving Brady's employ.

In another sense, however, Brady deserves full credit for the 7,000 Civil War photographs marketed under his name. A large and efficient corps of photographers was needed to cover the full sweep of the conflict and Mathew Brady was perhaps the only man who could have organized it. As the leading American portrait photographer of his time, he was acquainted with many generals and statesmen—including President Lincoln—and could count on their co-operation.

To cover the war, he dispatched as many as 22 horse-drawn photography wagons to every front—making assignments "like a large newspaper", he later recalled. Each wagon had a light-proof door leading to a boxed-in well that extended below floor level. "The work of coating or sensitizing the plates and that of developing them was done from this well, in which there was just room enough to work," wrote one photographer. "As the operator stood there the collodion was within reach of his right hand, in a special receptacle. On his left also was the holder of one of the baths. The chief developing bath was in front, with the tanks of various liquids stored in front of it, and the space between it and the floor filled with plates....Brady risked his life many a time in order not to separate from this cumbrous piece of impedimenta."

Although Brady spent a good deal of his time running the operation from Washington, he often ventured into the field. On the opposite page he is shown posing *(far right)* at the encampment of one of the Union Army's generals. He looked somewhat out of place with his broad-brimmed felt hat, which, as one reporter said, resembled "that of a Paris art student".

The pictures that Brady's men took were seen far and wide. But, despite their impact as documents of the war, their actual sales were not nearly sufficient to cover the expenses of Brady's small army of photographers. Although he could see himself sinking into bankruptcy as the war dragged on and on, he persisted right to the end—and was even able to persuade the defeated Confederate leader, General Robert E. Lee, to pose for one of his assistants after the surrender at Appomattox.

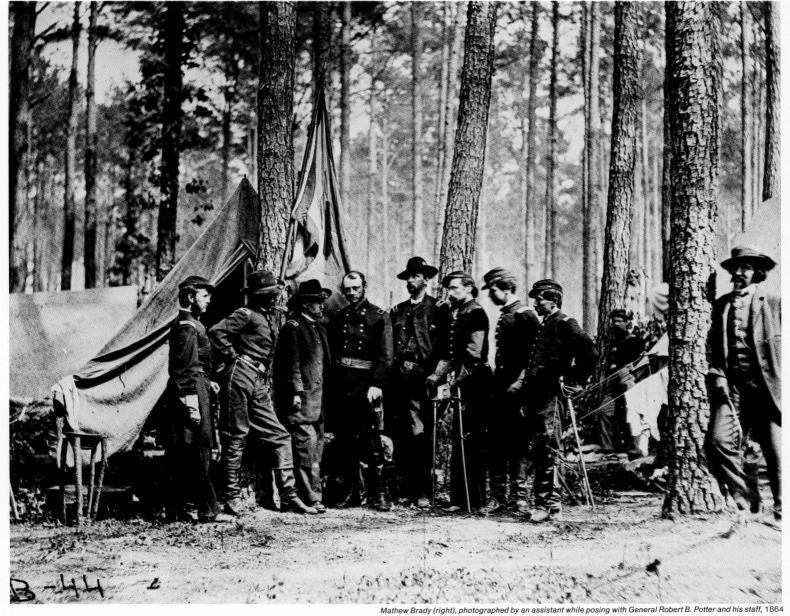

Mathew Brady (right), photographed by an assistant while posing with General Robert B. Potter and his staff, 1864

Pomp and Boredom in Camp

TIMOTHY H. O'SULLIVAN: *Headquarters Guard (114th Pennsylvania Zouaves), Army of the Potomac, Culpeper, Virginia,* c. 1863

Because the six to 10-second exposure required by the wet-plate process would have blurred moving objects, Civil War photographers usually limited their pictures to lulls in the action. But they turned this handicap to their advantage by capturing the look and feel of Union Army camps—the line-ups of lads on battlefields far from their homes and the long, dull days of men standing around, passing the time as they waited for orders. However, camp life often had a sense of glory as well as tedium. The company shown above, one of several exotically uniformed groups called the Zouaves, wore white turbans, blue jackets and scarlet trousers. They insisted on retaining their dazzling attire throughout the war, despite the proven dangers of its brilliant visibility.

PHOTOGRAPHER UNKNOWN: *Camp of the Oneida Cavalry, at the Headquarters of the Army of the Potomac,* 1865

The Grim Truths of Combat

ALEXANDER GARDNER: *Battery B, First Pennsylvania Light Artillery, Petersburg, Virginia,* 1864

The Civil War photographers frequently went to the front lines to catch the impressive preparations for battle—and its grisly aftermath. Making such pictures as the one above was dangerous, even if the shooting had not yet begun. Once, when Brady himself was supervising a picture of gunners at their cannons, a Confederate look-out spotted the activity and ordered a barrage. Brady calmly continued to work as the earth erupted all round him. During a similar bombardment, another photographer set up his camera in a crater that a shell had just made. When an officer expressed amazement, the man grinned and said: "Two shots never fell in the same place, Cap'n."

Brady's photographers brought back a number of pictures of less fortunate men, such as the felled infantryman *(opposite)* lying beside a spiked device designed to keep the enemy from the trenches. Such pictures were widely circulated and their effect was stunning. After viewing some of the battlefield scenes, one commentator said simply, "Brady never misrepresents."

MATHEW BRADY (or assistant): *Dead Confederate Soldier, Petersburg, Virginia,* 1865

The Aftermath of Battle

Death and destruction were frequent themes of Civil War photographs, even though the pictures that sold best were those that were easier to swallow— heroic generals posing with their troops or formations of the boys from home, still standing tall and straight with their rifles glinting in the sun. As the Union armies swept into the South, photographers were on hand to catch the images of ruin, such as Alexander Gardner's view on the right of a burnt-out flour mill in Richmond. The sight of the terrible ravages of war saddened the North and South alike. When author-physician (and amateur photographer) Oliver Wendell Holmes saw some Brady photographs of a Civil War battlefield, he wrote, "The sight of these pictures is a commentary on civilization such as the savage might well triumph to show its missionaries." □

ALEXANDER GARDNER: *Ruins of the Gallego Flour Mill, Richmond, Virginia,* 1865

The Grand Tour in Pictures

In the 19th century, travel to foreign lands was too expensive for all but the very rich. Stay-at-homes could learn of the world through books and drawings, but photography added a tempting new dimension by presenting "reality". Enterprising publishers, quick to realize that there was a hungry market for travel photography, soon had camera-wielding emissaries taking photographs of the well-known European cities and even of such exotic wonders as the Kremlin in Moscow *(right)*.

Armchair travellers bought the pictures by the millions, pasting prints in books and projecting glass slides for "magic lantern" shows in schools, churches and lecture halls. But the most popular form of the travel view was the stereoscopic picture, its three-dimensional realism a marvel of Victorian technology. By the 1870s, shops in major cities in Europe and America sold paired pictures, mounted on heavy cardboard and often tinted a rich sepia.

Many of the pictures were sold in sets, providing the purchaser with a complete pictorial tour of a city such as Paris or a whole country such as Scotland or Palestine. Publishers issued catalogues of the views and advertised in local newspapers. "For the Holidays," read a typical blurb from one large American publishing house, "we have just received a new and most exquisite Assortment, the cream of the London and Paris markets." Simply by placing an order through the post, an ordinary citizen could see the high spots of civilization—without budging from his home.

ROGER FENTON: *Domes of the Cathedral of the Resurrection, the Kremlin, Moscow,* 1852

Romantic Vistas from Far Away

To capture this serene view of the Swiss
city of Interlaken in the Alps, Adolphe
Braun, one of the early masters of travel
photography, used a special panoramic
camera that took in a wide angle of the
scene from a nearby hillside. This was
one of the easier assignments of his
picture-making expedition. It was taxing
enough to carry a large camera, chemi-
cals, a tent for developing and other
appurtenances over even mildly rough
terrain, but Switzerland was another story
altogether. To take pictures from one
mountain in the Alps, Braun needed the
help of 15 porters and guides. He spent
three days on the mountain and exposed
a total of five plates. The armchair tra-
veller, on the other hand, could enjoy one
of Braun's hard-won views for a few pence.

ADOLPHE BRAUN: *Interlaken*, c. 1868

Views of Worlds Left Behind

PHOTOGRAPHER UNKNOWN: *View of Rome from the Monte Pincio*, c. 1862

The Roman Empire may have declined and fallen more than a thousand years earlier, but to the 19th-century traveller —armchair variety included—Rome was the one place that had to be seen. Photographs of the city tended to focus on the architectural glories of the past. The sight of the Coliseum stirred strong memories of Christians and lions; the Forum summoned up the spectacle of toga-clad senators ruling the empire. Greece and the Holy Land shared with Rome a special place in the hearts of travellers (would-be and actual), because they too were rich and ancient sources of culture.

To the Europeans who had left their native lands to settle in colonies overseas or in the countries of the New World, views such as the solid houses of the burghers of Hamburg (opposite) served to remind them of the traditions of the world they had left behind.

G. KOPPMAN & CO.: *Houses on a Canal, Hamburg, Germany,* 1884

Wondrous Journeys up the Nile

For many 19th-century travellers, Egypt was a principal attraction of the Grand Tour, if only so that they could refer smugly to the fact that they had seen Cairo, the Pyramids and the Sphinx. But few had glimpsed the wonders farther up the Nile before Francis Frith recorded them on wet plates and brought the pictures back to England.

To make his photographs of life on the mighty river *(right)* and of the magnificent temples that lined its banks, Frith travelled in a photographic van he had fitted out to serve as both darkroom and sleeping quarters, its roof shaded from the blazing sun by a loose cover of white sailcloth. This "most conspicuous and mysterious-looking vehicle", he later wrote, "excited among the Egyptian populace a vast amount of ingenious speculation as to its uses. The idea, however, which seemed the most reasonable . . . was that therein, with right laudable and jealous care, I transported from place to place—my harem! . . . And great was the respect and consideration which this view of the case procured for me."

What actually went on inside the van was a tribute to Frith's patience. To meet the market's varying demands, many of the views had to be taken three times— with a stereoscopic camera, with a standard 20.3 x 25.4 cm (8 x 10 in) camera and finally with a huge camera that used 40.6 x 50.8 cm (16 x 20 in) plates. The temperature in his travelling darkroom went as high as 54° C (130° F), and more than once the collodion actually boiled when Frith poured it on his plates. But the demand for views of Egypt was seemingly insatiable and Frith set off on a second and then a third trip. In the summer of 1859 he went farther up the river than any photographer, and most other travellers, had ever gone before: past the Fifth Cataract, some 2,400 km (1,500 miles) from the Delta. The spectacular results of his three journeys through Egypt appeared in no fewer than seven different books. □

FRANCIS FRITH: *Aswan, Egypt,* 1856

Documenting a Way of Life

The ability of the camera to capture momentous events and romantic views was exploited from its earliest days, but photographers were slower to focus on the realities of life as lived by the people around them. The few who did use their cameras to document the scenes of everyday society, such as John Thomson *(page 99)* and Giuseppe Primoli *(pages 94-97),* left behind records that are now treasured. In their own time their work went almost unnoticed by the general public, and another achievement in this field perhaps even more remarkable—Ernst Höltzer's detailed depiction of life in 19th-century Persia—had to wait a century to be discovered.

Höltzer was a German engineer who in 1863 signed up to help construct the first telegraph line across Persia—part of a development programme that was underwritten by the British to provide direct communication with India and to open up new markets and sources of raw materials. Höltzer saw that the country was destined to undergo a profound change.

In the 1870s, married to an Armenian girl and permanently settled in Persia, he became an avid amateur photographer. He spent his spare time recording his surroundings with an encyclopaedic eye, paying equal attention to powerful rulers and the lowliest criminals chained in a state prison *(opposite).* He also took detailed notes on customs, professions, the legal system and practically every other aspect of his adopted land. However, he made no effort to publish the results of this labour of love.

In 1963, Ernst Höltzer's granddaughter brought several chests of his belongings back to Germany and stored them in a cellar. A pipe later burst and flooded the cellar. When the chests were prised open, it was discovered that the engineer had taken the precaution of lining them with waterproof zinc. Inside were several thousand glass-plate negatives in perfect condition—a precious and sensitive record of an entire way of life.

ERNST HÖLTZER: *State Prisoners in Chains*, c. 1880

Catching the Subtleties of a Vanished Society

ERNST HÖLTZER: *The Governor of Isfahan Province and His Son*, c. 1880

Construction of the telegraph line took Ernst Höltzer to every part of the country, from the Russian border to the Persian Gulf. For a time he believed the people to be living in a state of near chaos. Riots and robberies seemed everyday fare and the Shah apparently had little control over local chieftains. "Persia goes along like some kind of drunken dreamer," he wrote, "and I must stand by and watch its grimaces." But, as he grew more familiar with the people, he detected a dignity and orderliness that had supported Persian society for centuries.

The sultan on the left, posing with his son, has a lordly bearing that seems completely natural and the Persian women on the opposite page display both the reserve and the stern strength that they actually possessed. Höltzer achieved these revealing pictures by avoiding the artifice that was typical of photographic portraiture of his day. Most photographers posed all subjects—whether they were labourers or noblemen—among the overstuffed furnishings of their studios. Höltzer, by taking pictures of people either in their natural surroundings or with plain backdrops, was able to catch some of the fine shadings of the Persian social order.

ERNST HÖLTZER: *Nun, Woman and Child,* c. 1880

Men at Work in Old Persia

The Persian activities were diverse enough to test the energies of a whole army of foreign observers, but Höltzer did an extraordinary job of taking it all in—from the sultan's bodyguards testing their marksmanship *(right)* to a barber at work *(opposite)*. In addition to photographing every aspect of Persian life, he made detailed statistical studies. For example, he noted that the province of Isfahan, where he lived, had "1,456 dyers, 35 bookbinders, 10 architects, 10 donkey-saddlebag makers, 200 Abyssinian female slaves, and 350 fine white servant girls".

Even athletes and entertainers did not escape his photographic survey. Almost every Persian town had a square where men came after work to do traditional body-building exercises or watch gymnasts practising with heavy shields and other weight-lifting equipment *(overleaf)*. Höltzer's ubiquitous camera observed the scene and saved it all for posterity. ☐

ERNST HÖLTZER: *The Governor's Bodyguards*, c. 1880

ERNST HÖLTZER: *A Persian Barber and Customers,* c. 1880

ERNST HÖLTZER: *Persian Gymnasts*, c. 1880

Modern Film **4**

How Film Works 126

Making an Image in Silver 128

Making an Image in Dyes 130

A Characteristic Response to Light 132

Building Colour on Three Levels 134

The Problem of Graininess 136

How Black-and-White Film Sees Colour 138

How Colour Film Sees Colour 140

Latitude in Exposure 142

What Happens with Under-Exposure 144

Fitting the Film to the Picture 146

A Need for Speed 148

Making an Asset of Graininess 150

The Uses of Medium-Speed Film 152

For Maximum Detail, Slow Film 154

The Magic of Infra-Red Film 158

Instant Richness 160

EVELYN HOFER: *Composite portrait, using films of fast speed (top), medium speed (centre) and slow speed (bottom),* 1969

How Film Works

For photography, the advances in light-sensitive materials in the late 19th and early 20th centuries were equivalent in impact to the effect of the car on the rest of civilization. Certainly the leap from clumsy plates to handy, factory-prepared rolls of film was as great as the leap from horses to cars. The first films were as cantankerous and slow as the early horseless carriages, balking whenever photographers attempted to capture a dimly lighted or fast-moving subject, but technology soon remedied that. Today, in terms of sensitivity, resolution of detail, colour fidelity and other yardsticks of performance, modern films can run tight circles round their forebears.

The light sensitivity of silver crystals forms the basis of modern black-and-white and colour films. Light is captured by microscopic crystals of a compound called silver bromide. In most black-and-white films, the silver crystals form the image. In colour film, the silver crystals control the formation of dyes that create a full-colour image, and this same silver-to-dye technique is applied to black-and-white pictures in the so-called chromogenic films. These are films that can be produced at any speed, and produce grain-free results except at the very highest speeds *(page 136)*. The crystals are carried in a transparent gelatine made from animal hides and bones, and this mixture, called an emulsion, is thinly spread on a plastic base that provides support. Although silver bromide and gelatine have been in use a long time, today's films are vastly more effective at registering light than earlier versions.

For years manufacturers could not explain why batches of film, all containing the same type of silver bromide crystals, showed wide differences in sensitivity. The secret seemed to be in the gelatine that held the crystals; the ability of film to record light turned out to depend on, of all things, the diet of the animals whose hides went into the gelatine. The hides of cattle that ate mustard plants produced much more sensitive film than those from cattle raised on other diets. In 1925, scientists discovered that the key ingredient contributed by the diet was a sulphur-containing oil from the mustard plants. Since then manufacturers have learned that there are many other compounds that affect sensitivity of films. Today, these are synthesized and added to the emulsion in carefully metered amounts to make batches of film of uniform sensitivity.

Another factor that affects a film's sensitivity is the size of its silver bromide crystals. An emulsion containing large crystals needs less light to form an image than an emulsion with small crystals. Since high sensitivity is always desirable in photography, it might seem sensible for manufacturers to produce nothing but large-crystal emulsions. Unfortunately, the bigger the crystals are, the poorer the image. A very sensitive, coarse-crystal emulsion will produce a grainy result, as the top portion of the composite portrait on the preceding page demonstrates. So, manufacturers offer a choice. A photographer can select a very sensitive but grainy film, a very fine-grained but less sensitive

film, or a compromise between the two. Today, manufacturers have become so skilful at controlling the size of silver bromide crystals that they can now design a film with just the sort of characteristics they desire.

In modern colour films, this ability to control emulsions has reached its highest level of sophistication. Most colour films contain three basic emulsion layers, each sensitive to only one third of the visible spectrum. In fast colour films these layers are further subdivided into layers of large-grained silver crystals for increased sensitivity and small-grained crystals for improved image quality. This sophisticated technology has permitted an eight-fold increase in the sensitivity of colour film in 20 years with only a negligible sacrifice in the quality of the image. Even more complex than colour films are instant-developing films, which can have as many as 20 layers in one thin package. These instant films yield unique effects of their own *(page 160).*

The sensitivity, or speed, of a film is indicated by its ISO rating. This rating system, devised by the International Standards Organization in 1979, combines two older numerical ones for grading films according to amount of light needed to produce a normal image. It is written as two numbers separated by an oblique stroke: a typical high-speed film, for example, would be designated ISO 400/27°. The higher the numbers, the faster the film. The first number, the old American Standards Association (ASA) rating, varies in proportion to changes in the film speed—a doubling of the number indicates a doubling in film sensitivity. The second number is the old *Deutsche Industrie Norm (DIN)* rating; an addition of three to the DIN rating indicates a doubling in sensitivity. Thus, a film rated ISO 400/27° is twice as sensitive to light as one rated ISO 200/24°. For convenience, film is commonly classified as being slow, medium and fast. Slow films have ratings of ISO 64/19° or lower and offer the finest grain; medium-speed, medium-grain films are rated in the 100/21° to 200/24° range; fast films, the grainiest, have ratings of 400/27° or higher.

There is more to consider in selecting a film than simply its speed and graininess, of course. Some black-and-white films, for example, are more sensitive to certain colours than others are. Early films recorded only the shorter wavelengths of light. Modern films record the entire visible spectrum, although how closely they match human perception of the way the spectrum ought to look in black and white may vary from film to film. Some types can even be sensitized to very long waves the eye cannot see.

Colour films vary, too—in the vividness and fidelity of their hues, in the way they reproduce different parts of the spectrum, and in their response to different types of light; an experienced colour photographer might choose one film for shooting a portrait, another for a landscape and a third for candid action. Such choices are largely matters of personal taste, but the capabilities of modern films are such that they can meet the most exacting requirements.

Making an Image in Silver

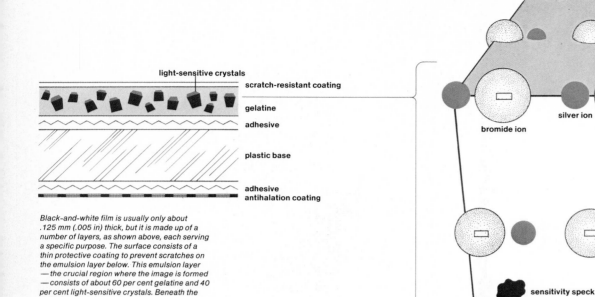

light-sensitive crystals

scratch-resistant coating

gelatine

adhesive

plastic base

adhesive
antihalation coating

Black-and-white film is usually only about .125 mm (.005 in) thick, but it is made up of a number of layers, as shown above, each serving a specific purpose. The surface consists of a thin protective coating to prevent scratches on the emulsion layer below. This emulsion layer —the crucial region where the image is formed —consists of about 60 per cent gelatine and 40 per cent light-sensitive crystals. Beneath the emulsion is an adhesive substance which binds it to the next layer. The thickest layer is the film base, a firm but flexible plastic, which provides support. The base is backed, by means of another adhesive bond, with an antihalation coating, which prevents light from reflecting back through the emulsion to cause halos round bright parts of a picture.

silver ion

bromide ion

electron

free silver ion

sensitivity speck

free silver ion

The process that creates a picture on a piece of film involves a remarkable reaction between light and the crystals spread through the gelatine of the emulsion layer. According to current theory, the reaction can be set off when one crystal—only about .001 mm (40 millionths of an inch) across—is struck by as few as two photons of light (a flashlight bulb emits a thousand billion photons per second).

Each crystal is made up of silver and bromine; in the crystal their atoms are electrically charged—that is, they are ions that are held together in a cubical arrangement by electrical attraction. If a crystal were really a perfect structure lacking any irregularities, it would not react to light. However, a number of the silver ions in the average crystal are out of place in the structure and these are free to move about to help form an image. The crystal also contains impurities— such as molecules of silver sulphide— that play a crucial role in the trapping of light energy.

As indicated by the diagrams on the opposite page, an impurity—called a sensitivity speck—and the out-of-place silver ions work together to build a small collection of uncharged atoms of silver metal when the crystal is struck by light. This bit of metallic silver, built up with the aid of light energy, is the beginning of what is known as the latent image; it is too small to be visible under even the most powerful microscope. But, when developing chemicals go to work, they use the latent image specks of metallic silver in an exposed crystal as a sort of hook to which the rest of the silver in the crystal becomes attached, forming the image.

A silver bromide crystal (above) has an internal structure that is cubic, somewhat like a jungle gym, in which silver (small grey balls) and bromine (larger balls) are held in place by electrical attraction. Both are in the form of ions—atoms possessing electrical charge. Each bromide ion has an extra electron (small box)—that is, one more electron than an uncharged bromine atom does, giving it a negative charge; each silver ion has one electron less than an uncharged silver atom does and is positively charged. The irregularly shaped object in the crystal represents a "sensitivity speck". In actuality, each crystal possesses many such specks, or imperfections, which are essential to the image-forming process (shown schematically on the right).

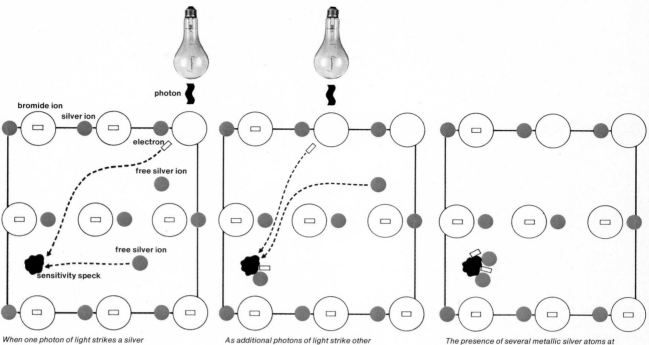

bromide ion

silver ion

photon

electron

free silver ion

free silver ion

sensitivity speck

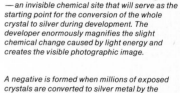

When one photon of light strikes a silver bromide crystal, image formation begins. The photon gives its energy to a bromide ion's extra electron, lifting it to a higher energy level. Then the negatively charged electron can roam the structure of the crystal until it reaches a sensitivity speck. There, its electrical attraction pulls a positively charged free silver ion to it.

As additional photons of light strike other bromide ions in the crystal and release electrons, more silver migrates to the sensitivity speck. The electrons join up with the silver ions, balancing their electrical charges and making them atoms of silver metal. However, if the crystal were examined through a microscope at this stage, no change would be discernible.

The presence of several metallic silver atoms at a sensitivity speck constitutes a latent image — an invisible chemical site that will serve as the starting point for the conversion of the whole crystal to silver during development. The developer enormously magnifies the slight chemical change caused by light energy and creates the visible photographic image.

A negative is formed when millions of exposed crystals are converted to silver metal by the developer. The result is a record of the camera's view in which the film areas struck by the most light are darkened by metallic silver, while the areas struck by no light remain transparent after processing, since they contain no silver. The intermediate areas have varying amounts of silver, creating shades of grey that depend not only on the amount of light striking the film but also on the colour of the light, the type of film and the way it was exposed in the camera.

Making an Image in Dyes

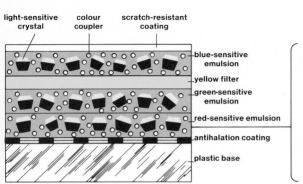

light-sensitive crystal colour coupler scratch-resistant coating

- blue-sensitive emulsion
- yellow filter
- green-sensitive emulsion
- red-sensitive emulsion
- antihalation coating
- plastic base

This simplified cross-section of colour negative film shows its protective coating, its three emulsion layers — each sensitive to one of three primary colours — its antihalation coating and its plastic base. The yellow filter under the blue-sensitive layer absorbs blue light that might pass through to affect other layers. All the emulsions contain silver bromide crystals and molecules of colour couplers — compounds that help developer form a colour as shown on the right.

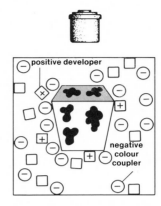

sensitivity speck

colour coupler

silver bromide crystal

A silver bromide crystal in the red-sensitive emulsion is struck by light during exposure. Sub-microscopic particles of silver metal are formed from silver ions at the crystal's sensitivity specks, as in the diagrams for black-and-white film on the preceding pages. The colour coupler molecules are not affected by exposure to light.

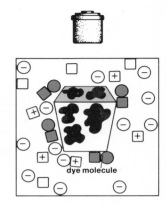

positive developer

negative colour coupler

When a molecule of developing agent touches an exposed crystal, it gives up a negatively charged particle that combines with a positive silver ion, as shown in the diagram on page 129. The developer molecule, having lost a negative charge, becomes positive; meanwhile, colour couplers acquire a negative charge by reaction with other chemicals.

dye molecule

Dye formation begins when the positively charged developer molecules combine with negatively charged coupler molecules in the area around the crystal. This combination creates molecules of coloured dye — in this case, cyan, red's complementary colour — which blocks the transmission of red light through the negative during printing.

In colour film tiny silver bromide crystals respond to light and create a black-and-white image exactly as they do in black-and-white film. However, in colour film the black-and-white image is only the starting point, quickly to be replaced by one in full colour from dyes.

The dyes are formed from molecules called colour couplers, which in most films are added to the emulsion when the film is made. Couplers are turned into dyes by the developer, which reacts first with exposed crystals and then with nearby colour couplers. When colour film is developed, two overlapping images result — one in metallic silver and one in dye. Later, the silver is bleached away.

Colour films reproduce all colours in a scene with dyes of only three colours, each in a separate layer of emulsion that has been made sensitive to a primary colour of the visible spectrum — one layer to blue light, one to green and one to red. The couplers in each layer form dyes complementary to recorded-light colours:

couplers in the blue-sensitive layer form yellow dyes, those in the green-sensitive layer form magenta dyes and those in the red-sensitive layer form cyan dyes.

When colour film is to be used to make prints, the dyes form negative images in each layer: light areas in the scene are registered dark on the negative and colours appear there as their complements.

When colour film is to provide slides, the dyes form positive images because the silver crystals go through two exposures and two developments. The first exposure is the ordinary one in the camera, and the first development converts it into a negative image in the usual way. The film is then exposed again in the darkroom — either to a strong light or to a chemical bath — so that all previously unexposed crystals are exposed. The second development converts these crystals to positive silver images, and it is only these crystals that guide dye formation. When all the silver is bleached away, the dyes remaining form the positive image.

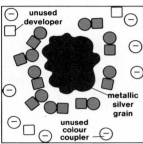

When the development is complete, silver atoms form a grain of metallic silver. Surrounding the grain is a cloud of cyan dye molecules. The molecules of unused developer and colour couplers remain. The developer is then poured off, a stop bath halts any further reaction and the film is bleached and fixed.

Bleaching and fixing dissolve the metallic silver grain, leaving an image formed of dye molecules. The stop bath has neutralized the negative charge on the unused colour couplers, which remain in all three layers. Those in the green and red-sensitive layers give the negative an orange cast and act as a colour-correcting mask in printing.

In a colour negative that has been completely processed, an image has formed in dyes in all three emulsion layers: yellow dye in the blue layer; magenta in the green layer and cyan in the red layer. The yellow filter between the blue and green layers and the antihalation coating next to the film base have both dissolved so that they will not block light during printing.

An exposed area in the red-sensitive emulsion layer of colour film is seen magnified nearly a thousand times at two different stages of processing. After initial development (above), clouds of cyan dye particles surround the grains of metallic silver. After the film has been bleached and fixed (above, right), only the dye clouds remain to form the final image.

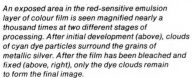

A Characteristic Response to Light

The pictures on the right, taken at the same aperture and shutter speed with black-and-white film, seem to illustrate a truism about photography—that increasing the amount of light reaching the film causes a proportional increase in the silver density of a negative. As more and more light bulbs illuminate the head of Buddha, the negative becomes denser and denser.

This, after all, is the very foundation of photography—the reason that shadows look dark and snow looks white in a picture. But the fact is, the density of an image does *not* always increase proportionally with the total exposure of the film. This fact has a profound effect on the way a picture turns out.

The response of every type of film can be predicted by what is known as its characteristic curve, which shows how silver density increases as the amount of light reaching the film increases. The graph on the right below represents the characteristic curve for the ISO 32/16° film used in taking these photographs. The middle part of the curve *(grey tint)* rises at an even rate—indicating that every increase in light within this region of exposure will bring a proportionate increase in silver density.

For good results in photography, both the greatest amount of the illumination to be recorded (from the highlights of a subject) and the least amount (from the shadows) should fall mostly within this "straight line" portion. If the lens and shutter settings admit too little light, the film will react as indicated by the "toe" at the end of the curve; detail is lost because the film does not see the differences between light and dark at low light levels. Similarly, if the film is overexposed (the "shoulder" at the upper end of the graph), detail is again lost.

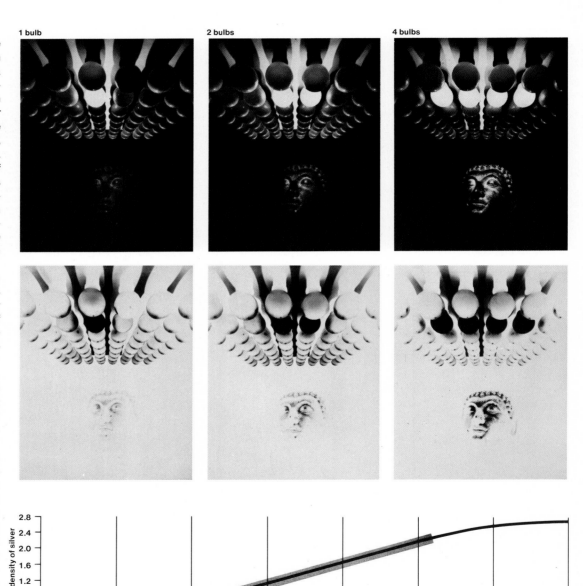

132

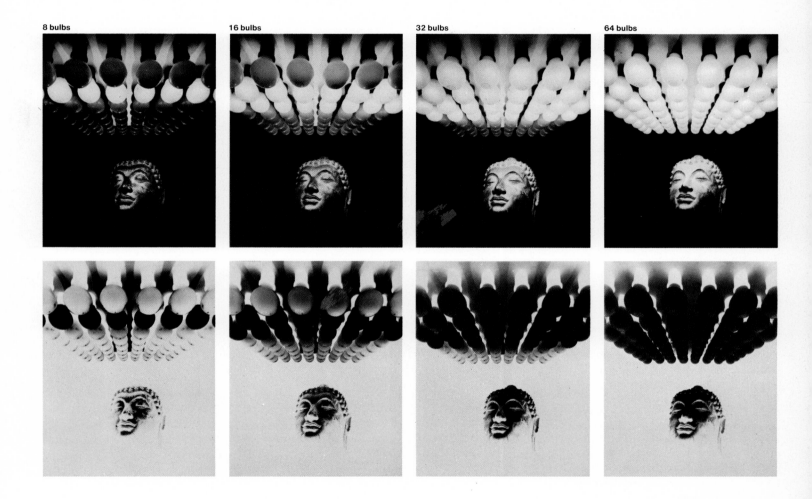

8 bulbs 16 bulbs 32 bulbs 64 bulbs

Building Colour on Three Levels

The response of colour film to light is essentially the same as that of black-and-white film *(preceding pages).* As more light bulbs are turned on for the pictures of an African mask *(right),* the density of dyes in the three layers of the colour negative increases. The responses of the three layers are different *(graph),* suggesting imbalances in colour at some exposures—yet colour films and processing steps are so engineered that essentially natural colour is usually achieved.

The potential errors arise because of the complexity of combining three image layers. The blue-sensitive layer delivers more density for a given exposure than the green-sensitive layer, and the green more than the red—a difference caused by varying amounts of colour couplers in the layers. The curves are also not exactly parallel, the blue-sensitive layer responding a bit more for each exposure increase than the others.

In addition, the starting and ending points of the straight-line portions of the curves *(grey tint)* differ; thus the blue-sensitive emulsion begins to increase its density with less exposure than the red emulsion requires. All of these variations can be compensated for in printing; even the extremes of exposure used for the pictures on the right cause losses of detail but not discernible colour imbalance.

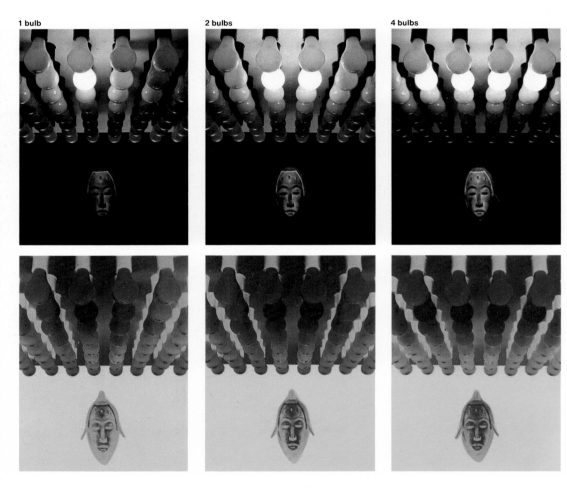

1 bulb 2 bulbs 4 bulbs

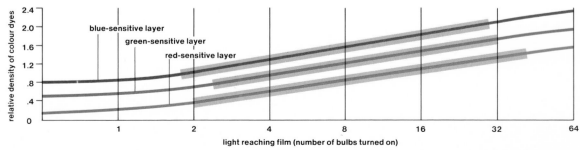

blue-sensitive layer

green-sensitive layer

red-sensitive layer

relative density of colour dyes

2.4 2.0 1.6 1.2 .8 .4 0

1 2 4 8 16 32 64

light reaching film (number of bulbs turned on)

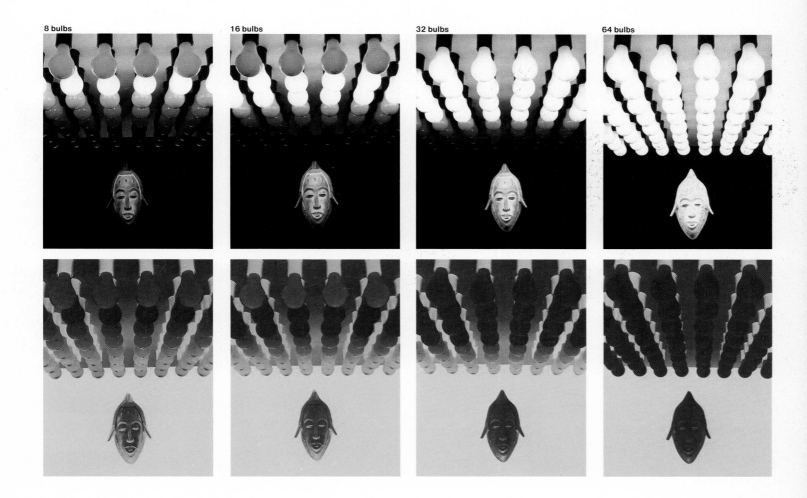

8 bulbs 16 bulbs 32 bulbs 64 bulbs

The Problem of Graininess

ISO 32/16° black-and-white film

ISO 400/27° black-and-white film

ISO 1,000/31° black-and-white film

When it comes to light sensitivity and graininess, film gives with the right hand and takes with the left. The faster the film, the greater its graininess. When a picture is enlarged, it reproduces shades of grey not as smooth tones but as distinct specks—clumps of silver or dye that can obscure detail. Films with large silver bromide crystals produce coarser grain than those with small crystals, because they yield larger bits of silver or dye clouds when developed. But high sensitivity to light or speed is desirable—and in this respect the large-crystal films perform best. A large crystal needs no more light to form a latent image than a small one, but it yields more metallic silver or a larger dye cloud when developed.

The relationship between speed and graininess shown on these pages applies to standard films. However, the grain barrier—usually evident in films rated ISO 400/27° and over—has been broken, for black-and-white films at least, by

The portrait above was shot on eight different standard 35 mm films with identical lighting: but actual exposure settings were adjusted for film speed so that the amount of light reaching the film was the same for each exposure. Enlargements of the eyes from each picture (right) reveal the effects of speed on graininess; each increase in speed exacts a corresponding penalty in graininess.

the revolutionary chromogenic films.

Chromogenic films are, in fact, variable speed films that allow the photographer to shoot at any setting between ISO 125/22° up to 1600/33°, mixing different speeds on the same roll—itself a considerable breakthrough. But its most important application is likely to be its high-speed, fine-grain performance. At ISO 400/27°, prints are sharp and free from grain, even when greatly enlarged. The results continue to be good up to ISO 800/30° and only at 1600/33° does grain become apparent. An added bonus of these films—the pioneers are Ilford XP1-400 and Agfa Vario-XL—is that they are virtually impossible to over-expose.

ISO 25/15° colour transparency film

ISO 100/21° colour negative film

ISO 64/19° colour transparency film

ISO 400/27° colour negative film

ISO 400/27° colour transparency film

How Black-and-White Film Sees Colour

While silver bromide crystals are wonderfully sensitive to light, they do not respond to all wavelengths of light equally. This accounts for a paradox in photography: colours, or different wavelengths within the visible part of the electromagnetic spectrum, must be taken into consideration when making black-and-white photographs. Different types of film react to colour differently, as the three pictures on the right indicate.

Unless silver bromide crystals are specially treated, they respond only to the shorter wavelengths of light, from ultraviolet through to blue-green. Photography got round this stumbling block in 1873, when H. W. Vogel added a dye that extended the response to the wavelengths of green and yellow. By a mechanism still not completely understood, the dye absorbs these slightly longer wavelengths and transfers their energy to the silver bromide crystals. This sort of emulsion is known as orthochromatic, and is used nowadays mostly to make photographic copies.

Other dyes now enable film to record practically all the colours seen by the human eye; this panchromatic film is the type almost universally used in ordinary photography. However, it does not respond to colours evenly. It is more sensitive to short wavelengths (bluish colours) than to long wavelengths (reddish colours). Unless this imbalance is compensated for by filters *(pages 184-186)*, blue sky tends to come out very bright, red apples are dark and even green leaves seem darker than they ought to be.

Special dyes have also been devised to make films respond to invisible infrared wavelengths in addition to all the visible colours—with results *(far right)* that are eerie but often beautiful.

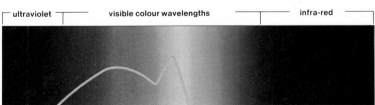

In a picture made on orthochromatic film (top) some of the fruits and vegetables come out looking darker than they would to the eye. In the graph on the spectrum above, the curve is highest where the film is most sensitive: this film is most sensitive to blue, green and yellow light, less sensitive to orange and does not respond to red. Thus the red apple, orange, and red pepper (upper right) and the red onion (lower left) appear unnaturally dim.

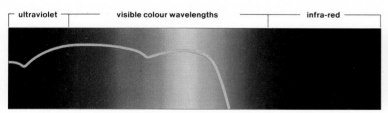

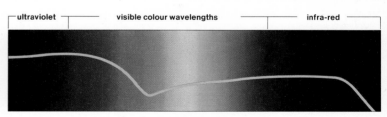

When panchromatic film is used, tones are more natural in appearance because the film records almost all colours seen by the eye. As the curve shows, the film's sensitivity drops off sharply at the red end of the spectrum where wavelengths are longest. Thus the apple, the red pepper and the red onion are somewhat more natural, but the orange and the lemon have the tones that the eye expects.

Infra-red film, as the curve shows, records all the colours of the visible spectrum as well as some wavelengths that are not visible. Although most natural objects strongly reflect infra-red rays, there is no consistent relationship between the colour of an object and the amount of infra-red rays that are reflected. In the picture above, only the avocado and the mushrooms do not reflect infra-red strongly; thus they appear darker than the other objects.

139

How Colour Film Sees Colour

Colour film records an image in full colour on three black-and-white emulsion layers, each of which responds to light of a different third of the visual spectrum—that is, to wavelengths of blue, green or red, the so-called primary colours. During processing, the three exposed emulsions are changed into separate images, each in a single colour of dye. The dye in each layer is the complement of the primary colour to which the layer is most sensitive.

When superimposed, the images create almost all shades of the spectrum, as in the bouquet on the right, recorded on transparency film. Each dye absorbs its complementary colour from light reaching it, and by controlling the amounts of blue, green and red light that pass through the slide, the dyes blend colours to re-create the hues of the original subject.

Getting each of the emulsion layers to respond to wavelengths of the appropriate colour is the key to accurate colour reproduction. All the layers are sensitive to blue, but a yellow filter keeps blue wavelengths from reaching any but the top. The middle layer is treated to respond to green light and the bottom layer is chemically sensitized to red.

The responses of the different layers of the transparency film used here *(graph, opposite)* are shown in the way the film recorded the bouquet. The light reflected from the red dahlias in the middle, for example, affected mainly the red-sensitive layer. The processed film recorded these flowers in the red-sensitive layer as only a faint cyan image but as dense magenta and yellow images in the other layers. When the transparency is viewed, green and blue light are blocked by the magenta and yellow images, but the thin cyan image lets red light through to re-create the dahlia colour.

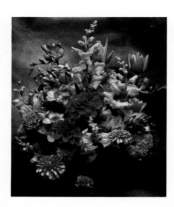

The three single-colour images above reproduce the three dye layers of a colour transparency to show how the rich hues of the bouquet above (inset) were recorded. The top layer (above), sensitive to blue wavelengths, creates a dye image in yellow, blue's complementary colour. The middle layer (centre), which responds mainly to green, forms a dye image in green's complement, magenta. The bottom layer (far right) responds to red and creates a dye image in red's complement, cyan.

The yellow, magenta and cyan curves on the spectrum on the right trace the responses of the blue, green and red-sensitive layers of the film used for the pictures of the bouquet. Each curve peaks in the colour to which its layer is most sensitive, but the bottoms of the curves overlap, indicating that each layer responds to more than just a single colour of light. This overlap produces an overall level of sensitivity that is fairly even across the spectrum, so that all colours can be registered. ▶

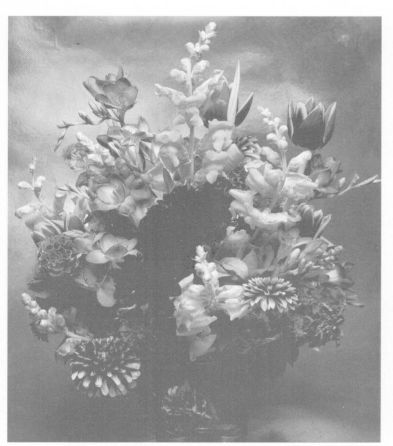

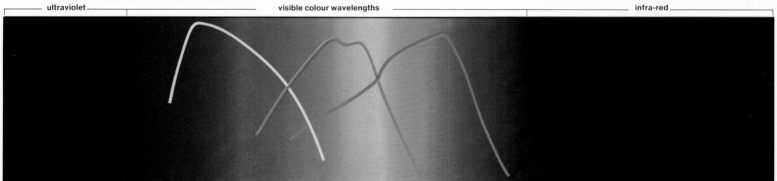

Latitude in Exposure

When slide film is used to shoot a scene in which bright sun creates glaring highlights and deep shadows, exposure must be correct. Correct exposure is critical in this situation because the range of brightness, from highlights to shadows, is almost at the limits of the film's usable exposure range — the range of exposure over which the film can record differences in brightness with corresponding differences in image density.

With transparency film this range is narrower than with print film. Moreover, there is no printing stage to compensate for an initial under-exposure or over-exposure. A dense, over-exposed negative, for example, can usually be printed satisfactorily with extra exposure during enlargement, but a transparency image is fixed when the shutter clicks, and detail obscured by improper exposure is lost.

A film's usable exposure range corresponds roughly to the straight-line portion of its characteristic curve *(pages 132 and 134)*. The graphs on the right show a combined curve and exposure range for the three emulsions of the film used here. The slope of the curve is reversed from that depicted in previous examples because increased exposure produces decreased density in a transparency.

The broader a film's usable exposure range, the more leeway it gives for under-exposure or over-exposure without loss of important details in either shadows or highlights. This leeway, or latitude, also depends on the brightness range of the scene. The degree to which the exposure range of the film exceeds the scene's brightness range is the film's latitude for that picture. As shown in the graphs, the film's narrow exposure range and the scene's wide brightness range gave minimal latitude for the picture on the right.

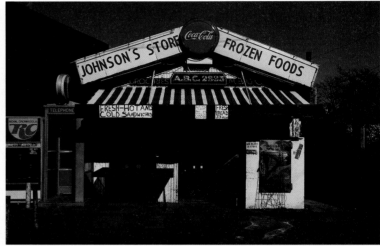

under-exposure

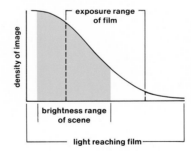

When this scene was under-exposed on colour slide film, highlight details show clearly — the signs on the awning, for example. But shadows are black and even middle tones, such as the awning's stripes, are unnaturally dark. As the graph on the left shows, the scene's brightness range (yellow tint) does not fall entirely within the film's usable exposure range (dash lines). The highlights — the right edge of the tint — stay well inside the usable range, but shadow areas fall outside.

correct exposure

over-exposure

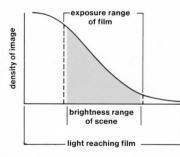

This exposure was carefully calculated to produce the balanced result shown here. Highlights and shadows are both sharply detailed, and colours are bright and rich. The graph on the left reveals that although the scene's brightness range extends almost to the full breadth of the film's usable exposure range, neither the highlights nor the shadows fall outside.

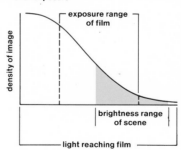

In an over-exposure of the scene, highlights become noticeably washed out — the door of the ice machine loses much of its metallic sheen, and the signs on the awning become difficult to read. But shadow details under the awning are clearly defined. The over-exposure shifted the scene's brightness range in relation to the film's usable exposure range so that shadows fall within the usable range while highlights fall outside.

What Happens with Under-Exposure

Photographers sometimes find it essential to under-expose pictures; the illumination may be too dim, stopping fast action may necessitate a high shutter speed, or the desire for great depth of field may require a small aperture. Considerable under-exposure can be tolerated by most modern black-and-white films, and also by some colour transparency films. With colour print film, however, under-exposure is not recommended.

When a photographer intentionally under-exposes a picture, he "pushes" the film; he simply assumes that it is more sensitive than it really is and arbitrarily assigns it a film speed higher than the standard one specified. Then he sets his shutter speed and aperture according to the pushed rating.

Compensation for this higher rating is made when the film is developed. Since the assumption of higher than normal speed provides less than normal exposure, the film must be developed longer to convert more silver bromide crystals to silver metal. This is a common procedure and manufacturers provide instructions that specify exactly how long to develop the film for different ratings.

Despite the compensation in development, however, pushing affects the image to some degree—as is shown by the three pictures on the right, taken with a fast film rated at its normal ISO 400/27°, then with the same film pushed to ISO 800/30° and then ISO 1,200/32°.

It is, of course, equally possible to rate the film at a lower than normal speed. This may be desirable when taking pictures in which the shadow detail of a scene is of major importance. Ordinarily, a different sort of developer is employed to compensate for such intentional over-exposure of the film. □

The bowl of roses directly above has been photographed with a fast film at its normal rating of ISO 400/27°. Since the negative is getting exactly the amount of light that the manufacturer intended, the detail in the picture shows up well, even in the shadow areas amidst the flowers.

When the same film is pushed to a rating of ISO 800/30°, reducing the amount of light that reaches it, the details within the flowers are less visible. Something has been gained, however: because the shadows on the tablecloth are darkened, the picture looks more three dimensional.

Rating the film at a very high ISO 1,200/32° causes a considerable loss of detail within the flower arrangement. Yet again something has been gained. The reduced exposure has emphasized the texture of the white tablecloth — which was somewhat over-exposed at the normal ISO rating.

Fitting the Film to the Picture

Many camera shops stock a wide variety of films in black and white or colour ranging in speed from ISO 25/15° to ISO 1,250/32°. Because the faster films produce grainier pictures, a photographer will theoretically get optimum results by selecting the slowest film that suits each lighting situation.

In practice, however, it is inconvenient and unnecessary to work with a dozen different types of film. Of the three general film-speed categories—slow, medium and fast—many photographers pick two. A slow-speed film, with a rating of ISO 64/19° or less, is chosen when fine grain and extra sharpness are needed—either because of subtle detail in the scene or because the final image will be greatly enlarged. The other film is a moderately fast film with a rating around ISO 400/27°. Some photographers use this film for all of their work because film manufacturers have made great strides towards reducing the grain problem.

The portrait of actor Kirk Douglas opposite reveals the precision of detail, unmarred by grain, that can be obtained with a moderately fast film—in this instance, a black-and-white film rated at ISO 400/27°. The picture was taken with a medium-format SLR camera by French photographer Jeanloup Sieff. Stopping down his aperture to f/16 at 1/60 second, he employed electronic flash to add brilliance to the highlights of the actor's face. The result was an extraordinarily intense close-up view in which every pore and hair is sharply revealed.

JEANLOUP SIEFF: *Kirk Douglas*, 1967

A Need for Speed

Modern fast films not only yield sharp, detailed images, but they do it with light that only a few years ago would have seemed hopelessly dim. Even if pushed beyond normal limits and given much less illumination than the standard ISO number calls for, these films can still produce a good image.

The picture on the right, for example, was good enough to appear on the cover of *Sports Illustrated.* Walter Iooss Jr. took it during the 1980 Super Bowl football game between Los Angeles and Pittsburgh. In order to use a shutter speed fast enough to freeze the action, Iooss had to quadruple the speed rating of his ISO 400/27° film to ISO 1,600/33°. Even so, light levels were so low that Iooss had to use a relatively slow shutter speed, 1/100 second. Yet he managed to freeze the dramatic play that decided the game.

German photojournalist Robert Lebeck had to compensate for darkness when he photographed the night-time funeral of Senator Robert F. Kennedy in June 1968 *(opposite).* Using a 300 mm lens set wide open and a shutter speed of 1/60 second, he exposed black-and-white film as if it were rated ISO 1,000/31° instead of its usual rating of ISO 400/27°. In the solemn scene opposite, the pall-bearers carrying the flag-draped coffin were led by the Senator's 14-year-old son, Robert F. Kennedy Jr.

WALTER IOOSS JR.: *John Stallworth's Winning Catch at the Super Bowl,* 1980

ROBERT LEBECK: *Funeral of Robert F. Kennedy,* 1968

Making an Asset of Graininess

Certain photographs are enhanced by emphasizing rather than suppressing a grainy texture. Coarse grain can add a theatrical impact to black-and-white pictures, and colour images gain a misty, dreamlike beauty. Fast films lend themselves to these effects because of their large silver bromide crystals.

Photographer Max Waldman was famous for his grainy shots of performers. Though he never revealed the method he used to exaggerate grain so dramatically, a test conducted for this book by the Time-Life Photo Lab suggests one technique for achieving similar results. It depends on recording film—a special film originally developed for low-light surveillance. This film, which sacrifices smooth tone and sharpness for maximum speed, is unusually coarse grained when exposed at its normal rating, ISO 1,000/31°; when the film is pushed to ISO 2,000/34° or even ISO 4,000/37°, grain is even more apparent. Printing on high-contrast paper exaggerates the grain still more.

Alain Chartier was less secretive about his method. An otherwise commonplace scene—a delivery van stopping outside a country house in Picardy, France—became suffused with a strange haze by a special developing process: the method normally used for colour negative film was used, although the film was actually slide film. Slide film has both large, fast crystals and slow, fine ones. The fast crystals produce a coarse black-and-white negative, which normally is reversed in processing to a colour positive created by the fine crystals. Print film developer short-circuits this action, producing a grainy colour negative from the coarse crystals.

MAX WALDMAN: *Actor Robert Lloyd in the role of the Violent Inmate in Marat/Sade,* 1966

ALAIN CHARTIER: *The Itinerant Groceryman,* 1977

The Uses of Medium-Speed Film

All-purpose fast films become an inconvenience when shooting such intensely bright scenes as the one on the right. For this picture of a fenced dune at Jones Beach, New York, freelance photographer Mel Ingber wanted to shoot towards the sun. If he had selected a fast film, the picture would probably have been badly over-exposed—even with the fastest possible shutter speed and the smallest aperture. However, a medium-speed film (ISO 125/22°) enabled him to handle the intense illumination. He used an exposure setting of f/8 at 1/250.

In this case a medium-speed film was also a better choice than a slow film, since Ingber wanted to capture the delicate shades of grey in the scene. This is more easily accomplished with medium-speed and fast films, which exhibit less tonal contrast than slow films, and thus may be more suitable for photographing subjects that have deep shadows and very bright highlights.

Medium-speed film need not be limited to such marginal projects as high-illumination photography, of course. It is an excellent all-round film, able to handle all but the dimmest light, capable of catching fast-moving subjects, and endowed with finer grain than the fast films. However, as manufacturers steadily improve the grain of fast films, the medium-speed film may play a reduced role in the future of photography.

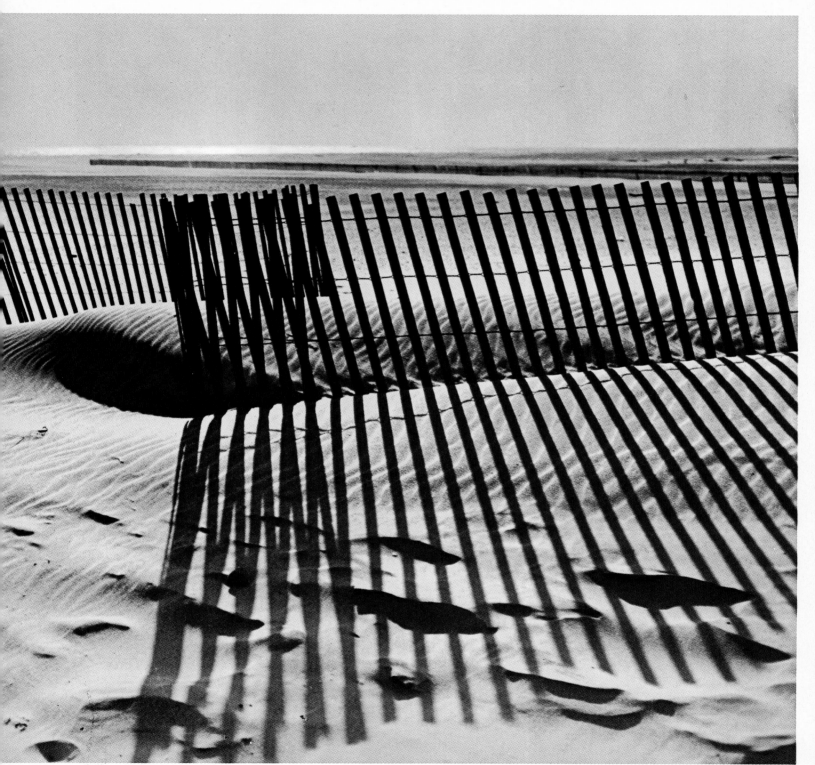

MEL INGBER: *Beach Patterns,* 1969

For Maximum Detail, Slow Film

A slow film, in the ISO 25/15° to 64/19° range, is photography's version of the old-style scholar—ill-suited to the dash and bustle of the world, but unsurpassed at working with tiny details. Its ability to record subtleties of colour and to render detail sharply is made possible by the small size of the silver bromide crystals and the thinness of the emulsion. (Thin emulsions reduce the internal reflection of light among the crystals—a bouncing that blurs edges.)

The slow film is not very sensitive, of course, since there are fewer crystals in a thin emulsion and small-sized crystals produce less image-forming silver. However, if a photographer has bright sunlight or if there is enough artificial light to illuminate his subject, slow film will allow him to make extreme enlargements of the picture without any sacrifice of clarity.

Slow film is a frequent choice for portraits *(page 156)*—and the pictures on the right, by Werner Köhler, a German freelance photographer, also demonstrate its value for nature studies. Köhler's photographs were shot on fine-grained black-and-white film, rated at ISO 50/18°, with a 35 mm rangefinder camera equipped with a 50 mm lens. Because the day was overcast, he set his aperture at f/5.6 and his shutter at 1/50 second. He captures such fine detail that the leaves and gravel look almost real enough to touch.

WERNER KÖHLER: *Patterns in Nature,* 1966

There is one colour transparency film, Kodachrome, that differs considerably from other colour films. It contains no colour couplers in its emulsion (couplers are added to the film during processing), and their absence makes possible a simpler film structure with thinner layers of emulsion. The thinner, simpler film forms sharper images because the light striking it has less room to scatter within the film itself. Sharpness is also enhanced by the film's fine-grain emulsion—it is slow, available for use with natural light in speeds of ISO 25/15° and ISO 64/19°, and for use with artificial light at a rating of ISO 40/17°.

Kodachrome film was used to produce both pictures on these pages. French photojournalist Roland Michaud was in the rugged terrain of northern Afghanistan, shooting a picture essay on a strenuous and violent game called *buz kashi* that requires players to gallop on horseback across the open steppe, carrying a goatskin filled with more than 27 kg (60 lb) of wet sand while fending off rivals.

For this portrait of one of the professional horsemen who play the game, Michaud used an aperture of f/4 and a shutter speed of 1/125 second on a 35 mm camera with a 105 mm lens. The slow film rendered, with almost grainless fidelity, finely etched details in the man's face and the fur trim on his cap.

The still life of glistening fruit opposite was shot in available dim light in Richard Jeffery's Manhattan studio. On a 35 mm camera with a special close-up lens—a 55 mm macro lens—Jeffery used an aperture of f/11 and an extra-long shutter speed of 15 seconds to produce a richly detailed image that conveys the mouthwatering succulence of a melon.

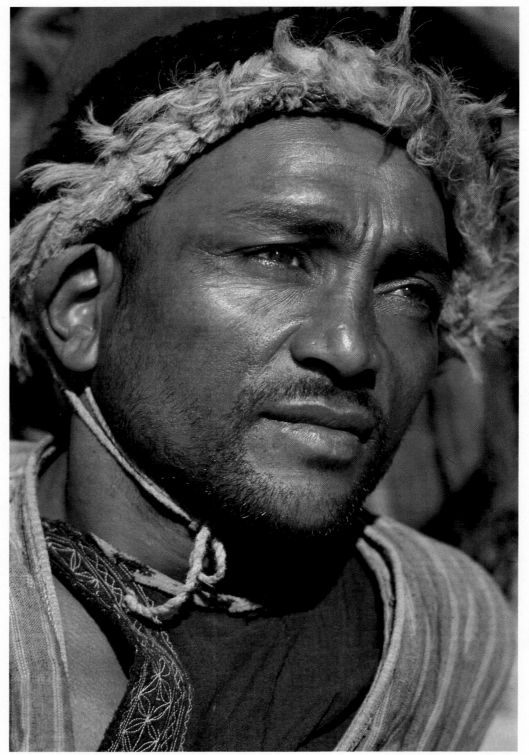

ROLAND MICHAUD: *Afghani Chopendoz Horseman,* 1973

RICHARD JEFFERY: *Melon Slice with Grapes,* 1968

The Magic of Infra-Red Film

Infra-red film can produce hauntingly beautiful outdoor photographs, giving the world a moonlit appearance—the sky dark, the clouds fleecy and the green foliage unexpectedly luminous. Minor White wrought this sort of transformation in his picture of a farm near Avon, New York *(right),* taken on infra-red film with a red filter fitted to his 10.2 x 12.7 cm (4 x 5 in) view camera.

Most of the infra-red films that are used for non-scientific purposes not only respond to some of the visible wavelengths seen by the eye, but gain their special qualities from their additional sensitivity to invisible infra-red wavelengths that are just slightly longer than the visible waves of red light.

These "near-red" waves, emitted copiously by the sun and incandescent bulbs, can create bizarre photographic effects because they are not always absorbed or reflected in the same way as visible light. When a deep-red filter is used to block most visible wavelengths, so that the photograph is taken principally with near-red waves, these effects become particularly evident.

The leaves and grass in this picture came out snowy white because they reflected near-red waves very strongly (the surface features of leaves were lost, however, because the radiation was reflected not from the surface but from sub-surface layers in the leaf tissue). The large water particles in clouds also reflected near-red waves quite strongly, making the clouds seem a brilliant white. But the sky turned out black, because its blue light, mainly in the short-wavelength range, was largely blocked by the deep-red filter.

Sometimes photographers use infra-red film and a filter for long-distance views on hazy days. The haze results from the scattering of visible light by very small particles of water and smoke in the air—an action that does not affect the near-red radiation. Instead of being scattered by these particles, infra-red waves reflected off the scenery can pass right through them as if they did not exist; a hazy scene caught on infra-red film thus looks perfectly clear.

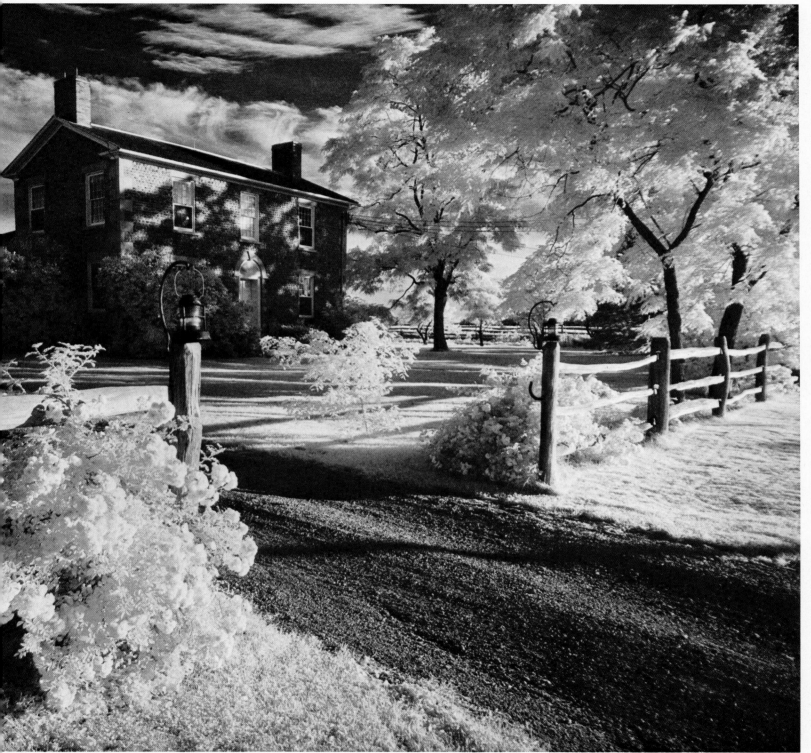

MINOR WHITE: *Cobblestone House, Avon, New York,* 1958

Instant Richness

Like other special films, instant film has unique virtues to attract the photographer; among its advantages are creamy smooth tones in black and white, and brilliant hues in colour. For this portrait of a jazz singer, freelance photographer Barbara Bordnick used Polaroid colour sheet film in a 20.3 x 25.4 cm (8 x 10 in) view camera. The film produced an exceptionally sharp image, but its most distinctive characteristic—its brilliance—can be traced to the film's response to light as indicated by its characteristic curve *(pages 132, 134)*.

This Polaroid film has a steep curve: each increase in the amount of light that reaches it creates concentrations of dye in proportions higher than in films with more gradual curves, producing an image high in contrast. In colour film, a high-contrast image is interpreted by the eye as being sharper than a low-contrast image, and the colours appear to be more brilliant. Brilliance is further enhanced in this film by a cyan dye that produces especially luxurious tones in the long wavelengths—the red end of the spectrum. In the portrait on the right, the dye and high contrast combine to produce the rich hues seen in the singer's flesh tones and red, robe-like dress.

For Barbara Bordnick, the instant film had another advantage. She found that having an image ready to view in 60 seconds helped to overcome the formality that often stifles a portrait sitting. Not only could she immediately appraise the picture herself, but she could show it to her subject while she took more shots. This relaxed the sitter and led to a sharply detailed view-camera portrait with a feeling of spontaneity. □

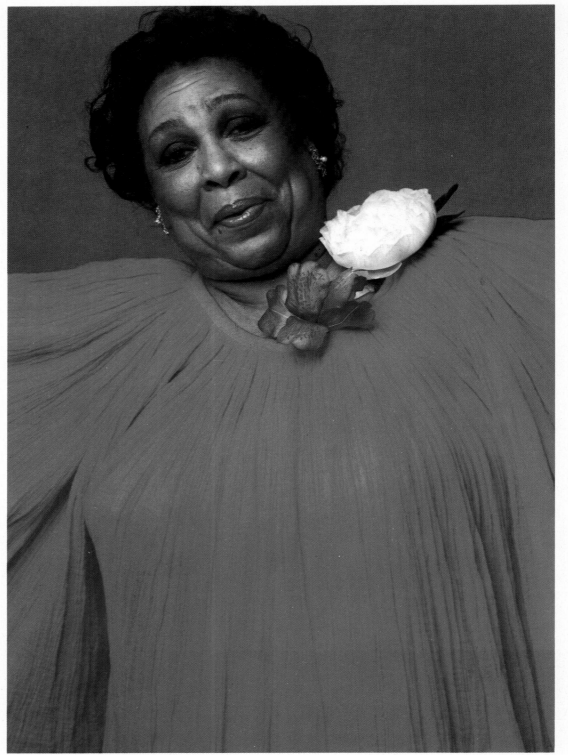

BARBARA BORDNICK: *Jazz Singer Helen Humes,* 1977

How to Expose for a Good Image 164

The Built-In Meter and How to Use It 166
Scenes That Fool the Controls 168

The Hand-Held Meter 172
Measuring Reflected Light 174
Measuring a Small Spot 176

The World in Shades of Grey 178
Photographing in Soft and Hard Light 180
Adding Tones by Adding Light 182
Changing Tones with Filters 184
Eliminating Tones with Filters 186

HENRY GROSKINSKY: *Temple of Dendur, The Metropolitan Museum of Art, New York,* 1978

How to Expose for a Good Image

The spectacular sunset view on the preceding page is the result of a perfect exposure made under unusually complex lighting conditions. Photographer Henry Groskinsky set out to show Egypt's 2,000-year-old Temple of Dendur as it looked in its anachronistic setting: a glass enclosure of The Metropolitan Museum of Art surrounded by Manhattan skyscrapers and Central Park. He had to find a moment when the light inside the museum balanced the intensity of the light outdoors.

On an evening when the temple was brightly illuminated for a party, natural twilight aided by street lamps and car headlights gave the needed balance. Groskinsky set up his camera on the roof of a building opposite the museum and just after sunset gauged the light inside the temple enclosure with a special spot meter, which measures light reflected from a small area of a scene. He knew from experience that he would have no more than seven or eight minutes before outdoor light dimmed below the interior level. Checking the light level continually, he waited until his meter indicated an exposure for the outdoor scene about half that required for the indoor one and then began shooting, using several combinations of shutter speed and aperture. He took 12 shots before the outdoor light failed; of the 12, two were good.

Photographers seldom have to cope with such tricky lighting. But accurate exposure is always necessary for a good picture. In the early days of photography, there was a brief period when a photographer could see exactly how his picture was coming out at the time he was taking it. He simply watched the plate through a hole in the camera and, when a good image had been recorded, he stopped the exposure. Some professionals still determine the exposure needed by making test pictures with a camera adapted for instant film. But most photographers rely on light meters and judgment. With films of standardized sensitivity, and with versatile meters to gauge light intensity, a photographer can be almost as certain of getting the shading he wants as his 19th-century counterpart was when he observed the image forming in the camera.

Setting exposure is the final step—after film is chosen and lighting fixed—that determines how a scene will be recorded. Before the camera is a world of rich and subtle colours, multiple textures, and strong and diffuse light—all to be translated into varying deposits of silver, which in black-and-white film create tones of grey, and in colour film are converted into dyes of different shades.

The ability of a photograph—either black-and-white or colour—to reproduce a range of illumination is limited. Nature is far less limited. In an ordinary scene, some areas may be hundreds of times brighter than others, and the eye readily detects features in the darkest and brightest regions. A photograph compresses this range, and in doing so loses some details as distinctions between tones merge. Which details are lost and which registered depends on exposure.

Adjusting exposure for maximum detail is, to most photographers, the way to

These strikingly different pictures of the same bunch of tulips were obtained by exposing for different parts of the scene. In the top picture, the photographer captured the rich colour and details of the back-lighted flowers by using a shutter speed of 1/60 second and an aperture of f/5.6, though this meant over-exposing the lace curtains. In the bottom picture, taken with the same shutter speed but at an aperture of f/11, the tulips were reduced to silhouettes, but delicate details in the curtain are clearly seen.

get a technically good image when using black-and-white or colour print film. The explanation is simple: during the printing process, undesirable details can be suppressed easily, but no darkroom legerdemain can supply details that are not in the negative. To get maximum detail, the rule of thumb is: expose for the shadows. That way the scene's darkest important features, reflecting the least light and producing the least silver metal, will be recorded. Bright areas may then be so strongly registered that they generate patches of almost solid silver; rarely, however, are these over-exposed sections featureless, and detail can be brought out in the final print by a number of darkroom techniques. Thus over-exposure is seldom as serious a defect as under-exposure, and the time-honoured exhortation "expose for the shadows" remains useful guidance. Moreover, most black-and-white and colour print films have a considerable tolerance for over-exposure. If the aperture is a stop or two greater than the lighting requires, or the shutter speed is somewhat slower, the results are rarely disastrous. In most cases, the miscalculation can be remedied in the printing.

Colour transparency film, however, is another matter. It has very little latitude or tolerance for under-exposure or over-exposure, and there are no simple darkroom manipulations that can compensate for errors after exposure. A miscalculation of a single f-stop can produce a slide with washed-out highlights or featureless shadows *(pages 142-143)*. When circumstances permit, many photographers make certain of getting at least one optimum exposure by "bracketing". One picture is taken at the estimated correct exposure, a second is made at one f-stop greater than the first and a third at one f-stop less.

Establishing the centre point of the bracket is easier now that photo-electric meters "take a reading" of the light falling on or reflected by the subject. Many kinds of meters are available, either built into the camera or as separate instruments. All measure light by the electrical reaction it causes when it strikes certain sensitive materials. Some built-in meters display their light readings on a scale visible in the viewfinder; the photographer then sets aperture and shutter to match the meter indication. Others control the camera automatically, adjusting shutter, aperture or both for proper exposure. The most versatile set the controls automatically and indicate their measurements with signals and scales, permitting the photographer to interpret the reading.

Judgment is still necessary, even with the most accurate meter. For one thing, the area in the scene gauged by the meter may not be the one that is most important to the picture; the reading can then indicate an exposure that seems technically correct yet fails to yield detail where the photographer intended. And for the finest results, the film's limited range of response to light must also be taken into account. Most scenes contain interesting details in many areas of widely varying brightness. The photographer must decide which are most important and adjust his exposure accordingly *(left)*. □

The Built-In Meter and How to Use It

Modern 35 mm SLR cameras have built-in exposure meters that measure the light that will reach the film during exposure. All built-in meters are the reflected-light type—they read light reflected from the scene to be photographed, not light falling on the scene (incident light). The meter is pointed at all or part of the scene the photographer wants to meter, and the reading appears on a scale—in many cameras, it is processed by a mini-computer that sets shutter speed or aperture.

With most built-in meters, this measurement is centre-weighted—that is, it averages all the light on the scene but weights its average to give more emphasis to a small area in the centre of the viewfinder than to the surrounding area. This system is based on the assumption—usually correct—that the subject will be in the centre of the scene. Often a centre-weighted meter will give an inaccurate reading when it is pointed at the scene from the picture-taking position—if the subject is at the side of the frame, for instance, or if the subject does not fill the central area and the surroundings are much brighter or dimmer than it is.

There are also scenes that can cause any reflected-light meter to produce inaccurate measurements. All such meters are designed to indicate exposure for scenes including both very light and very dark areas in a more or less equal balance. If a scene is uniformly light or uniformly dark, the meter acts as though it were an equal mixture and the indication is incorrect. But this problem, and the limitations of centre-weighting, can be dealt with by a few simple manoeuvres *(pages 168-171)*, and a built-in meter can be manipulated to produce accurate readings in all but the most difficult lighting.

Most built-in meters work in the same way. Some of the light passing through the camera lens is directed by a mirror to a light-sensitive cell in the camera body or near the viewing prism. The cell conducts (or generates) electric current, depending on the amount of light striking it. Batteries elsewhere in the camera power the cell. The current reaches the meter's circuits along with other exposure information—the camera's film speed, aperture and shutter-speed settings.

The circuits translate this information into an exposure indication that appears in the viewfinder. In some cameras, this display tells the photographer how to adjust aperture and shutter speed for the correct exposure. In automatic-exposure models, such as the one illustrated opposite, a built-in computer converts the meter reading into signals that set exposure; the viewfinder display merely tells the photographer what exposure adjustments have been made. Most automatic types are "aperture priority": the photographer selects the aperture and the computer selects the shutter speed. Some types work in the opposite way, however, and a few operate either way.

Some cameras that have automatic-exposure controls can be switched to manual. The meter then acts as it does on a manual camera; the photographer uses it to take the readings he needs to set shutter speed or aperture. Another way of overriding exposure controls on most automatic cameras is a knob that can be used to increase or reduce by one or two stops the exposure dictated by the meter. Other automatic cameras have a device that will hold exposure settings taken from one part of a scene while the scene as a whole is photographed. And on all cameras, film-speed setting can be changed to alter the meter action.

The rings drawn on the picture below indicate the way most built-in meters give different emphasis to different parts of an image in gauging light. The meter is centre-weighted, that is, made 100 per cent responsive to light reflected from the area of the scene inside the central ring; response falls off sharply from there outwards. Each surrounding ring denotes the point at which the meter's responsiveness is reduced by half.

The viewing screen (above) of a 35 mm SLR camera such as the one on the right gives information from the built-in meter. The number at the top shows the lens aperture, f/8. The scale on the right shows the shutter speeds, and the red dot indicates that at f/8 the meter has chosen a shutter speed of 1/125 second. When the camera is set for manual operation, a lighted dot appears next to "M"; the red dot then indicates the recommended shutter speed to be set manually. A lighted arrow at the top of the scale signals light too bright for exposure at the chosen aperture. A lighted arrow at the bottom shows need for exposure longer than 1 second. The centre circles are focusing aids.

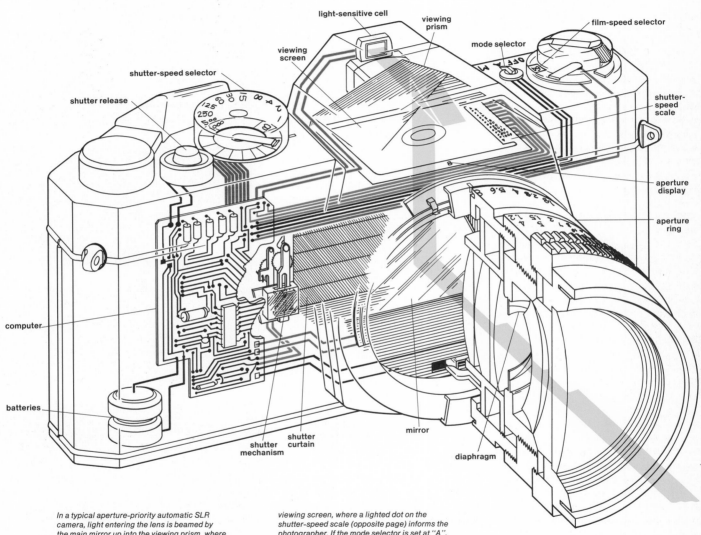

light-sensitive cell

viewing prism

mode selector

film-speed selector

viewing screen

shutter-speed selector

shutter release

shutter-speed scale

aperture display

aperture ring

computer

batteries

shutter mechanism

shutter curtain

mirror

diaphragm

In a typical aperture-priority automatic SLR camera, light entering the lens is beamed by the main mirror up into the viewing prism, where part of it strikes the built-in meter's light-sensitive cell. The cell registers the intensity of the light and relays this information to the camera's computer (blue). When the photographer chooses an f-stop by adjusting the aperture ring, this information, together with the other manually set exposure input, the film-speed rating, is relayed to the computer (red). The computer determines instantly what shutter speed is needed for a correct exposure at the chosen aperture and film speed. It relays its shutter-speed choice (green) to the viewing screen, where a lighted dot on the shutter-speed scale (opposite page) informs the photographer. If the mode selector is set at "A", the photographer need only press the shutter-release button; the computer signals the shutter mechanism (green) to open the shutter curtain for the amount of time that the computer has determined is required. If the photographer wants to set the shutter speed himself, he switches the mode selector to "M" for manual operation; the computer will indicate its recommendation for shutter speed, but the photographer can set the selector to inform the computer (purple) to give whatever speed he has chosen.

Scenes That Fool the Controls

A built-in exposure meter may indicate the wrong settings if something much darker or lighter than the main subject occupies a large portion of the scene, or if the subject itself is exceptionally light or dark. Such errors arise when the centre-weighting of the built-in meter is insufficient to keep unimportant bright or dark areas from distorting the measurement, even when the subject is centred.

The most common case is illustrated on the right, but many variations exist *(following pages)*. They can all be solved by moving close to the subject and gauging light reflected from it alone. Then use this measurement to set exposure when the camera is back at picture-taking position. If it is impossible to get near the subject, a telephoto or zoom lens can magnify it so that it dominates the frame, or the meter can be aimed at an object of similar tone, such as the photographer's hand, that is illuminated by the same light as that reaching the subject.

Occasionally, the meter is "fooled" by a scene that is uniformly very light or dark, such as the white cat on the white couch opposite. This error is caused by the way the meter is calibrated. It is set by its maker to give accurate readings for scenes in which the lights and darks, if averaged together, reflect 18 per cent of the light falling on them — overall, a medium grey shade. If the meter is pointed at a scene reflecting much more than 18 per cent — the cat on the couch — or much less, it will recommend an exposure rendering the subject as grey.

For such subjects, the exposure reading should be taken from an 18 per cent grey card, sold in camera shops. The palm of a hand will do nearly as well, but since a palm is lighter than the card, an exposure reading taken from it should be increased by one stop.

Three views of a little girl show how a built-in meter is used to determine correct exposure for the most common problem scene — one in which the subject is surrounded by a large, much brighter area. At the top, the bright background makes the meter indicate an exposure of f/8 at 1/500 second; a picture taken at these settings would have under-exposed the girl. The middle measurement, made with the camera held close to the girl's face, indicates that a shutter speed two stops lower is needed. Switch to manual control; using the corrected settings and shooting from the original camera position produces the picture at the bottom, correctly exposed for the girl but rendering the background slightly over-exposed.

f/5.6 at 1/30 second

This white subject reflected so much light that the meter initially recommended an under-exposure that dulled it to grey (above, left). A reading from an 18 per cent grey card gave an exposure that revealed true whites (right).

f/4 at 1/30 second

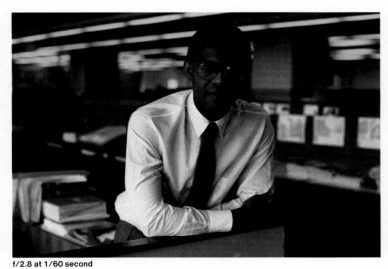

f/2.8 at 1/60 second

The contrast between dark skin and white shirt created this problem: the shirt made the centre-weighted meter under-expose the face (above, left). A close measurement of the face yielded accurate tones (right).

f/2.8 at 1/30 second

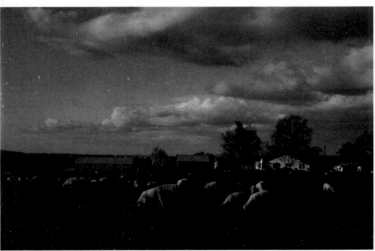

f/11 at 1/250 second

The bright sky occupying half the picture produced an initial reading that under-exposed the sheep and the farm (above, left). Aiming the camera lower to exclude the sky gave a correct exposure for the main subjects (right).

f/8 at 1/250 second

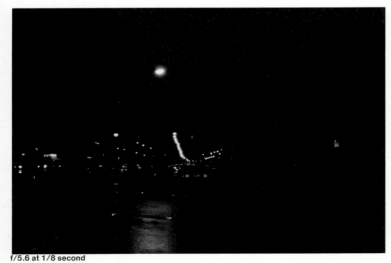

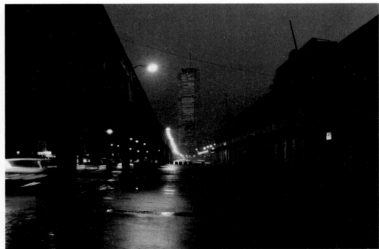

f/5.6 at 1/8 second

Street lamps near the centre of the frame distorted the meter's measurement of this night scene (above, left). The under-exposure was corrected (right) with a second reading, taken aiming away from the lights.

f/5.6 at 1/4 second

f/2.8 at 1/250 second

f/8 at 1/250 second

The problem here is the opposite of that caused by the sky on the left. The dark background so dominates the frame that the meter measurement over-exposes the figure (above, left). A close-up reading of the man's face gave correct exposure.

f/2.8 at 1/30 second

f/5.6 at 1/30 second

This scene was all dark except for the spotlighted subjects, and to compensate for the general gloom the meter recommended too much exposure. A measurement of just the guitarists yielded a better picture.

The Hand-Held Meter

When measuring dim light or when the most precise exposure calculation is required, many photographers turn to a separate hand-held meter. Like a built-in meter, this type of meter can measure light reflected from the subject, but many models can also gauge incident light—the light that falls on the subject.

When the hand-held meter is used in this way, registering only the light falling on a subject, it is not misled by dark or light areas around the subject, or by unusually dark or light subjects. It is particularly useful in determining exposures for distant subjects such as a city skyline viewed from across a river.

For such a picture, the light on the photographer will generally be the same as the light on the subject, and an incident meter will indicate accurate exposure; a reflected-light meter might be excessively influenced by sky light and light reflected from the water. Useful as incident measurements are, they cannot measure the actual brightnesses of different objects in a scene, nor can they give an exposure for an object that is itself emitting light, such as a neon sign or a lamp.

Whether the separate meter is used to gauge incident or reflected light, it offers advantages of versatility. Though it functions basically like an in-camera meter, with a cell that reacts electrically to light intensity, it is more sensitive, able to indicate exact exposure in illumination so dim as to require time exposures of several minutes. And unlike the built-in meter, which displays only one correct combination of shutter speed and aperture, the separate meter designates as many as 16 different combinations, any one of which will give good exposure.

This versatility exacts some complexity in operation. On most separate meters, the position of the pointer—at the centre of the scale or at a number on it—merely serves as a reference. On some models this reading is converted into exposure indications with the aid of manually adjusted dials; on more advanced models, the dial rotates automatically when the unit is turned on.

When a separate meter is used to measure reflected light, it is simply pointed at the subject in the same way as a built-in meter. To gauge incident light, a translucent dome, generally of white plastic, is placed over the sensitive cell to diffuse all illumination falling on the subject over an angle of about 180°. The meter is pointed not towards the subject but towards the camera, so that it receives the same light that reaches the subject.

Photographer Henry Groskinsky could have used either incident- or reflected-light readings when he photographed the church entrance shown here; in this instance he elected to work with incident light. To take a reading *(right)*, Groskinsky faced the meter away from the church and made sure that no shadow, including his own, fell on the diffuser dome. This reading, taken at camera distance from the church, would have been satisfactory for an overall picture. But since he planned to photograph a side entrance to the church, where there was a strong contrast of highlights and shadows, he moved to the immediate areas to take readings in both sun and shadow.

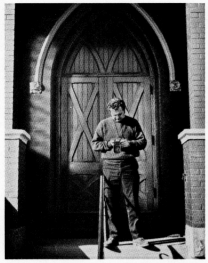

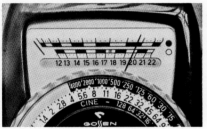

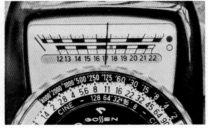

In the top picture, Groskinsky measures the bright sunlight falling on the steps and side of the church, pointing his meter at the light to gauge incident illumination. The needle points to just under 20 on the gauge. The exposure given on the dials for this reading produced the picture below. The highlights in this photograph are clear but the tonal range of the side of the building is limited; the shadowy area is grossly under-exposed and all detail there is lost.

At a second reading in the shadows beneath the portico (top), the needle drops to 17, almost three numbers on the scale less than the reading made in direct sunlight. If this reading were relied on for the exposure setting, it would lead to the photograph below. The shaded areas are no longer black and the desired detail on the door is clearly visible. But the highlights on the steps and side of the church are now burned out because of over-exposure.

To get a proper overall exposure, the photographer made a compromise between the two previous exposures, choosing a reading of just under 19 and setting his camera accordingly. This produced a photograph with good detail in the highlights, a broad tonal range and good detail within the shaded area as well (below).

Measuring Reflected Light

The easiest way to use a separate meter to measure reflected light is to hold the meter alongside the camera and point it at the scene *(left)*. This procedure is generally effective if light and dark tones are of about the same distribution and interest; the meter indicates an average exposure that serves well. But if either light tones or dark ones predominate, the indicated exposure may fail to record the detail in the minority tones.

The procedure followed by most photographers involves several readings taken from close range of different areas that will appear in the scene, dark and light, as shown on the right. An exposure between the extremes indicated by the meter is then selected. A simple average is sufficient under most circumstances but, because detail is most easily lost in the darker parts of a photograph, an exposure somewhat greater than midway is often desirable if the shadow detail is particularly important or if it covers a large area.

Frequently the light must be measured from the camera position. If the subject is the Grand Canyon, no one is going to climb the far cliffs to take meter readings. The same result can be obtained, however, by pointing the meter at nearby objects that share illumination and colour with those in the subject and then averaging those readings.

This technique can even be used when taking photographs of people who are not easily approached for light measurement. Very often their faces are in shadow and an exposure based on a measurement of the entire scene from the camera position may make facial features disappear. The solution is to measure a shadowed face nearby—or even the skin on a shaded hand.

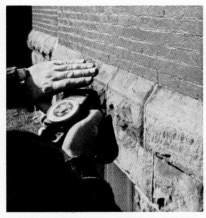

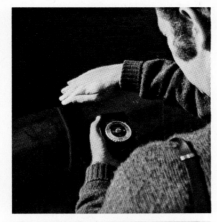

Using his hand to shade the meter opening from direct sunlight and sky glare (top), Henry Groskinsky begins his estimation of correct exposure for the church scene by measuring the intensity of light reflected from one brightly lit wall of the building. The gauge (above) shows just over 21. But this reading alone does not lead to a picture containing maximum detail. The indicated exposure records highlights satisfactorily, but the shaded areas are under-exposed and almost wholly devoid of detail (photograph below).

Measuring the illumination of the dark part of the scene (top) is also an essential step in accurate use of a reflected-light meter. With the meter aimed at a shaded section of the church wall (top), the needle on the gauge (above) points to about 17. But this indication is no more useful alone than was the one based solely on bright-area illumination. If it is used, the picture (below) is far from what the photographer wants. There is excellent detail in shaded areas but the highlights are nearly blank white.

For a well-balanced negative with detail clearly visible in all areas, the readings of the bright and dark sections of the scene were averaged. The photograph below shows the result. On the side of the church that is sunlit, the texture of the bricks and the patterns of masonry and roofing are no longer blanked out. On the shaded side, the doorway and window openings are plainly visible and the features of the door itself can be easily seen. Even the flowers in the foreground seem to be more realistically rendered.

Measuring a Small Spot

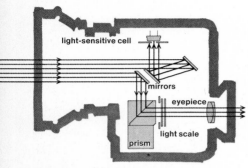

The operating principle of a spot meter such as
the one below is shown in the greatly simplified
diagram above. Part of the light entering through the
focusing lens is redirected by a mirror and prism to
pass through the exposure scales and eyepiece
lens, so that the photographer can aim the meter at
his target. The rest of the light is reflected towards the
light-sensitive cell. In front of the cell is a shield with a
small opening, and this shield blocks most of the
light; only the small fraction reflected by a small part
of the scene gets through to be measured. The meter
reading is visible over the scene as it is viewed
through the eyepiece.

The spot meter also measures reflected
light, but of only a minute section of the
scene in front of it. Where an ordinary
hand-held reflected-light meter will mea-
sure light over an angle of 30° to 50°, a
spot meter may measure only one de-
gree or less. It is a specialized and often
expensive tool, used primarily by pro-
fessional photographers and advanced
amateurs who want to gauge precisely
the exposure required for one or more
key areas in a photograph, such as the
interior of the glass enclosure in the pic-
ture on page 163.

The spot meter is especially effective
for obtaining readings of distant objects.
The top picture on the opposite page
was made with exposure settings based
on a reading with an ordinary reflected-
light meter. Because of the dark bushes
and trees in the foreground, the reading
was low and the buildings are over-
exposed. With an exposure obtained from
a spot-meter reading of one of the distant
structures, the bottom picture has excel-
lent detail of the buildings, but at the cost
of some loss of foreground detail.

Looking through the viewfinder of the
spot meter, the photographer sees a part
of the scene *(right)* through a focusing
lens that magnifies the image. A small
circle in the centre of the viewing screen
shows the precise area being measured.
Around the edge of the viewing screen
can be seen the two dials. The photogra-
pher sets the outer one, which bears ap-
erture markings, for the speed rating of
the film he is using. When he has the
small circle superimposed on the area he
wants to read, he presses a button and
the motor-driven inner dial, which bears
the shutter-speed markings, automatical-
ly turns to align shutter speeds and aper-
tures that will give correct exposure.

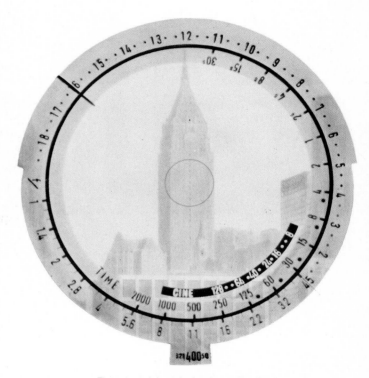

The spot meter's lens takes in only a small section of
the photographic scene, but the image observed in
the eyepiece is magnified four times. The actual area
measured for reflected light (small circle) is a very
small part of the visible scene, covering just one
degree. To use the meter, a photographer sets the
outer dial to his film's speed rating (bottom), and
points the instrument so that the small aiming circle
is on the area to be measured; the inner dial then
moves automatically to line up the proper aperture
and shutter-speed combinations. The short,
innermost scale lists frames-per-second settings for
motion-picture cameras.

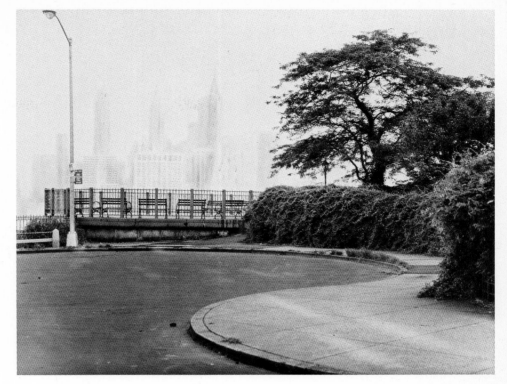

Because of the dark foreground in the scene, an ordinary reflected-light meter gives an excessively low reading, leading to a picture (top) with good detail in the foreground but little in the distant buildings. A reading of a small area of one of the brightly lit buildings with a spot meter indicates a lesser exposure. In the picture taken at this exposure (bottom) the foreground is darker but there is good detail in the buildings.

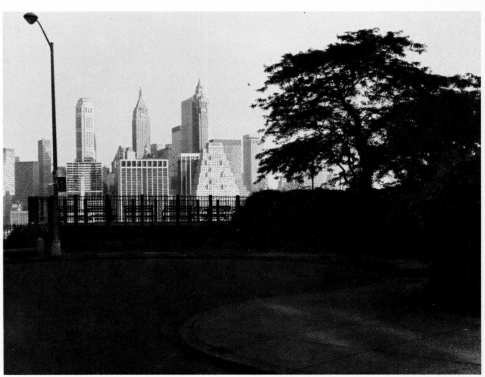

The World in Shades of Grey

A light meter does not really gauge exposure. It measures the intensity of the light. How that datum eventually determines exposure depends on how the photographer aims to reproduce on film the real world before his camera—a scene that almost always includes many colours of many brightnesses. Does he simply want to record as much of the scene, from shadows to highlights, as his film will register? Or does he want to bring out shadow detail with extra exposure, or to enrich shadow tones and soften the highlights with less exposure? How bright should he make clouds? How dark the sky?

Such questions are not automatically answered by meter readings. They require that the photographer be able to translate into exposure settings his personal vision of how a scene should be reproduced in a photograph. For black-and-white photography, such a sophisticated approach to exposure turns out to be simpler than it seems, thanks to the "zone system" developed by the noted Californian photographer Ansel Adams.

Adams' system is based on a printed "grey scale" like the sample opposite (they can be bought from most camera shops and sometimes come with exposure meters). Its 10 distinct shades of grey show the range of tones, or zones, that the print encompasses. The various zones can be compared—either from memory or from the actual scale—to the tones in essential elements of the scene. Then exposure is set to reproduce those elements in desired zones.

The zones are numbered from 0, deep black, resulting from no exposure on the corresponding part of the negative, to 9, paper white, a dense section of the negative. Each succeeding zone (after zone 1) represents a doubling of the exposure of the previous zone—an increase of one f-stop. Obviously, the average tone in the average scene is a medium grey—zone 5—and in the average picture it should appear as zone 5. This is what reflected-light meters are designed to accomplish; all of them indicate exposures that will reproduce as zone 5 the average light intensity they measure. Only in the middle zones—from 3 to 7—is detail clear.

How the zone system helps determine exposure can be seen in the picture opposite, on which numbers indicate the zones for various areas. The light shadows under the decks are zone 5 and a reflected-light meter reading of this area would have indicated the exposure for this negative. This exposure gave detail in the cloth cover (zone 2), but made the stairs (zone 9) too bright for clarity and the reflection of the hull (zone 1) too dark. Suppose some detail had been essential in the zone 1 reflection. By opening the lens one stop, the photographer would have shifted one zone up the scale, making some slight detail visible. But all other areas would be lightened similarly; zone 0 might disappear, and the zone 8 wall area would most likely be indistinguishable from the stairs, which are in zone 9.

This picture suffers no lack of detail. Its magnificent range of tonal values, from 0 to 9, provides not only the accents of the extreme tones but also rich shades in the middle zones where the most detail can be readily accommodated. This full-scale rendition is generally the aim of the photographer, simply because it does make available more usable tones.

However, in some scenes only a few tones are of interest, and only they need be reproduced. The zone system can be used to interpret light-meter readings for either result.

DAVID VAN DEVEER: *Excursion Boat,* 1968

Photographing in Soft and Hard Light

MICHAEL SEMAK: *Italian Village,* 1962

To catch the mood of a softly lit scene or present a dramatic contrast of hard light and deep shadows in black and white, a photographer frequently produces a picture with a severely limited tonal range. In the above picture of a lone priest walking along a fog-shrouded street in a village near Rome, photographer Michael Semak ignored the upper and lower zones of the grey scale and concentrated on the middle zones—from 4 to 7. For the harshly lit picture of a man on New York City's

Staten Island ferry shown on the opposite page, photographer Neil Slavin omitted practically all of the middle zones and employed mainly the extremes—0 and 1, 8 and 9.

In each instance, the photographer deliberately sacrificed detail to get the desired effect. In the picture of the village street, the trees, except for the one in the foreground, are only ghostly shadows. There is slightly more detail in the photograph of the ferry but the wall is com-

Because he wanted an under-exposed negative, the photographer exposed for the average of all the light reflected by the scene rather than for a dark object, recording the luminous fog as medium grey zones 6 and 7. Using a 35 mm SLR loaded with film rated at 125/22°, he made the exposure 1/125 second at f/5.6.

NEAL SLAVIN: *On the Staten Island Ferry,* 1967

pletely black and nothing can be seen on the outside of the windows.

Both photographers could have incorporated more zones of the grey scale, and still have achieved almost the same effects by eliminating unwanted zones during the printing process. When the desired result is clearly seen, however, it is usually best conveyed if it is registered in the negative.

Semak simply measured the light reflected by the fog, knowing it would indicate an exposure too small to record the darker zones in the scene; in this way he produced what would normally be considered an under-exposed negative. Slavin also elected to make a deliberately under-exposed negative, basing his exposure on the brightest zone, the light from the window. The long experience of these two photographers enabled them to visualize the negatives such under-exposure would create, and in both instances the results are excellent.

Seeking limited tonal range and little detail in this picture, the photographer adjusted his exposure to make the windows a blank zone 9, with nearly all of the shadows an equally featureless zone 0. Only portions of the bench and the man's clothing are in the middle zones. The exposure was 1/125 second at f/11 on high-speed film.

Adding Tones by Adding Light

Both of the above photographs were taken with a tripod-mounted view camera loaded with high-speed film, which the photographer deliberately over-exposed slightly. Even so, the dark areas in the picture on the left remain featureless. To get detail on the shadowed side of the subject's face (right), a white cardboard reflector was placed to the left and slightly in front of him.

Under certain lighting conditions, a reflector or additional illumination is necessary to broaden the tonal range and to add detail. In the portrait above on the left, for example, the highlighted half of the face is properly exposed but the other half is so dark—zone 2—that practically all of the detail is obscured. Through the use of a white cardboard reflector, illumination is supplied to the darker area, thus bringing it into the middle zones so that a considerable amount of detail appears.

Reflectors could not solve the problem posed by the scene on the opposite page. Because a small f-stop was desired to provide depth of field and bring all of the parts of the picture into clear focus, the illumination from the room lights was sufficient only for the highlights *(top picture opposite).*

A flash to the left of the camera supplied light to bring most of the scene into the desired middle zones of grey *(centre picture opposite),* but made the bright areas too bright. For the bottom picture, the lighting was not changed, but a faster shutter speed was used, darkening the higher zones of grey so that some detail can be seen in them. This also darkened the tones in the rest of the picture, but enough of them remain in the middle range of the scale to give the detail the photographer sought.

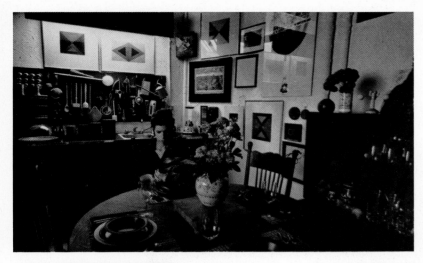

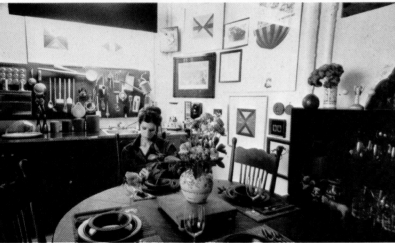

The top picture in this sequence was taken with the kitchen's normal light — the exposure was 2 seconds at f/8 on film rated at 125/22° in a 10.2 x 12.7 cm (4 x 5 in) view camera. Only in the brightest parts of the scene — the higher zones of grey at the top and right centre — is any detail clear. Aided by one flash, the same exposure (centre picture) illuminated detail throughout, but shifted the bright areas to such high zones on the grey scale that their detail was blanked out. This was corrected by changing the exposure to 1 second, and the bottom picture shows details in both shadows and bright areas.

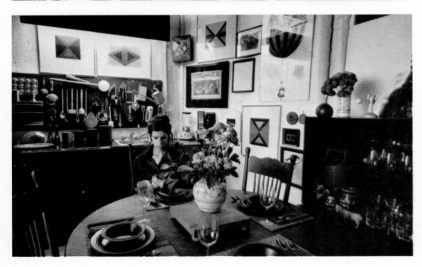

Changing Tones with Filters

The green filter *used to take the picture above on the right blocks out much red light and allows green to reach the film, making the red apples darker than the leaves, a natural appearance. Without the filter (above, left), the tones seem confusingly similar. To make up for light absorbed by the filter, the aperture is opened 2⅔ stops above the normal opening.*

Because black-and-white film records the world in tones of grey, dramatic contrasts in nature's colours are often almost indiscernible in a photograph. To the normal human eye, red apples are easily distinguished against a background of dark green leaves, but when photographed in black and white the apples and the leaves are reproduced in almost exactly the same grey shades *(above, left)*. Colour filters are used to get a tonal separation that approximates to the colour contrast in nature.

Objects acquire colour because they reflect part of "white" light—a mixture of all colours—and absorb the rest. Filters also absorb some of the colours in light, passing others. When the apples and leaves are photographed through a green filter *(above, right),* the apples are considerably darker—i.e., less exposed—than the leaves because the filter has absorbed much of the red light the apples reflect but has let the green re-

flection of the leaves register on the film.

Green filters are often used when a comparatively natural tonal separation is needed because they alter the exposure of the film to red, making the relative difference between the two colours closely match that sensed by the human eye. To control the exposure of bluish colours, yellow or red filters are used, particularly for adjusting the tone of the sky. Film is so sensitive to the sky's blue and ultraviolet waves that even a dark blue sky causes about as much exposure as white would, and the sky often becomes nearly indistinguishable from clouds when it is photographed without a filter *(opposite, left)*.

By using a yellow filter, which absorbs much blue, the sky is darkened and the smoke clouds become visible *(top, right)*. The contrast between sky and clouds can be made even more marked if a red filter, which blocks nearly all blue light *(bottom right)*, is used.

With the yellow filter, *much of the sky's blue light is absorbed, making the sky in the picture on the far right appear in its natural brightness (zones 5-7), somewhat darker than the smoke (zone 9). Without a filter (near right), details of the smoke are lost. Because the filter absorbs some light, the aperture must be opened one stop larger than would otherwise be necessary.*

A red filter *absorbs nearly all blue and green light, making the sky in the picture on the far right much darker (zone 3) than it normally appears and also darkening leaves and sand. Shadows, too, appear darker than in the unfiltered view (near right), for they are illuminated largely by blue sky light, which the red filter blocks. Because of the large amount of light absorbed by the filter, the aperture was opened three stops larger than normal.*

Eliminating Tones with Filters

Reflections from glass or water *(below, left)* are tones a photographer may wish to avoid in his picture. They can be eliminated very simply because they are made up of light that is unusual in that it is polarized; i.e., the waves are oriented at one angle rather than many angles *(pages 20-21)*. This makes it possible to control them with a polarizing filter which can block light oriented at one angle and thus also block the reflections *(below, right)*.

A polarizing filter looks transparent but contains sub-microscopic crystals lined up like parallel slats. Light waves that are parallel to the crystals pass between them; waves oriented at other angles are obstructed by the crystals,

as indicated in the diagram on the right. Since the polarized light is all at the same angle, the filter can be turned to block it. This also blocks some waves in the general scene light, but only those oriented like polarized light; the rest get through.

To find the orientation that will block polarized light, the photographer looks through the filter and rotates it until the unwanted reflection vanishes. The filter is then placed in the same position over the lens. (With a single-lens reflex camera, the filter can be adjusted while it is in place over the lens.) Because of the partial blockage of light by the filter, the aperture must be opened 1 ⅓ stops above the normal exposure. □

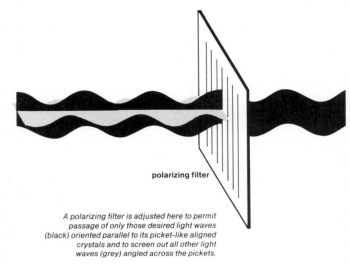

polarizing filter

A polarizing filter is adjusted here to permit passage of only those desired light waves (black) oriented parallel to its picket-like aligned crystals and to screen out all other light waves (grey) angled across the pickets.

Basic Lighting Techniques 190

Taking Advantage of Existing Light 192

Six Ways to Use Flash 194

Avoiding Common Mistakes with Flash 196

Balancing Flash and Available Light 198

The Special Virtues of an Electronic Unit 200

Floodlighting and Spotlighting 202

Directing Light for Effect 204

Suiting the Film 206

Modifying Light with Reflectors 208

A Simple Studio for Flattering Portraits 210

Building Effects by Adding Lights 212

Wizardry with Flood and Flash 214

A Whole Race at a Glance 216

Syncopated Strobes 218

Lighting for a Knockout 220

Blending Natural and Artificial Light 222

Total Lighting 224

Balancing Light in Two Worlds 226

Capturing a Laser's Own Light 228

Painting with Light 230

Computer Composition 232

HOWARD HARRISON: *Floodlights, Spotlights and Reflectors,* 1968

Basic Lighting Techniques

With modern fast films and lenses, no photographer has to wait for bright day-light to take his pictures. Even the ordinary illumination from a lamp in a room or a street light after dark is enough for striking shots *(pages 29 and 46)*. But in many situations a supplementary light source can make a subject more fully visible, bring out the details in shadows, give an impression of three dimensions, or achieve special dramatic effects. Today, there is a broad array of equipment and techniques to help the photographer gain these ends, from the flash bar or cube that is popped into the top of a camera to the batteries of devices that professionals use to stop a tap dancer's action, light up an arena, or computerize a multiple exposure *(pages 215-232)*.

These light sources are the fruit of more than a century of experimentation aimed at finding ways to make photographs at any time, indoors or out. In the earliest days, getting enough light of any kind to record a recognizable image was one of the photographer's most frustrating problems. At first, bright sunlight, and plenty of it, was the only real solution. All sorts of experiments were tried to hasten the agonizingly long exposure times, and to enable portraits to be taken indoors and on dull days. Among the first successful devices was an intensely flaming jet of oxygen and hydrogen gases that heated a disc of lime to brilliant incandescence—the famous "limelight" used to spotlight actors on the 19th-century stage.

In the 1850s came the discovery that burning magnesium wire produced an extremely bright light similar to daylight; photographers were soon setting off magnesium to record the wonders inside British coal mines, Kentucky's Mammoth Caves and even Egypt's Great Pyramid. The thick clouds of white smoke the magnesium produced, however, drove the cameramen choking into the open air after they had managed to get no more than one or two pictures. From the 1880s on, most artificial-light pictures were made with flash powder—an explosive mixture of finely ground magnesium, potassium chlorate and antimony sulphide that proved very effective but extremely dangerous. Whenever it was used there was always a threat of fire and many photographers and their assistants were burned or blinded by accidental explosions.

It was not until the 1930s that flash photography became simple and safe with the first mass production of flash bulbs, which looked like ordinary electric light bulbs but contained crumpled aluminium foil and pure oxygen that generated an intense light when touched off by a powder primer activated by batteries. Today's peanut-sized bulbs, filled with zirconium foil, are the miniaturized descendants of those early bulbs. They are inexpensive and very easy to use—particularly in the form of multiple units, such as flash cubes or flash bars, which hold from four to 10 separate bulbs, each with its own reflector, so that pictures can be made in rapid succession. Cubes and bars are often mounted directly on to the camera; while this restricts the choice of lighting

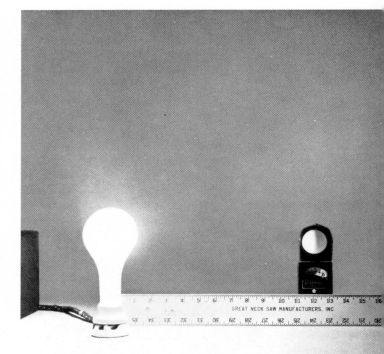

The intensity of artificial light drops rapidly with distance. A light meter 30 cm (1 ft) from the bulb shown here receives 1,345.5 lux. (125 foot-candles) of illumination; twice as far away, at 60 cm (2 ft), the light is cut to 1/4, or about 336.4 lux. (32 foot-candles); at 90 cm (3 ft), to 1/9 or about 149.5 lux. (16 foot-candles). Thus the amount of light is inversely proportioned to the square of the distance.

angles, the limitation can be overcome and satisfactory results achieved with little effort *(pages 194-199)*.

The flash bulb's glamorous younger cousin, electronic flash *(pages 200-201),* is an even more versatile and convenient light source. It, too, produces a momentary burst of light. But it can do so again and again as long as electricity is supplied, and is even easier to use than bulbs; and it is more economical for those who take more than a few dozen flash pictures every year.

An electronic flash is less like a simple spark than like a small bolt of controlled lightning. Electricity from batteries or a wall outlet is built up to a high voltage (as much as 4,000 volts in some units) and stored in the unit's circuits; when the switch is pressed this high-voltage electricity jumps from one electrode to another inside a glass tube filled with xenon gas. The electrical discharge forces the gas to glow briefly and brilliantly with a colour approximating to that of daylight. An automatic switch inside many units turns off the flash when enough light has reached the subject. The burst of light is so short—1/1,000,000 second or less in some specialized units—that it can be used to stop movement as fast as that of a bullet travelling at 2,900 km (1,800 miles) per hour.

An electronic flash is sometimes called a strobe, a hangover from the days when the newly developed device was first employed as a stroboscope—a light that flashes repeatedly at a controllable rate for studies of rapidly rotating machinery. The units now commonly used in photography are not stroboscopic; they produce a single flash each time the camera shutter is released.

A flash's short, bright burst of light is both an advantage and a disadvantage, for its illumination is difficult to control. Many photographers prefer to use flood and spot lamps when circumstances permit. Their continuous light is easily adjusted so that the pattern of illumination—the brightness and location of highlights and shadows—can be manipulated to suit the subject. The equipment need not be elaborate—many bulbs have built-in reflectors to concentrate or spread the light, and inexpensive sockets to hold them are fitted with clamps that grip shelves or mouldings so that they can be placed where required. (In addition, it may be helpful to have a tripod to keep the camera steady in one position while lights are being arranged, a cardboard reflector to soften portrait illumination and eliminate shadows, and a lens shade to prevent the lamp's direct light from shining into the lens.) The basic techniques for deploying such lights are simple *(pages 204-213)*, and with practise one can learn to create pleasing illumination for indoor scenes and portraits.

Taking Advantage of Existing Light

ENRICO FERORELLI: *St. Peter's Cathedral, Rome,* 1978

In a world heavily dependent on artificial light, there is frequently enough of it already in use to take pictures by. So before a photographer puts in a flash bulb or sets up a floodlight, he should examine the scene carefully; by using the light that is available he may avoid fussing with equipment, he can judge how shadows and highlights fall—and he may get a picture that will look more natural and

authentic than one taken any other way.

The two pictures shown here demonstrate the point. Both of them capture the mood of a moment, which is largely created by the quality of the light.

In the picture above, an air of solemnity is created by a mixture of candlelight and overhead illumination bathing the altar of St. Peter's during a ceremony mourning the death of Pope Paul VI in 1978. This

mood is heightened by the type of colour film the photographer used: it is outdoor film, balanced to reproduce natural colours in daylight, which gives a warm, golden cast when used with artificial illumination. In the picture on the right, the impersonal look of a New York City subway is implied by the cold glare of fluorescent lights. In both photographs, the illumination itself becomes a key element of the picture.

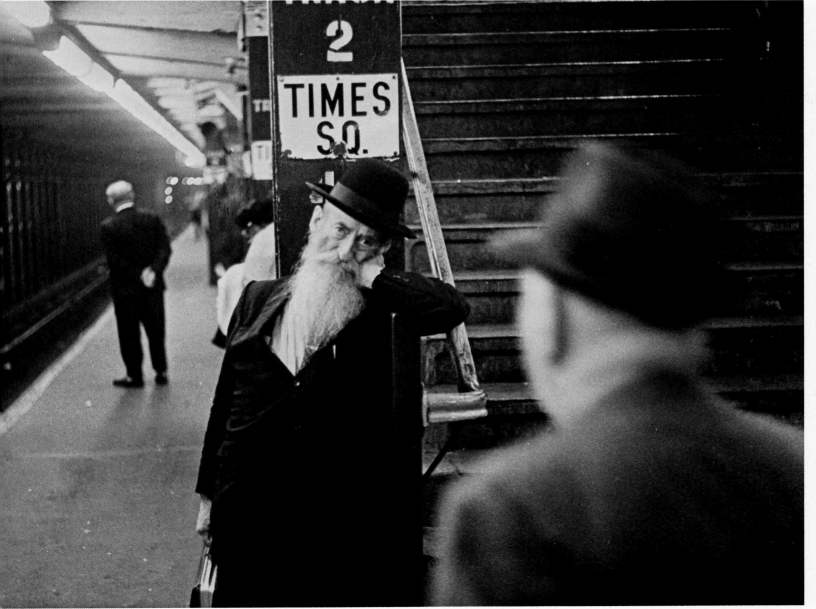

GARY RENAUD: *New York City Subway*, 1965

193

Six Ways to Use Flash

For most photographers, a simple flash unit—either bulb or electronic—mounted on top of the camera provides the easiest means for supplying necessary light. An adequately exposed picture depends on the power of the flash unit and the distance between the unit and the subject. The distance is easily measured; but determining the power of the flash is more complex.

To simplify this calculation, manufacturers assign each flash unit guide numbers that relate exposure to distance. To determine the proper f-stop required, divide the guide number by the flash-to-subject distance. For example, if the unit's guide number is 12 and the subject is 3 metres (10 ft) away, the correct aperture is f/4. Some units automatically time the flash to give correct exposure; with them, guide numbers are not usually needed.

Even when the correct calculations are made, however, flash pictures frequently come out flat and the subject appears two-dimensional, with details bleached out by the head-on burst of light (broad faces are made still broader looking). The fault lies not with the flash itself but with the way it is used.

More natural-looking pictures can be obtained by using such simple tricks as those demonstrated on the right. Raising the flash, covering it with a diffusing screen, bouncing some of its light off walls and adding a second or third flash all help to give a multi-directional quality to the light, creating the soft shadows, interesting textures and life-like depth that most people prefer.

1　Direct flash on camera: for the majority of photographers, especially when they want to catch a fleeting moment, this is the quickest and simplest method, but the light is often flat and uninteresting, producing few of the shadows or textures that add roundness and sparkle.

4　Bounced flash: for soft, natural-looking lighting, with good modelling of features, many flash units, whether on or off the camera, can be tilted so that the light does not reach the subject directly but is reflected off a white or light-coloured wall, as here, or a ceiling.

2 *Diffused flash on camera: for a softer effect, the harshness and intensity of the flash can be reduced by placing a diffusing screen or filter in front of the unit, or by simply draping a handkerchief over it. This is a particularly useful way of preventing glaring white features in close-ups.*

3 *Reflectorless flash: removing the flash reflector or, on some electronic flash units, attaching a bare flash tube lets the light radiate in all directions. Some light reaches the subject directly, but light reflecting off walls and ceiling helps to soften the effect, lightening shadows and adding depth.*

5 *Flash off camera: with a single light source, this is the best way to create appealing shadows and a three-dimensional feeling. The flash here is detached from the camera and held about 45 cm (18 in) above the camera and slightly to the right.*

6 *Multiple flash: this can give the subject maximum three dimensionality by making him stand out from the background. The main light here comes from an extension unit to the right; a second flash illuminates the background; a third, filtered, unit on the camera lightens facial shadows.*

Avoiding Common Mistakes with Flash

Ominous shadows give the subject a sinister appearance in this picture. To correct the problem, raise the flash above the camera. This will soften the unflattering facial shadows and reduce or completely conceal the distracting wall shadow.

Flash held high and close also casts unnatural shadows. These flaws can be eliminated by moving the flash lower and to one side.

A mirror behind the subject has caught the burst of the flash and thrown it back into the lens, causing a "hot spot". It could have been avoided by placing the flash at an angle to the mirror rather than shooting directly into it.

It is difficult, particularly for beginners, to tell how a picture made with flash will look until it is too late. The light's shadows and reflections are non-existent until the picture is actually snapped, and then they disappear so quickly they are hard to catch with the eye. Even shutter speed can affect the way flash records an image. The film catches all these effects, often with the results shown here.

Shadows are a particular problem, especially in close-ups of people, because they are very noticeable when a single flash is aimed directly at the subject (instead of being bounced off a reflecting surface). It is difficult to make shadows fall naturally unless the flash unit is removed from the camera and carefully aimed; this sometimes means that the flash must be mounted on a separate stand, or that one person must hold the flash while a second works the camera.

Unexpected reflections of the flash itself frequently pop up from shiny surfaces: metal, windows, a mirror, the polished surfaces of furniture or panelled walls. If the subject wears glasses, these may be a problem; they should be tilted slightly downwards.

Flash illumination for colour film requires special precautions against "redeye", a reflection of the flash from the blood-rich retina inside the eye *(far right)*.

When the subject moves and strong available light combines with flash during an exposure of more than 1/30 second, a half-sharp, half-blurred double exposure occurs. The part of the subject primarily lit by the brief flash burst will be sharp; other parts primarily lit by the available light will blur. Only the image frozen by the flash will be recorded if the camera is set for synchronization; at that shutter speed too little available light enters to have any effect.

Shutter speeds faster than the camera synchronization setting produce partial pictures like this because the camera shutter then uncovers only part of the image area at the instant the flash fires; the area uncovered before or afterwards goes unrecorded. Such fast settings are unnecessary, for the flash burst lasts such a short time it freezes almost any motion.

The scarlet pupils mark this subject as a victim of "red-eye", a common defect in colour portraits. It can be avoided by detaching the flash unit from the camera and moving it farther from the lens or by asking the subject to look away. Either technique will prevent the interior of the subject's eyes from reflecting the flash directly into the camera.

Balancing Flash and Available Light

All flash units have a limited range. When flash exposure is correct for a nearby subject, its light will scarcely illuminate anything beyond it. The background will be under-exposed or will disappear altogether unless some other light source illuminates it as brightly as the flash does the subject—a condition seldom met.

The disappearance of unattractive or distracting details in the background is sometimes welcome, but they often add interest and a sense of naturalness to a flash exposure. By taking separate light-meter readings of the subject and the background, and by carefully controlling shutter speed, the photographer can balance flash and available light to preserve the background detail.

In the picture on the right, the subject and her immediate surroundings are properly exposed, but the background is a black void. A 1/60 second shutter speed was too brief for the late afternoon sun outside to affect the slow film in the camera.

For the picture on the opposite page, the photographer used the same flash exposure but slowed the shutter speed to 2 seconds—enough time for the light outside to record the urban background that enlivens the portrait. The subject was asked to hold still during the exposure to avoid a blurry ghost image, and the camera was on a tripod.

A flash exposure made with the aperture set at f/5.6 and a shutter speed of 1/60 second—the proper synchronization speed for the camera's flash—recorded the figure in the foreground correctly but was too fast for light outside the window to expose the building across the street.

To show both subject and background, the photographer used the same flash set-up and lens aperture that he used for the picture on the left, but he took meter readings of the subject and the light outside the window and adjusted the shutter speed accordingly. A 2-second exposure was long enough for the available light outside to register background details but not so long that the room light, added to the flash, could over-expose the subject.

The Special Virtues of an Electronic Unit

Because the electronic flash makes it unnecessary to change bulbs after each shot, convenience is its most obvious asset. But it also offers a number of other advantages as a source of artificial light for the amateur as well as the professional photographer. Such units eliminate the need to halt to recalculate exposure as a subject moves closer or farther away— they gauge the light that is reaching the subject, near or far—and thus make possible correctly exposed shots of wide-ranging activity.

Most of the units recycle or regenerate themselves for another flash, in a matter of seconds, and those that also control exposure automatically can be used to take a series of pictures in rapid sequence—such as the fast-changing expressions and activities of children at play in the sequence on the right. The burst of light from an electronic flash is so brief—1/1,000 second or less in the average unit—that it is not only less likely to startle or annoy subjects, but it also freezes all but the fastest motion regardless of the shutter speed that is used.

In addition, the colour of the light produced by an electronic flash is an important virtue. It is very similar to that of daylight, which means that it provides natural-looking results with daylight-type colour film *(right)*. However, with automatic flash units, colour negative film has an advantage over slide film, especially at distances closer than 75 cm (2½ ft). At close range, the automatic control cannot shut off the flash fast enough, resulting in slight over-exposure. With negative film, colour corrections can be made during processing; with slide film, no such correction is possible.

A child shows off briefly for the camera in the midst of lively play. The photographer was able to capture the moment, despite the child's quick movement towards and away from the camera, because his automatic electronic flash instantly altered its output for proper exposure.

A sequence of pictures of two children testing the qualities of a soft sofa was taken with an electronic flash, which recycled quickly enough to permit shots to be fired in rapid succession. The duration of each flash was so short that even such fast action as the jump shown in frame 15 is perfectly frozen on film.

Floodlighting and Spotlighting

For quick, candid pictures in dim light, flash is the most convenient form of artificial lighting. But when a photograph can be staged—even informally in a corner of a room—a combination of floodlights and spotlights permits much more precise control over the result. Their continuous light can be turned on or off at will, making it possible to observe immediately the effects different lights and their placement actually produce and to control these effects by moving lights and reflectors around until the illumination is satisfactory. Proper exposure is determined easily and exactly with a light meter.

Floodlights and spotlights come in a variety of forms, including inexpensive

bulbs with built-in reflectors that eliminate the need for heavy equipment. The one used most frequently is the floodlight, which, as its name suggests, casts a wide beam of light and can be used as general lighting for most subject matter, from room interiors to close-up portraits, like that of the cat on the opposite page. A spotlight throws a concentrated beam, producing smaller, sharper highlights, darker, harder-edged shadows and a more dramatic effect. Although it can be used effectively as the sole light source, as in the picture above, it is generally an adjunct to floodlights, employed either to emphasize a feature of the subject or to add a bright accent to a background or a person's hair.

Directing Light for Effect

1 Front lighting: with the light placed at the camera position (and very slightly to the left), the illumination is straight, even and fairly flat, leaving thin, uninteresting shadows to the right of the nose and on the right side of the face.

2 Under lighting: when the light is aimed upwards, the subject's face assumes unnatural shadows and a faintly evil look. In special circumstances this kind of lighting can be put to use to give the picture an aura of mystery.

3 High side lighting: a main light aimed at about 45° to the subject has long been the classic angle for portrait lighting, one that seems most natural for the majority of people. It models the face into a three-dimensional form.

In this series of six pictures of one man, the position of the main light source—floodlight or flash—influences the character of the image. For an actual portrait, a photographer would probably not use any of these single-light positions alone (and would probably not use the extreme lighting of positions 2 and 4 at all); normally he would add reflectors or secon-dary lights to brighten shadows and create livelier detail for a more balanced effect, as shown on the following pages.

Nevertheless, one principal source for light is usually needed because we are accustomed to seeing things illuminated in this way by the sun, or by windows or lamps. If, in a picture, there are two or three equally important sources of illumi-nation, arranged so that shadows and lights will criss-cross in all directions, the result is visually confusing.

Since natural light usually comes from overhead, this is a logical location for the main source of artificial light. But very slight changes in the angle of illumina-tion can drastically alter the overall result, and the exact position of the main source

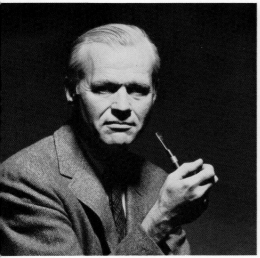

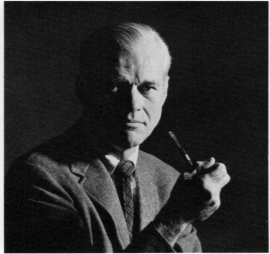

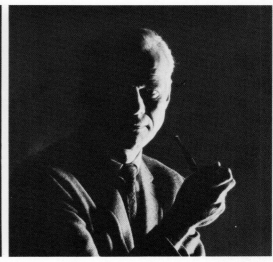

4 Top lighting: a light almost directly above the subject creates deep shadows in the eye sockets and under the nose and chin. In practise the light would be moved forwards to lessen contrasts and illuminate the eyes.

5 Side lighting: sometimes called "hatchet" lighting because it appears to split the subject in half, this type of lighting can be useful in emphasizing rugged masculine features or in revealing the texture of skin or fabrics.

6 Side-rear lighting: a light to the side and slightly behind the subject yields an even more dramatic effect. If the light were directly behind, it would bring out the shape or silhouette of the subject and turn the hair into a halo.

depends both on the subject and on the kind of interpretation to be given it.

For a striking photograph of a pretty young woman, some professionals would use high front lighting—a cross between the positions shown in pictures 1 and 4—because it provides straight-on, even illumination that results in an overall bright softness (especially if a diffusing screen is placed over the bulb) and it is also high enough to produce sculptured shadows under the eyebrows, cheekbones, lips and chin. For a woman who has less than perfect features, however, such shadows may be unflattering; they can be subdued with a secondary light source or partly eliminated by shifting the position of the main source down or sideways.

While overhead lighting usually gives a natural quality, side and low-angle lighting suggest mystery or drama just because they seem unnatural. A portrait of a weather-beaten old man, for example, can be made expressive with side lighting—the positions shown in pictures 5 or 6—to bring out the line of a nose or chin, or the wrinkles that lend character.

Suiting the Film

Controlling contrast between highlights and shadows can make the difference between an ordinary and a dramatic portrait. Contrast is adjusted by altering the amount of light striking different parts of the subject, but the photographer must ensure that the level of contrast he creates suits both his subject and his film.

The two sets of pictures on the right show how changing the amount of "fill" light that reaches the shadows on the subject can alter the quality of the portrait. Each of the sequences begins with identical flash units at the same distance from the subject; the right side of the face is illuminated by both lights but the left side only by the fill light, so there is twice as much light on the right side as on the left—a lighting ratio of 2 to 1. For each succeeding portrait the amount of fill light reaching the subject has been reduced by moving the flash farther away to achieve higher ratios and greater contrast.

The 2 to 1 ratio produces flat, unattractive pictures in both black and white and colour. The subject's hair and skin are inherently low in contrast and require a higher lighting ratio to add drama and sparkle. The 4 to 1 ratio, common for portraits, gives better modelling of facial contours, and the 6 to 1 ratio, especially in colour, produces dramatic contrast and highlights in the hair with a minimal loss of shadow detail. At a ratio of 16 to 1, black-and-white film gives exaggerated yet acceptable contrast, but colour film leaves the left side of the face unacceptably dark.

Each of these sets of portraits was shot with identical flash units placed as indicated in the diagrams, in which a cylinder represents the subject's face. Light from both units reaches the right side of the face but only the fill light (below the cylinder) illuminates the left. As the fill light is moved farther away, the lighting ratio changes and contrast between highlights and shadows increases.

2:1 lighting ratio

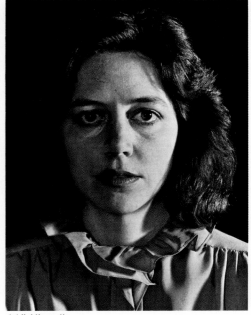

4:1 lighting ratio

2:1 lighting ratio

4:1 lighting ratio

6:1 lighting ratio

8:1 lighting ratio

16:1 lighting ratio

6:1 lighting ratio

8:1 lighting ratio

16:1 lighting ratio

Modifying Light with Reflectors

Although great pictures have been taken with a single flood, flash or spotlight, most artificial lighting needs some modification to reduce harsh contrasts, bring out details otherwise lost in dark shadows and separate the subject from the background. The simplest, least expensive and frequently the most effective way of doing this is to use a reflector to bounce the main light into areas where it is needed.

Reflectors come in many shapes, sizes and materials. All that is usually needed, however, is what photographers call a "flat": a piece of stiff cardboard, about 40 x 50 cm (16 x 20 in), with a soft matt white finish on one side. The other side can be covered with kitchen aluminium foil that has first been crumpled and then partially smoothed flat. The white side will give a soft, diffused, even light suitable for lightening shadows in portraits, still lifes and other subjects. The foil side reflects a more brilliant, "harder" light that tends to pick out surface textures.

No reflector: a single floodlight is positioned in front of the sculptured head, above and to one side of it (small photograph above). The light reveals rounded contours but leaves the right side of the face hidden in dark shadow.

White reflector: a flat piece of white matt cardboard has been placed to the right of the head, held in a clamp stand and angled so that the light bounces back into the shadow areas on the right cheek and chin to lighten them.

Aluminium reflector: when the foil side of the same reflector is turned towards the light, the many facets of its crinkled surface bounce a harder, more sparkling light that reveals both the shape and the texture of the head.

A Simple Studio for Flattering Portraits

An attractive colour portrait generally requires soft, diffused illumination. Direct lighting emphasizes sharp contrasts and deep shadows that are particularly unflattering in a colour picture. Diffused lighting softens or eliminates shadows and has the effect of smoothing skin and features *(far right)*.

Soft lighting does not require an elaborate or expensive studio set-up. Both portraits reproduced here were made with modest equipment: a 35 mm SLR camera with a 105 mm lens and an automatic electronic flash unit. But while the deeply shadowed portrait on the right was shot with the flash aimed directly at the subject, the one on the far right was made with light bounced towards the subject from an umbrella reflector, a simple device that has long been a favourite tool of professional portrait photographers.

Umbrella reflectors resemble familiar rain umbrellas, but the fabric has a highly reflective white or silvered coating. When a flash or floodlight is aimed at the centre of the umbrella, the light is reflected back towards the source but rebounds in many directions from the curved inside surface of the umbrella. This spreads and softens the light that reaches the subject.

For portraits, diffused umbrella light is usually directed towards the subject from one side; a white cardboard reflector positioned on the opposite side bounces some illumination back towards the subject to fill in shadows.

A handy accessory when lighting portraits with flash is a modelling light, a 150-watt lamp used only to prepare for the shot. Its light, although not powerful enough to affect the exposure, can be aimed in the same direction as the flash to indicate where highlights and shadows will fall during the exposure.

Direct flash, used for this picture, produces such dark shadows and harsh contrasts that it is seldom employed alone for portraits.

An umbrella reflector, a flash aimed into the umbrella, and a sheet of white cardboard soften light for a pleasing colour portrait. Some umbrella light bounces off the card (right) to fill shadows. A small "modelling" light on top of the stand was aimed, like the flash, into the centre of the umbrella to aid in positioning the flash and reflectors.

This improved portrait results when the set-up on the left is used. Strong dark shadows are gone, and the tones of skin, hair and clothing are softened.

Building Effects by Adding Lights

It takes more than a simple set-up to do justice to a complex subject such as the ballerina executing a *croisé en avant* on the right, her arms outstretched, her head turned down, her skin contrasting sharply with a costume that almost matches the background. To give each part of such a scene the brightness it needs, most professionals build up a system of several lights, each of them carefully arranged to serve a specific purpose.

First the direction, type and intensity of the main light is decided on. In this situation, the photographer planned his composition around the linear pattern formed by the dancer's arms, legs and neck; a 500-watt floodlight, placed high and to the front right, successfully delineates all parts of this design except the upraised left arm. That essential is added with a diffused 500-watt fill light angled downwards from the front left. The second lamp also lightens the dark shadows cast by the first one, so that the ballerina's face, throat and legs appear in rounded detail. But she still seems a cardboard figure.

A 500-watt spotlight, placed high and to the left rear of the dancer, picks out highlights in her hair and on the upper edges of her arms and legs to suggest depth, and also casts a clear shadow perpendicular to her body to emphasize horizontal and vertical dimensions. Finally, to orient her in the space included in the picture, a fourth light—a 500-watt spotlight—is placed to the right and behind her to illuminate the backdrop. □

one light: pattern established

two lights: composition completed

three lights: depth added

In the first picture (opposite page, top), the photographer placed the main light on the stand 2.1 metres (7 ft) off the ground. The second, or fill, light (opposite, bottom) was placed at the same level as the camera, about 1.2 metres (4 ft) from the ground. The third, or accent, light (left, top) was placed high and to the left behind the dancer about 2.1 metres from the ground. The background light (left, bottom), used to separate the subject from the background, was also set at a height of 2.1 metres.

four lights: three dimensions created

Wizardry with Flood and Flash

Modern sophisticated lighting equipment can illuminate a whole stadium for a night shot or stop runners in their tracks. It can also create a surrealistic realm in which concepts of time, motion and space acquire new meanings, and even the contours of a head *(opposite page)* reveal a unique view of man.

This picture resulted from a far-out aspect of space flight research. In 1954, when America's space programme was still in its infancy, *Life* photographer Ralph Morse spent 11 weeks with engineers from the U.S. Air Force, photographing their various efforts to prepare men for survival in a weightless environment.

In one experiment to develop designs for flight helmets, the engineers were using a "contourometer", an instrument that measured the head and facial contours of large numbers of men. The device, which resembled a huge metal staple (visible at the top of the photograph), had a narrow slot on its inner surface through which a pulse of light flashed at intervals on each subject's head; as the rig moved from front to back, these stripes of light outlined contours that could be recorded by a camera for measurement.

Morse wanted to capture the bizarre overall effect, but he realized that the light emitted during normal operation, although adequate for records, was too weak to make a dramatic picture. He loaded the fastest film available into a twin-lens reflex camera, set it on a tripod, darkened the room and opened the shutter for a time exposure. Then he moved the rig over one man's head, a centimetre at a time, permitting it to flash several times in each spot to build up the exposure. However, despite these efforts, the first try was badly under-exposed.

"We kept shooting and developing until we finally got one that had enough exposure," says Morse. "It took six flashes in each spot to register the light properly." The resulting photograph showed a strangely striped man who seemed to be the very embodiment of the eerie, unknown world that the first astronauts were soon to enter.

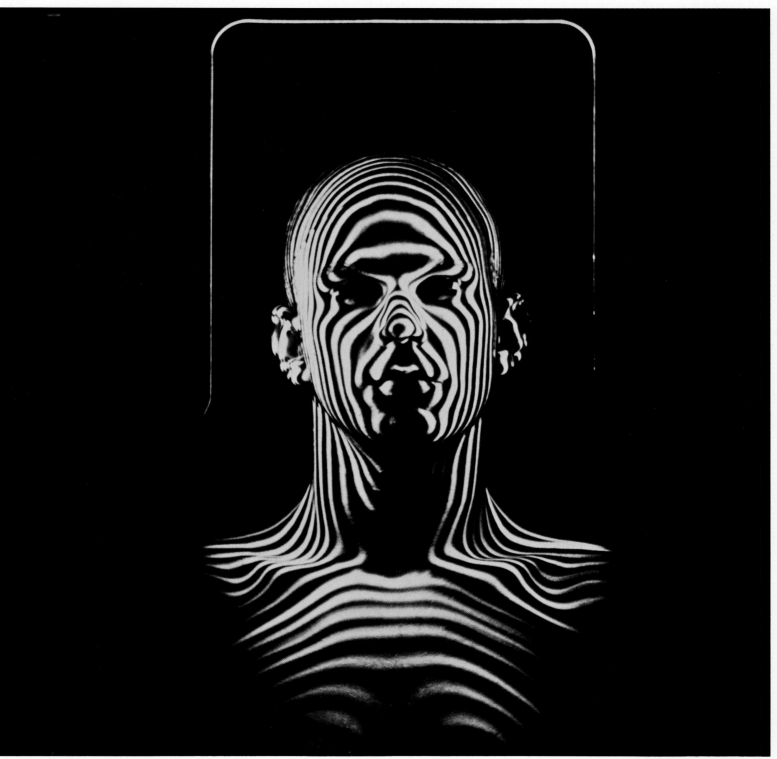

RALPH MORSE: *Space-Age Man,* 1954

A Whole Race at a Glance

While covering an athletics' meeting in Madison Square Garden in New York City, Ralph Morse hit on the idea of using a triple exposure of the 55 metre (60 yard) sprint to show the beginning, middle and end of the race—all in a single photograph that would stretch time to make separate instants appear simultaneous.

To get the picture, Morse set up three pairs of electronic flash units. One pair was placed to illuminate the start, the second the mid-point, the third the finish. But if all three pairs went off together each time the shutter was clicked, as they would if hooked up by a standard circuit, the successive flashes would bleach out the images of the runners.

To solve this problem, Morse made a special circuit-breaking switch that permitted him, with the help of an assistant, to operate each pair of lights independently of the others. The assistant was to set the switch to connect only the first pair just as the runners took off, then to switch to the second pair before they crossed the mid-point and finally to switch again to the third pair as the winner neared the tape. That way only one pair of lights would flash each time Morse pressed the camera's shutter release.

Having rigged his lights and wiring, Morse climbed up with a 12.7 x 17.8 cm (5 x 7 in) view camera on to a specially built platform above the track. Using sheet film rated at ISO 250/25°, he set his shutter at 1/400 second, his aperture at f/11 and tilted his adjustable lens mounting, changing the optical perspective to keep the parallel track lines from converging too sharply.

Morse needed reflexes almost as quick as those of the sprinters, since he had to press his shutter three times within the 6.2 seconds the race took—and precisely at those instants when the runners came within the range of each battery of lights. His timing was virtually perfect, as the photograph on the right shows.

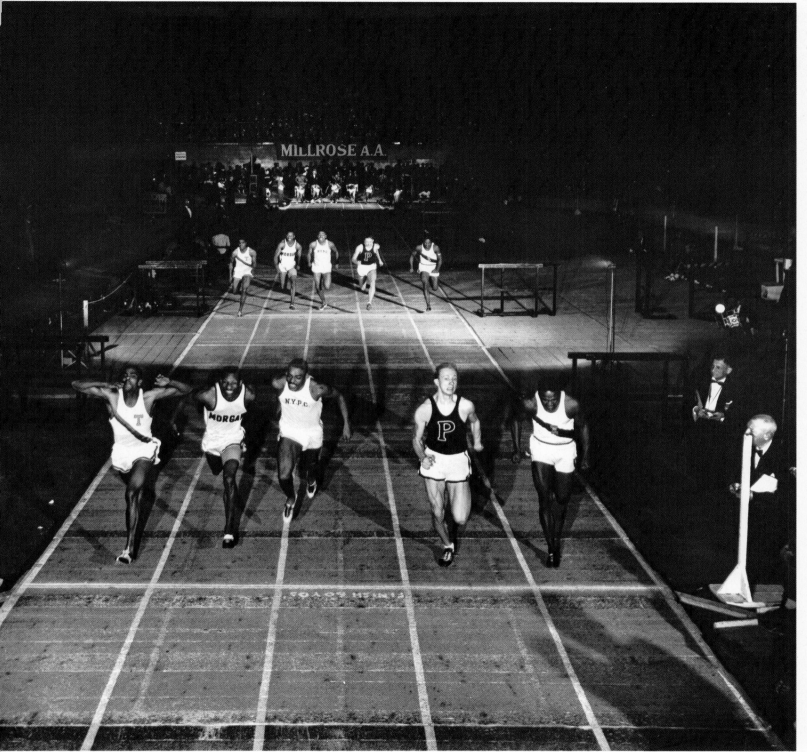

RALPH MORSE: *Sixty-Yard Dash, Madison Square Garden, New York City,* 1956

Syncopated Strobes

Assigned by *Life* to capture the flying feet of virtuoso tap dancer Gregory Hines, lighting expert Enrico Ferorelli used repeated strobe flashes pulsing to the beat of the dancer's music to create an exciting multiple exposure. A 5.5 metre (18 ft) long stage, specially constructed in a studio, was the background. To light the shot, an electronic flash unit was set for repeated firing by adjusting its power output to recycle and fire about twice a second—in time with the beat of Duke Ellington's "Sweet Mama", the music Hines would be using for his dance.

Supplementing the syncopated strobe were three other units that were automatically triggered by the flash from the main light. The four were arranged in pairs at each end of the stage. A fifth flash, not linked to the others, was equipped with a special attachment that focused the burst like a spotlight.

There were a few days of practice with a stand-in, after which the final shooting went quickly. Ferorelli worked with a 20.3 x 25.4 cm (8 x 10 in) view camera and a normal lens—300 mm for this camera—set at f/11, and used slow colour slide film. He started the music, and, as Hines danced from left to right across the enclosed stage, the photographer opened the shutter and started the strobes blinking. The shutter stayed open about 4 seconds.

Of the 18 pictures shot during the session, this one is Ferorelli's favourite. In it, the dancer's feet are clearly tapping to the beat. The four synchronized strobes were used for all but the last image; for that one the spotlight strobe recorded a final head-back view.

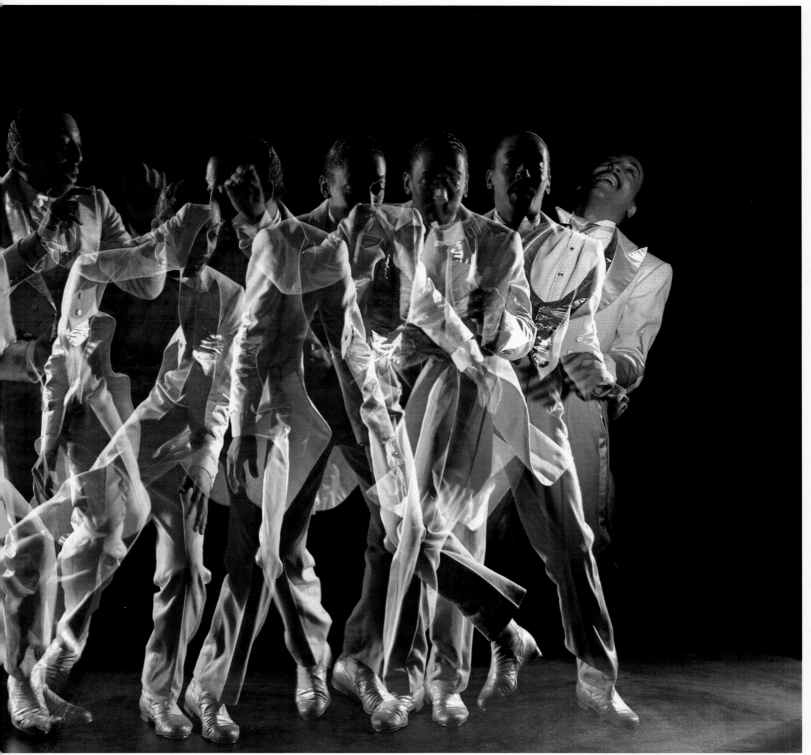

ENRICO FERORELLI: *Gregory Hines, New York City,* 1981

Lighting for a Knockout

Suddenly the fight was over. Half way through the first round in Lewiston, Maine, heavyweight challenger Sonny Liston lay motionless on the canvas. Towering above him in the referee's restraining embrace was the young, scornful champion Muhammad Ali, taunting his opponent to get up and fight. The famous knockout happened so fast that most of the crowd, including many of the ringside photographers, never even saw the shattering punch that put Liston down. But Neil Leifer of *Sports Illustrated* magazine, anticipating a knockout—although not necessarily of the favoured Liston—had been preparing for such a moment for several days.

Leifer's motorized 35 mm SLR camera was mounted on the framework holding the floodlights directly above the ring (the announcer's microphone can be seen at the centre dangling from the same framework). The camera was equipped with an 8 mm fisheye lens to take in a field of 180°. Leifer's main problem was to provide enough light to cover the crowd and to permit the fast shutter speed needed to freeze the swift central action. He had assembled a set of 40 electronic flash units to supplement the arena's light system. Several flash units were mounted on the framework with the camera; others were hung from the arena's ceiling.

Leifer chose his moment carefully, because he had to wait 25 to 30 seconds between exposures for the lights to recharge. He chose well. While shooting close-ups with another camera at the ringside 46 metres (150 ft) below, he got an assistant to trip the shutter by remote control to catch one of the most dramatic moments in modern ring history.

NEIL LEIFER: *Victor and Vanquished, Lewiston, Maine,* 1965

Blending Natural and Artificial Light

In the pictures shown here, photographer Arnold Newman balanced natural light and artificial light to achieve two quite different effects. For a portrait of German industrialist and wartime arms manufacturer Alfried Krupp von Bohlen und Halbach, Newman sought to suggest the dark career of a man who was convicted of war crimes for collaborating with the Nazis and was imprisoned for 12 years. He posed Krupp in one of his factories. Daylight filtered in through grimy skylights, and two spotlights (fitted with blue filters to match their colour with that of the daylight) were placed low to cast harsh shadows on Krupp's face.

To heighten the effect of the lighting, Newman took advantage of a characteristic of daylight colour film—the tendency of its colour rendition to be altered by a long exposure time. The dim illumination called for an exposure of more than a second. This was enough to produce a greenish cast in the skin, adding to the ominous aura.

Newman's more flattering portrait of American architect Louis Khan *(opposite)* posed another delicate exercise in balancing light. Newman wanted to show Khan against both the interior and exterior of his glass-walled art gallery at Yale University and decided to shoot the picture at dusk when the inside lights were on but the fading rays of the sun still lit the façade.

Newman chose indoor-type colour film, which is colour-balanced to suit both the colours emitted by the incandescent lights of the building and the two spotlights used to illuminate the architect's face. It is not colour-balanced for daylight, however. The result was a face warm and natural against the cool, blue-tinged background lit by rays of the fading sun.

ARNOLD NEWMAN: *Alfried Krupp von Bohlen und Halbach, Germany,* 1963

ARNOLD NEWMAN: *Louis Kahn, Connecticut,* 1964

Total Lighting

During the 1950s and 1960s, *Life* magazine spared no effort in covering a big story, even if the assignment required lighting the whole of Yankee Stadium for just a single shot. Such elaborate measures have become rare, partly because of cost and partly because new fast colour film eliminates the need for such lighting.

Even the fastest film, however, could not have made possible these two examples, shot in New York City within hours of each other during the 1965 visit to the United States of Pope Paul VI. Both took days of preparation and more equipment than even *Life's* lavishly stocked photographic supply room had on hand.

For a colour picture of the Pontiff's entrance into the vast, dim interior of St. Patrick's Cathedral, Yale Joel positioned 50 large portable electronic flash units round the upper gallery of the church to create enough illumination to record the historic moment *(right)*. However, his use of almost all of *Life's* equipment meant that the next great event, a mass held at Yankee Stadium, would have to be lit in some other way.

Ralph Morse, who was given the Stadium assignment, could count on plenty of illumination at the centre of the scene, because the television networks had focused their powerful beams on the altar. However, he wanted to include a sizeable portion of the 90,000 onlookers in the picture as well, so he had to supplement the television and stadium lights with floodlights which were aimed at the crowd.

To balance the intense light at the centre of the stadium, Morse used more than 100 rented lights, mounted above the crowds in the dark areas of the balconies. The result dramatically conveyed the spectacle of thousands of worshippers being led by the Pope in prayer.

YALE JOEL: *Pope Paul VI Entering St. Patrick's Cathedral, New York City,* 1965

RALPH MORSE: *The Papal Mass at Yankee Stadium, New York City,* 1965

Balancing Light in Two Worlds

Life photographer George Silk needed both ingenuity and luck to get this remarkable view of two forms of wildlife sharing a stream in Montana. He set up near the stream to photograph rainbow trout with a camera mounted in a partially submerged box with a glass front *(diagram below)*. But soon after he began work he noticed that a fawn came to drink from the stream every day late in the afternoon. He immediately saw the potential for an extraordinary photograph that would show fish and deer together.

The light in the underwater realm of the trout, however, was far dimmer than that in the sun-splashed world above. In order to achieve a balance, Silk set a single-electronic flash unit beside the stream and aimed it down on the water. He put it close enough to the surface to make the illumination that was cast underwater match the quality of the daylight at the hour of the deer's visit.

Finally, after weeks of on-and-off waiting, the lighting conditions and the animal participants came together. With fast colour slide film in a 6 x 6 cm (2¼ x 2¼ in) SLR camera, the shutter set at 1/60 second and the lens at f/22 (for maximum depth of field), Silk was ready. He recalled, "The fawn was a perfect actor—he walked over to the stream, drank and looked around, and I had time to take several shots before he disappeared."

electronic flash unit

camera enclosed in
glass-fronted box

GEORGE SILK: *Fawn and Trout, Montana*, 1961

Capturing a Laser's Own Light

In the early 1960s, the editors of *Life* magazine assigned Fritz Goro to do a story on the laser beam, then just beginning to attract public attention for its potential in fields as diverse as communications and surgery. Laser light, unlike ordinary light, disperses relatively little, even over long distances, and therefore can be directed with pinpoint accuracy. This precisely focused energy is now routinely used in eye operations to weld detached retinas into place, a technique that was perfected through experiments with animals.

When Goro decided to photograph a rabbit undergoing such an experimental operation, the scientists involved said the task was virtually impossible because of the difficulty in capturing the laser beam itself on film. Their laser consisted of a rod, made of synthetic ruby, that emitted a thin beam of red light when struck by the white light of an electronic flash tube. The beam lasted only a few thousandths of a second and Goro found that it could not be seen under normal laboratory light conditions. However, he knew the laser beam could be made visible by passing it through a field of smoke—if the smoke was of exactly the right density.

Goro had a special box constructed *(diagram below),* to contain the rabbit and the smoke. He generated smoke by burning briquettes of incense, and then fed this into the chamber with a tiny blower. After dozens of test exposures, Goro found the right combination of film (fast indoor colour transparency film), aperture (f/8), and smoke density. The result, seen on the right, was one of the first photographs ever taken of a laser in action.

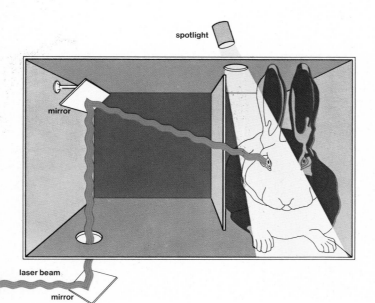

spotlight

mirror

laser beam

mirror

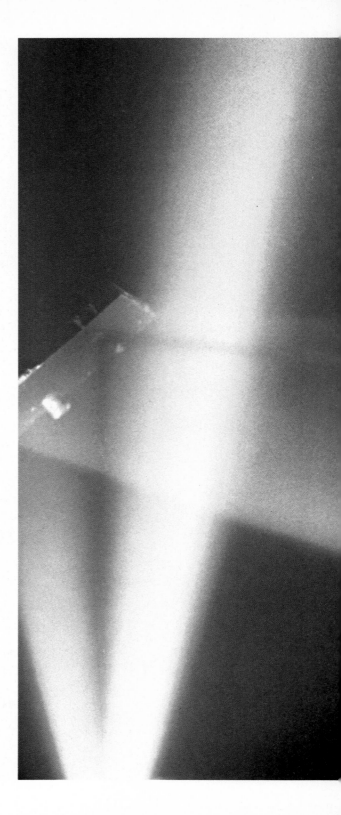

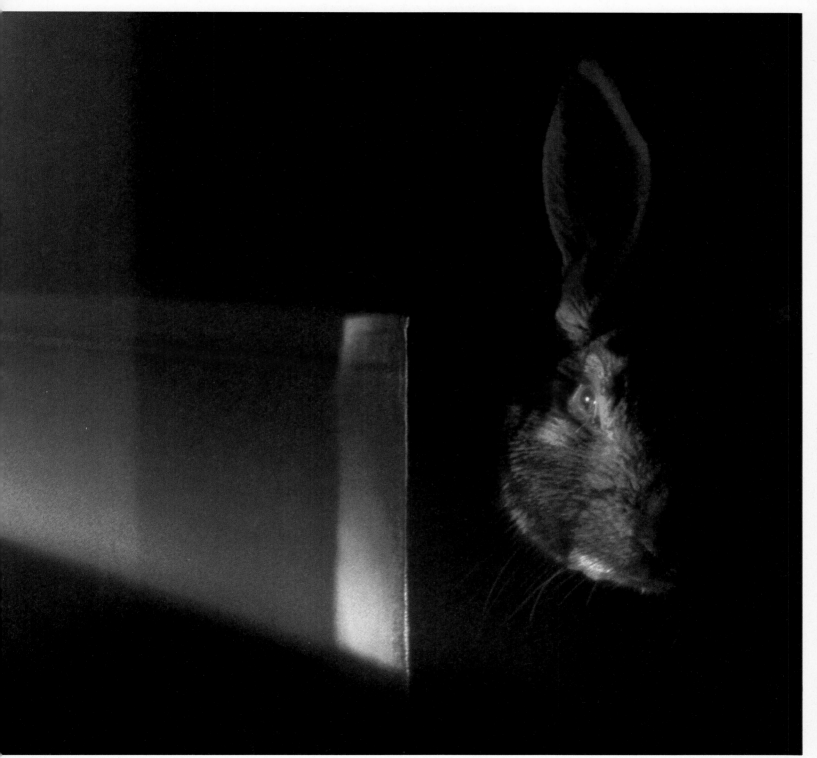

Artificial Light: Flood and Flash
Painting with Light

Any photographer who has left a shutter open at night to capture the swirling patterns of exploding fireworks or speeding cars has made use of the camera's ability to trace the movement of a point of light during a long exposure. It is this capability that has inspired imaginative photographers to transform light tracings into dazzling works of art.

The fanciful centaur limned by Pablo Picasso *(right)* exists only on film. The artist traced it in total darkness with a bare torch bulb connected by wires to some batteries, while Gjon Mili stood by with an open shutter until Picasso was almost finished. Only then did he trigger a flash to illuminate the artist and freeze him at the end of the downstroke that completed his light drawing.

Photographer Eric Staller created the mysterious display of curves and rectangles on the opposite page. He began by building a window-sized plastic frame studded with tiny Christmas tree lights. Then, working at night in a New York City schoolroom, he got an assistant to hold the frame against one of the room's windows; as the photographer opened his camera shutter the assistant turned on the lights, lowered the frame to the floor and turned the lights off again. He repeated the procedure at each window.

To avoid even the slightest vibration, Staller did not touch the camera throughout the 5-minute exposure, leaving the shutter open the entire time; the light from the windows was so dim that the movements of his assistant from window to window went unregistered on the film.

GJON MILI: *Centaur by Picasso, Vallauris, France,* 1949

ERIC STALLER: *Window Dressing, New York City,* 1979

231

Computer Composition

The intriguing pattern of shapes and colours in the picture on the right is the creation of photographer Ben Rose, a master of multiple-image photography who devoted the last years of his career to perfecting the complex programming required to convert the computer into a useful photographic tool.

This picture, one of a series that Rose executed for advertisements for a lift company, required a programme of 29 steps in a specially devised computer code called PISCAL—Photographic Interface System Computer Language. Some of the steps controlled the lighting. Other commands activated motors that tilted, panned or zoomed a tripod-mounted 35 mm SLR equipped with a 50-300 mm zoom lens.

The three elements of the picture—a ring, a box and a woman's silhouette recorded on photographic film—were arrayed in a semicircle before the camera. As the camera performed its computer-directed acrobatics, seven separate exposures were recorded on a single frame of film. These included shots of the ring at several distinct focal lengths as well as in mid-zoom, then the box, shot while zooming and at two focal lengths, and finally the silhouette.

The computer-controlled strobe units flashed on cue when Rose wanted a frozen image, such as the silhouetted dancer, and the floodlights were turned on when he wanted the blurred image produced by a zoom lens in motion, as in the wide red band surrounding the figure. It was a *tour de force* that, if accomplished manually, might have exhausted a skilled crew. But Rose did it with his computerized camera and only one assistant in 14.3 seconds. □

BEN ROSE: *Box, Ring and Woman, New York City.* 1979

Bibliography

General

Carroll, B. H., G. C. Higgins and T. H. James, *Introduction to Photographic Theory*. John Wiley & Sons, 1980.

Feininger, Andreas, *The Creative Photographer*. Prentice-Hall, 1955.

Focal Press, Ltd., *Focal Encyclopedia of Photography*. 1978.

Neblette, Carroll B., *Photography: Its Materials and Processes*. Van Nostrand Reinhold, 1977.

Rhode, Robert B., and Floyd H. McCall, *Introduction to Photography*. Macmillan, 1965.

Sussman, Aaron, *The Amateur Photographer's Handbook*. Robert Hale, 1974.

History

Darrah, William Culp, *Stereo Views: A History of Stereographs in America and Their Collection*. Times and News Publishing, 1964.

*Eder, Josef Maria, *History of Photography*. Columbia University Press, 1945.

Gardner, Alexander, *Gardner's Photographic Sketch Book of the Civil War*. Dover Publications, 1971.

Gernsheim, Helmut, *History of Photography*. Thames & Hudson, 1969.

Gernsheim, Helmut, and Alison, *L.J.M. Daguerre: The History of the Diorama and the Daguerreotype*. Dover Publications, 1969.

Newhall, Beaumont:
 The Daguerreotype in America. Dover Publications, 1977.
 The History of Photography from 1839 to the Present Day. The Museum of Modern Art. Secker & Warburg, 1973.

Pollack, Peter, *The Picture History of Photography*. Thames & Hudson, 1977.

Shipman, Carl, *Understanding Photography*. H.P. Books, Tucson, Ariz., 1974.

†Taft, Robert, *Photography and the American Scene*. Dover Publications, 1965.

Biography

Barnett, Lincoln, *The Universe and Dr. Einstein*. William Sloane Associates, 1948.

Gernsheim, Helmut, and Alison, *Roger Fenton, Photographer of the Crimean War*. Secker and Warburg, 1954. U.K. Distributor: Art Book Company, London.

Horan, James D.:
 Mathew Brady, Historian with a Camera. Crown Publishers, 1955.
 Timothy O'Sullivan, America's Forgotten Photographer. Doubleday, 1966.

Jackson, Clarence S., *Picture Maker of the Old West, William H. Jackson*. Scribner, 1947.

Special Fields

Adams, Ansel:
 Polaroid Land Photography Manual. Morgan & Morgan, 1963.
 The Negative. New York Graphic Society, 1978. U.K. Distributor: Hutchinson Publishing Group Ltd., London.

Eastman Kodak:
 †*Applied Infrared Photography*. Eastman Kodak, 1968.
 **Color as Seen and Photographed*. Eastman Kodak, 1972.
 †*Kodak Color Films*. Eastman Kodak, 1980.
 †*Kodak Professional Black-and-White Films*. Eastman Kodak, 1976.
 †*Professional Portrait Techniques*. Eastman Kodak, 1980.

Eaton, George T., *Photographic Chemistry*. Morgan & Morgan, 1965.

Eynard, Raymond A., ed., *Color: Theory and Imaging Systems*. Society of Photographic Scientists and Engineers, 1973.

Feininger, Andreas, *Successful Color Photography*. Prentice-Hall, 1966.

Hackforth, Henry L., *Infrared Radiation*. McGraw-Hill, 1960.

Jacobs, Lou, Jr., *Electronic Flash*. Amphoto, 1971. U.K. Distributor: Patrick Stephens Ltd., Cambridge.

James, Thomas H., ed., *The Theory of the Photographic Process*. Macmillan Publishing Co., 1977.

*Logan, Larry L., ed., *The Professional Photographer's Handbook*. Logan Design Group, Los Angeles, Calif., 1980.

Massy, H. S. W., and R. L. F. Boyd, *The Upper Atmosphere*. Philosophical Library, 1958.

Mees, C. E. Kenneth, *From Dry Plates to Ektachrome Film*. Ziff-Davis, 1961.

Mees, C. E. Kenneth, and T. H. James, *The Theory of the Photographic Process*. Macmillan, 1966.

Mueller, Conrad G., and Mae Rudolph and the Editors of Time-Life Books, *Light and Vision*. Time-Life Books, 1969.

*Nadler, Bob, *The Color Printing Manual*. American Photographic Book Publishing Co., 1978.

Newhall, Beaumont, *Airborne Camera, The World from the Air and Outer Space*. Focal Press, 1969.

Smith, Alpheus W., and John N. Cooper, *Elements of Physics*. McGraw-Hill, 1964.

White, Minor, *The Zone System Manual*. Morgan & Morgan, 1968.

Magazine Articles

Hurter, Bill, and Mike Stensvold, "Basic 35mm Single Lens Reflex Photography." *Petersen's Photographic,* September, 1979.

"Keppler's slr notebook," *Modern Photography,* January, 1980.

Schneider, Jason, "When a Built-In Meter Won't Work," *Modern Photography,* July, 1979.

*Available only in paperback
†Also available in paperback

Acknowledgements

The index for this book was prepared by Karla J. Knight. For their help in preparing this book, the editors would like to thank: Myles Adler, AGFA-Gevaert, Inc., Teterboro, N.J.; Photography Archives, Art Institute of Chicago, Ill.; Norbert S. Baer, Institute of Fine Arts, New York Univ., New York City; Samuel Berkey, President, Berkey Photo, Inc., New York City; Richard O. Berube, Polaroid Corp., Cambridge, Mass.; Robert E. Bilbey, and Richard Craig, Weston Instruments, Inc., Newark, N.J.; Priscilla Bresbery, Society of Illuminating Engineers, New York City; Nigel Catt, Kodak Ltd., U.K.; Josephine Cobb, Specialist in Iconography, General Services Administration, National Archives and Records Service, Washington, D.C.; Glen F. Cruze, Application Engineer, Mallory Battery Co., Tarrytown, N.Y.; Peter Denzer, Brooklyn, N.Y.; Stanley Erinwein, Tiffen Manufacturing Co., Roslyn Heights, N.Y.; George Eastman House, Rochester, N.Y.; David Haberstich, Museum Specialist, Section of Photography, Smithsonian Institution, Washington, D.C.; James Hartnett, Supervisor, Photographic Service Dept., Polaroid Corp., Cambridge, Mass.; James D. Horan, Weehawken, N.J.; Ilford Inc., Paramus, N.J.; Charles C. Irby, Assistant Curator, Photographic Collections, Gernsheim Collection, Humanities Research Center, The University of Texas, Austin; Dmitri Kessel, Paris, France; Carole Kismaric, *Aperture,* New York City; Susan Kismaric, The Museum of Modern Art, New York City; Kling Photo Corp., Woodside, N.Y.; David S. Lewandowski, GAF Corp., New York City; George A. Massios, Senior Science Editor, Corporate Communications, Eastman Kodak Co., Rochester, N.Y.; John W. Mathewson, Herbick & Held Printing Co., Pittsburgh; Edward Murphy, Consumer Relations Dept., Ehrenreich Photo-Optical Industries, Inc., Garden City, N.Y.; Nikon Inc., Garden City, N.Y.; Olympus Optical Co., Ltd., Woodbury, N.Y.; Allan Porter, Editor, *Camera* magazine, Lucerne, Switzerland; William P. Ryan, Vice President, Calumet Manufacturing Co., Chicago; Patricia Savoia and Elfriede Merman, The Manhattan Ballet School, New York City; Leonard Soned, New York City; William F. Swann, Manager, Professional, Commercial and Industrial Division, Eastman Kodak Co., Rochester, N.Y.; Robert Tow, Matrix Publications, Providence, R.I.; John L. Tupper, Cousin's Island, Yarmouth, Me.; Robert Walch, Brooklyn, N.Y.; Joel Snyder, Chicago; David Vestal, U.S. Camera Publishing Co., New York City; Peter Wehmann, Account Executive, Needham, Harper & Steers, Inc., New York City; Paul Wentz, Photographic Division, Honeywell, Inc., Long Island City, N.Y.; Woodlawn Plantation, a property of The National Trust for Historic Preservation, Woodlawn Plantation, Alexandria, Va.; Contax Division, Yashica, Inc., Paramus, N.J.

Picture Credits

Credits from left to right are separated by semicolons, from top to bottom by dashes.

Index *Numerals in italics indicate a photograph, painting or drawing.*

A

Aberdeen, Lord, 86
Absorption of light waves, by filter, *24-25, 184-185*
Accent light, *212-213*
Adams, Ansel, 178
Adams, John Quincy, 62, *63*
Aesthetic qualities of light, 26, *27-46, 147-160;* artificial light, *215-232*
Agnew, Thomas, & Sons (publishers), 85
Albert, Prince, 85, 86
Ali, Muhammed, *220-221*
Ambrotypes, *78-79,* 80
American Film, 60
American Indians, 19th-century photographs of, *80,* 91, *92-93*
American Standards Association (ASA), film ratings of, 127. *See also* ISO film ratings
Anderson, James, 90
Angles of artificial lighting, *194-196, 204-207, 212-213*
Animal photography, *202-203, 226-227, 229*
Ansco Film Company, The, 61
Antimony sulphide, 190
Aperture, *165,* 198, 199; light meter readings and, 165, *166-167,* 172, *176*
Aperture-priority camera, *166-167*
Artificial lighting: accent, *212-213;* aesthetic qualities of, *215-232;* angles of, *194-196, 204-207, 212-213;* available light balanced with, *163,* 164, *198-199, 222-223, 226-227;* basic techniques of, 190-191, *192-213;* for close-ups, *194-197, 202-211;* for colour portraits, *197, 206-207, 210-211, 222-223;* computerized, *232;* electronic flash, *see* Electronic flash; fill light, *206-207, 212-213;* flash, *see* Flash lighting; floodlights, *see* Floodlights; fluorescent, 12, 15, *192-193;* history of, 190; incandescent, 12, 15, 158, *222-223;* intensity of, *190-191;* Kodachrome used with, 156; limelight, 190; magnesium, 190; modelling light, *210-211;* motion frozen by, 191, *197, 200-201, 216-221, 230, 232;* multiple exposure taken with, *216-219, 232;* multiple sources of, *195,* 204, *206-207, 212-213;* natural light blended with, *163,* 164, *222-223, 226-227;* night use of, *225, 230-231;* for portraits, *182,* 191, *194-199, 204-211, 215, 222-223;* reflectors used with, *182, 189,* 191, 202, 203, 204, *208-209, 210-211;* shadows controlled in, *194-196, 204-213;* soft, *210-211;* special effects with, *204-205, 212-213,* 214, *215-232; spotlights, 37, 189,* 191, *202-203, 212-213, 218-219, 222-223;* syncopated strobe, *218-219;* for tone quality, *182-183;* underwater, balanced with daylight, *226-227;* use of existing, *192-193*
Asphalt, use in early photography, 51-52
Atmosphere, light wave penetration of, 16-17, *18-19*
Audubon, John James, 95
Automatic cameras, 165, *166-167,* 194

B

Babbitt, Platt D., 69; photograph by, *69*
Background detail, in flash pictures, *198-199*
Batteries, camera, 166, *167*
Belle Époque, la, *95-97*
Bernhardt, Sarah, *78*
Bingham, Robert, 58, 59
Biow, Hermann, 84, 85
Bisson, Auguste Rosalie and Louis Auguste, 90
Black-and-white film, 42, 164, 165, 184; composition of, *128;* contrast of, in flash lighting, *206-207;* emulsion of, *128,* 130; filter use with, *184-186;* grain quality of, *136, 150;* influence of light on, 12, 15, 126, *128-129,* 130, *132-133, 138-139;* introduction of, 50-51, 59, 60-61; light response of, *132-133, 138-139;* sensitivity of, 127, *136, 138-139,* 144; silver crystal image formation in, 126, *128-129,* 130; under-exposure of, *144-145*
Bleaching, of colour film, *131*
Bleaching of silver, in colour films, 130
Bordnick, Barbara, 160; photograph by, *160*
Bourke-White, Margaret, 98
Bracketing, 165
Brady, Mathew, 58, 85, 88, 95, 100, *101,* 104, photographs by, 88, 100, *105,* 106
Braun, Adolphe, 110; photograph by, *110-111*
Brightness range, of scene, *142-143,* 164-165
Bromide ions, *128-129*
Buena Vista Lake, California, photograph of, *38*
Built-in light meter, 165, *166-167,* 172; common errors in use of, and corrections, *168-171*

C

Caldwell, Erskine, 98
Callahan, Harry, photograph by, *42*
Calotypes, 57, 58, 62, 64, *70-75;* disadvantages of, 57; invented by Talbot, 57, 72; making of, *70-71;* soft effect of, *72-73*
Cameras: automatic, 165, *166-167,* 194; computerized, 166, *167, 232;* human vision differing from, 12; Kodak, introduction of, 60-61; obscura, 50-51, 52, 55, 56; rangefinder, 154; Sinar view, *64,* 65, *70,* 71; stereoscopic, 84, 114; 35 mm single-lens reflex, *166-167,* 220, 232; twin-lens reflex, 214; underwater use of, *226-227;* view, *64,* 65, *70,* 71, *83,* 158, 160, 182, 183, 216, 218
Celluloid, 61
Centre-weighted light meter, *166, 168-169*

Characteristic curve of film, *132, 134, 142-143,* 160
Chartier, Alain, 150; photograph by, *151*
Chromogenic films, 126, 136
Cincinnati, Ohio, daguerreotype of, *68-69*
Civil War, documentary photography of, 85, 88, 90, 100, *101-107*
Close-up photography, *37, 147, 154-157;* artificial lighting in, *194-197, 202-211*
Clouds: dye, *131,* 136; light wave behaviour in, *22-23*
Collodion emulsion, 61, 62, *76-77, 78-79,* 80, 88, 100, 114; discovery of, 58. *See also* Wet-plate photography
Collotypes, 96
Colour: black-and-white film reactions to, *138-139;* complementary, *130, 140-141;* distortions, 46; filter control of, *24-25,* 46, *184-185;* imbalance, corrections for, 134; of light, effect on film, 12, 15, *40-41,* 129, *138-141;* portraits, artificial lighting for, *197, 206-207, 210-211, 222-223;* primary, *130-131, 140-141;* of sunlight, due to atmospheric dispersion, 16-17, *18*
Colour couplers, 134, 156; dye formation by, *130-131*
Colour film, 164, 165; composition of, *130;* contrast of, in flash lighting, *206-207;* daylight, 192, 200, 222; development of, 51, *130-131;* dye formation in, controlled by silver crystals, 126, *130-131;* emulsion, 127, *130-131, 134, 140-141,* 156; flash illumination causing red-eye in, 196, *197;* grain quality of, *136-137, 151;* indoor, 222, 228; Kodachrome, *156-157;* light response of, 12, 15, 42, *134-135,* 160; modern advantages of, 126-127; negative, *46, 130-131, 137,* 142, 144, 150, 165, 200: Polaroid, *160;* prints made from, 130; sensitivity of, 127, *136-137, 140-141;* slides made from, 130; spectral sensitivity of, *140-141;* transparency, 46, *137, 140, 142-143,* 144, *150-151, 156-157,* 200, 218, 226, 228
Complementary colours, *130, 140-141*
Composites, *cover,* 4
Composition: light source emphasized in, 26, *27-46, 192-193;* shadows emphasized in, 26, *29, 33-34, 38, 42-43*
Contact printing, 56, *71*
Contrast, controlled in flash-lit photographs, *206-207*
Coplan, Anni-Siranne, photograph by, *41*
Couplers, colour. *See* Colour couplers
Crawlers, The (Thomson), 96, *99*
Creation, The (book), 41
Crimean War, documentary photography of, 85, *86-87,* 88

D

Daguerre, Louis Jaques Mandé, 50, 52-55, 56, 62, 72, 84; daguerreotypes invented by, 53-55
Daguerreotypes, 53-55, 57, *62-63, 64-69,* 72, 84, *85,* 91; detail in, *68-69,* 72; disadvantages of, 55, *66-67;* making of, *64-65;* mercury use in, 54, 55, *65;* silver iodide use in, 54, 64
Daylight colour film, 192, 200, 222
Density, of negatives, *132-135, 142-143*
Depth of field, 144, 182, 226
Dermer, Irwin, photograph by, *29*
Deutsche Industrie Norm (DIN) film ratings,127. *See also* ISO film ratings
Developer: effect on colour couplers, *130-131;* manipulation of, for coarse grain quality, *150-151*
Development: of calotypes, *70-71;* of colour film, 51, *130-131;* of daguerreotypes, *65;* of over-exposed film, 144; of under-exposed film, 144; in wet-plate process, 77
Diaphragm, 167
Diffusing screen, 194, *195,* 205
Diffusion, of light, *22-23,* 26, *30-31, 40-41,* 210-211
Dim light, exposure for, *46, 148-149,* 172, *222, 230-231*
Distance, flash-to-subject, 194, 206
Distortion, colour, 46
Documentary photography, 19th century, 84, *85-87,* 88, *89-99,* 100, *101-107;* first, *84-85;* in Persia, 116, *117-122;* social, *94-99,* 116, *117-122;* travel, *83,* 85, 88, *89-93,* 116, *117-122;* war, 85, *86-87,* 88, 90, 100, *101-107*
Douglas, Kirk, *146-147*
Dumas, Jean, quoted, 50
Dyes, 138, *140-141;* clouds, *131,* 136; colour coupler formation of, *130-131,* 134, 156; density of, *134,* 160; formation in film, controlled by silver crystals, 126, 127, *130-131*
Dye couplers. *See* Colour couplers

E

Eastman, George, 59-61, 126; quoted, 59, 60
Eastman Dry Plate and Film Company, The, 60
Ecuadorian Andes, photograph of, *40-41*
Edgcumbe, Lady Caroline Mount, *72-73*
Egg white, use in early photographic emulsions, 57-58
Egypt, 90, 114; photograph of Aswan, *114-115*
Einstein, Albert, 13
Electromagnetic energy, 12, *14-15*
Electromagnetic spectrum, *14-15,* 16, *138-139*
Electromagnetic waves, 12, *14-15,* 16
Electronic flash, 15, *147,* 191, 194, *200-201, 210-211, 220-221,* 224, *226-227;* advantages of, *200-201;*

automatic, colour negative film used with, 200; computerized, *232;* for multiple exposure, *216-219, 232*
Electrons, *12,* 16, 20, 24, *128-129*
Emulsion: black-and-white, *128,* 130; collodion, 58, 61, 62, *76-77, 78-79,* 80, 88, 100, 114; colour, 127, *130-131, 134, 140-141,* 156; egg white used in, 57-58; gelatine, 59, 60, 61, 126, *128,* 130; modern, advantages of, 126; orthochromatic, *138;* silver bromide crystals in, 126, *128-129, 130-131,* 154; of slow-speed films, 154. *See also* Film
Energy: electromagnetic, 12, *14-15;* light, *12,* 13, 14, 16, 20, 24, 128-*129*
Enlargements, 142, 154; grain quality of, *136-137*
European social photography, 19th century, *95-99*
Evans, Dame Edith, *29*
Exposure, 13, 164, *165, 166-177, 178, 179-186;* automatic, 165, 166-*167,* 194; bracketing of, 165; for colour print film, 165; common errors in light meter readings for, and corrections, *168-171;* corrected, in printmaking, 165; for detail, *142-143,* 165, *173,* 174-175, *176-177, 178-179, 182-183;* in dim light, *46,* 148-149, 172, *222,* 230-231; early experiments with, 54, 57, 58, 59, 164; effect on density of negative, *132-135, 142-143;* filter use for, *184-186;* flash, 194, *198-199,* 200; in hard light, 180-*181;* light-meter readings for, 165, *166-176;* long, in dim light, 172, *230-231;* multiple, *cover,* 4, *216-219, 232;* range, of film, *142-143;* for shadows, *142-143,* 165, *173,* 174-175; in soft light, *180-*181; for sunlight, indoors, 33; for tonal quality, *174-175, 178, 179-186;* for transparency film, *142-143,* 165; zone system for, 178-*179,* 180-181, 182, 183, 185. *See also* Over-exposure; Shutter speed; Under-exposure
Exposure meters. *See* Light meters
Eye and vision, human: camera differing from, 12; light wave perception of, *14, 20*

F

Fast-speed film, *125,* 127, *144-145,* 146, *148,* 152, 181, 190, 214, 226; for dim light, *148-149;* grain quality of, 136, *146-147, 150-151,* 152; motion frozen by, *148*
Fenton, Roger, 85-88; photographs by, *86-87,* 88, *109;* quoted, 86, 87
Ferorelli, Enrico, 218; photographs by, *192, 218-219*
Fill lighting, *206-207, 212-213*
Film, 126-145, 146, *147-160;* ''American Film,'' 60; characteristic curve of, *132, 134, 142-143,* 160; chromogenic, 126; colour of light affecting, 12, 15, *40-41,* 129, *138-141;* daylight colour, 192, 200, 222;
dye formation in, controlled by silver crystals, 126, 127, *130-131;* exposure range of, *142-143;* grain quality of, 126-127, *136-137, 150-151,* 152, 154, *156;* holder, *cover,* 4; infra-red, 16, 138-*139, 158-159;* instant, 127, *160,* 164; ISO ratings for, 127, 132, *136-137, 144-145,* 146, 148, 150, 152, 154, 156, *176,* 183; Kodachrome, *156-157;* modern, advantages of, 126-127; operation of, 126-145; orthochromatic, *138;* over-exposure of, 46, *132,* 142-143, 144-145, 152, 165, *168, 171, 173, 176, 182,* 199, 200; panchromatic, 138-*139* Polaroid, *160;* pushing, *144-145,* 148, 150; reaction of light on, 12, 13, *14,* 15, 16, 126-127, *128-129,* 130, *132-135, 138-143,* 156, 160; recording, 150; roll, introduction of, 51, 59, 60-61, 126; sensitivity of, 126-127, 136, *138-141, 144-145;* silver crystal image formation in, 126, *128-129, 130-131;* speed, *see* Film speed; types of, and uses, 146, *147-160;* under-exposure of, 13, *132, 142,* 144-145, 165, *168-170, 173, 175, 180-181,* 198, 214. *See also* Black-and-white film; Colour film; Development: Emulsion; Exposure; Negatives
Film speed, 127, 146, 166; camera selector for, *167;* fast, *125,* 127, 136, *144-145,* 146-147, *148,* 152, 181, 190, 214, 226; and grain quality, 127, *136-137, 150-151;* ISO ratings for, 127, 132, *136-137, 144-145,* 146, 148, 150, 152, 154, 156, *176,* 183; medium, *125,* 127, 146, *152-153;* slow, *125,* 127, 136, 146, 152, *154-157*
Filters, *24-25,* 138, 222; colour control by, *24-25,* 46, *184-185;* light wave absorption by, *24-25, 184-185;* polarizing, *186;* tone changed with, *184-185;* use in printmaking, 46; use with infra-red film, 158
Fisheye lens, *220-221*
Fixing: calotypes, 71; of colour film, *131;* daguerreotypes, 54, 55, *65;* early experiments with, 50-51, 56
Flash lighting, 15, *182-183,* 190-191, *194-199;* angles of, *194-196, 204-207, 212-213;* available light balanced with, *198-199, 222-223, 226-227;* background detail in, *198-199;* bars, 190-191; bulbs, 190-191, 194; camera synchronization with, 197, 198; common mistakes avoided with, *196-197;* cubes, 190-191; exposure for, 194, *198-199,* 200; fill light use with, to control contrast, *206-207;* flash-to-subject distance, 194, 206; motion frozen by, 191, *197, 200-201, 216-221, 230, 232;* multiple, *195,* 204, *206-207;* powder, 190; power of unit in, 194; red-eye avoided in, 196, *197;* reflections avoided in, *196-197;* reflectors used with, 210-*211;*
shadows controlled in, *194-196, 204-207, 210-213;* shutter speed affecting, *182-183,* 196, 197, 198, 199; techniques of, *194-199;* without reflectors, *195,* 210. *See also* Electronic flash
Flat (reflector), 208-*209*
Flatiron Building, New York, *46*
Floodlights, *189,* 191, 202-203, *212-213, 220-221,* 224-225; angles of, *204-205, 212-213;* computerized, *232;* reflectors used with, *208-209,* 210
Fluorescent light, 12, 15, *192-193*
Fog, 180-181
Fontayne, Charles, 69; photograph by, *68-69*
Form, light to reveal, *36-37*
Fortune magazine, 98
Freed, Leonard, photograph by, *35*
French Academy of Sciences, 53, 54, 55, 56, 57
Frith, Francis, 90, 114; photograph by, *114-115;* quoted, 114

G

Gallery of Illustrious Americans, The (Brady), 95
Gamma rays, *14-15,* 17
Gardner, Alexander, 100, 106; photographs by, *104-107*
Garnett, William, photograph by, *38*
Gelatine emulsion, 59, 60, 61, 126, *128,* 130
Geological Survey, United States, 91-93
Glass plates, use in early photography, 57-58, 59, 60, 62, *76-79*
Gnant, Robert, photograph by, *28-29*
Goodwin, Hannibal, 61
Goodwin Film and Camera Company, 61
Goro, Fritz, 4, 228; photographs by, *cover, 228-229*
Grain quality, of film, 126-127, *136-137;* of black-and-white film, *137, 150;* coarse, emphasis of, *150-151;* of colour film, *136-137, 151;* due to silver crystal size, 126-127, *136-137,* 150; of fast-speed film, 136, *146-147, 150-151,* 152; and film speed, 127, *136-137;* of Kodachrome, 156; of medium-speed film, 152; of slow-speed film, 136, 146, 154, *156. See also* ISO film ratings
Grant, Ulysses S., 93
Grey card, 18 per cent, 168, 169
Grey scale, 178-*179,* 180-181. *See also* Zone system.
Groskinsky, Henry, 164, *172-175;* photographs by, *163, 173, 175*
Guncotton (cellulose nitrate), 58

H

Haas, Ernst, 41; photograph by, *40-41;* quoted, 41
Half-tone printing process, 84, 93
Hamburg, Germany, 84, 112; photographs of, *85, 113*
Hand-held light meter, *172-175,* 176
Harbutt, Charles, 26; photograph by, *27*
Harrison, Howard, photograph by, *189*
Hayden, Dr. Ferdinand V., 91-92, 93
Helena of Montenegro, Princess, 95
Heliogravure, 52, 53
Helium-selenium laser beam, *cover,* 4
Herschel, Sir John, 56, 57
Hine, Lewis W., 98
Hines, Gregory, *218-219*
Hofer, Evelyn, photograph by, *125*
Holmes, Oliver Wendell, 84; quoted, 106
Höltzer, Ernst, 116, 118, 120; photographs by, *117-122;* quoted, 118, 120
How the Other Half Lives (Riis), 98
Humes, Helen, *160*
Hydrogen atom, *12*
Hypo, 54, 55, 56, 65

I

Image: density of, *132-135, 142-143,* 160; dye formation of, 126, 127, *130-131;* fixing, early experiments with, 50-51, 54, 55, 56; isolation of, *34-37;* latent, 54, 57, *128-129;* quality, dependent on silver crystal size, 126-127, *136-137,* 150; reflected, *38-39;* silver crystal formation of, 126, *128-131*
Impressionism, 38
Incandescent light, 12, 15, 158, 222-*223*
Incident-light meter, 166, *172-173*
Indians, 19th-century photographs of, *80,* 91, *92-93*
Indoor colour film, 222, 228
Indoor lighting, natural, *32-34*
Infra-red film, 16, 138-*139, 158-159*
Infra-red waves, *14-15,* 16-*17,* 138-*139,* 158
Ingber, Mel, 152; photograph by, *152-153*
Instant films, 127, 164; Polaroid, *160*
Intensity, of light, 13, 15, 164, 167, 172, 175, 178; artificial light, *190-191*
Interlaken, Switzerland, photograph of, *110-111*
International Standards Organization. *See* ISO film ratings
Iodine, use in early photography, 53, 54, 64
Ions, *128-130*
Iooss, Walter, Jr., 148; photograph by, *148*
ISO (International Standards Organization) film ratings, 127, 132, *136-137, 144-145,* 146, 148, 150, 152, 154, 156, *176,* 183. *See also* Film speed

J

Jackson, William Henry, 58, *83,* 91-93; photographs by, *90-93;* quoted, 92
Jeffery, Richard, 156; photograph by, *157*

Joel, Yale, 224; photograph by, *224*
Josephson, Kenneth, 44; photograph by, *44*
Journal of the Franklin Institute, Philadelphia, quoted, 53-54
Journal of the Photographic Society, London, 59
Jousson, Pierre, photograph by, *37*

K

Kahn, Louis, 222-223
Kay, Ken, photograph by, 11
Kennedy, Robert F., funeral of, 148-*149*
Kessel, Dmitri, photograph by, *39*
Kodachrome, *156-157*
Kodak camera, introduction of, 60-61
Köhler, Werner, 154; photographs by, *154-155*
Koppman & Co., G., photograph by, *113*
Krause, George, 26; photograph by, *43*
Kremlin, Moscow, photograph of, 108-*109*
Krupp von Bohlen und Halbach, Alfried, *222*

L

Landscape photography, *18-23, 40-41, 152-153, 158-159, 226-227;* Western United States, 19th century, *83, 89-91,* 92-93
Laser beam, photograph of, *cover,* 4, *228-229*
Latent image, 54, 57, 128-*129*
Lebeck, Robert, 148; photograph by, *149*
Lee, General Robert E., 100
Leifer, Neil, 220; photograph by, *220-221*
Leipziger Stadtanzeiger, quoted, 54
Lenses, 190, 218; fisheye, *220-221;* macro, 156; wide-angle, 4; zoom, 168, 232
Life magazine, 98, 218, 224, 228
Light: aesthetic qualities of, in photography, 26, *27-46, 147-160;* characteristics of, 13; colour of, effect on film, 12, 15, *40-41,* 129, *138-141;* dependence of photography on, 12, 13; diffusion of, *22-23,* 26, *30-31, 40-41,* 210-*211;* dim, *46, 148-149,* 172, 202, *222;* directional qualities of, 26, *27-37, 42-46;* energy, *12-13,* 14, 16, 20, 24, 128-*129;* film sensitivity to, 126-127, 136, *138-141, 144-145;* form revealed by, *36-37;* hard, *180-181;* indoor, natural, *32-34;* intensity of, 13, 15, 164, 167, 172, 175, 178; light-matter reaction, 13; as matter, 12-13; mood created with, *27-46, 180-181, 192-193;* moonlight, *28-*29; natural and artificial, blended, *163,* 164, *222-223, 226-227;* night, *28, 46, 148-149, 170,* 225, *230-231;* origination of, *12,* 15; particle theory of, *12-13;* polarization of, 13, *20,* 186; reaction of, on film, 12, 13, *14,* 15, 16, 126-127, *128-129, 130, 132-135, 138-143,* 156, 160;

reflection of, *20-21,* 22, 30, *38-39,* 184; refraction of, *22-23, 40-41;* scattering of, *18-19,* 158; soft, *180-*181; source, composing with, 26, *27-46, 192-193;* texture revealed by, *36-37, 175,* 194, 205, *208-209;* as theme, 26, *27-46;* time of day affecting, *18-21, 163,* 164; tracings, *230-231;* underwater, *226-227;* weather affecting, 26, *30-31, 40-41, 46,* 180-181; white, *22, 24,* 184. *See also* Artificial lighting; Natural light; Sunlight
Light meters, 164, 165, *190-191,* 202; automatic, 165, 166-*167;* built-in, 165, *166-171,* 172; centre-weighted, *166,* 168-*169;* common errors in use of, and corrections, *168-171;* hand-held, *172-175,* 176; incident-light, 27, 166, *172-173;* light-sensitive cell in, 166, *167,* 172, *176;* readings, zone system interpretation of, *178-179;* reflected-light, 44, *166-167,* 168, 172, *174-175, 176-177,* 178; shutter-speed reading of, 165, *166-167,* 172, *176;* spot, 164, *176-177;* tone values, *169, 173, 174-175,* 178
Light-sensitive cell, in light meter, 166, *167,* 172, *176*
Light waves, *12,* 13, *14,* 15, 16-*17, 18, 20, 22, 24,* 51, 127, *186;* atmosphere penetrated by, *16-17, 18;* filter absorption of, *24-25, 184-185;* polarized, 13, *20,* 186; silver crystal sensitivity to, in film, 127, *138-139*
Lincoln, Abraham, 88, 100
Liston, Sonny, *220-221*
Lithography, 51, 96
Lloyd, Robert, *150*
London Nomads (Thomson), 96, 98, *99*
Lukas, Jan, photograph by, *24-25*

M

Macro lens, 156
Madden, Robert W., photograph by, *34*
Magnesium, 190
Margherita, Queen, 95
Matter, light as, 12-13
Medium-speed film, *125,* 127, 146, *152-153;* grain quality of, 152
Ménard, Louis, 58
Mercury, daguerreotype use of, 54, 55, *65;* danger in use of, 62
Michaud, Roland, 156; photograph by, *156*
Mili, Gjon, 230; photograph by, *230*
Mining Journal (British), quoted, 55
Modelling light, *210-211*
Monet, Claude, 38
Mont Blanc and its Glaciers (book), 84
Mood, created with light, *27-46, 180-181, 192-193*
Moonlight, *28-29*
Morse, Ralph, 214, 216, 224; photographs by, *215-217, 225;* quoted, 214

Motion: frozen, by fast-speed film, *148;* frozen, by flash lighting, 191, *197, 200-201, 216-221, 230, 232*
Multiple exposure, *cover,* 4, *216-219, 232*
Multiple light sources, *195,* 204, *206-207, 212-213*

N

Nadar, photograph by, *78*
Natural light: artificial light blended with, *163,* 164, *222-223, 226-227;* indoor, *32-34;* Kodachrome used with, 156. *See also* Sunlight
Nature photographs, slow-speed film for, *154-155*
Negatives, 165; black-and-white, *129;* colour, *131;* density of, *132-135, 142-143;* paper, in calotype process, 56-57, 62, *70-71. See also* Film; Grain quality, of film
Negative-positive system of photography, Talbot discovery of, 56-57, 62, *72-73*
New York World, quoted, 100
Newman, Arnold, 222; photographs by, *222-223*
News photography. *See* Documentary photography
Niagara Falls, daguerreotype of, *69*
Niepce, Isidore, 51, 55
Niepce, Joseph-Nicéphore, 51-53, 57; quoted, 52
Niepce de Saint-Victor, Abel, 57-58
Niger River, West Africa, photograph of, *41*
Night lighting, *28, 46, 148-149, 170, 225, 230-231*
Nile River, Egypt, photograph of, *114-115*
19th-century photography, 164; documentary, 84, *85-87,* 88, *89-99,* 100, *101-107,* 116, *117-122;* Indian, *80,* 91, *92-93;* inventors of, 50-61; photographic processes in, *49,* 50-61, 62, *63-80,* 84, *85-87,* 88, 92, 100, 102, 114; portraits, 63, *66-67, 72-74, 78-80,* 85, *92-93,* 95, *99,* 100, *117-122;* printing methods of, 51-52, 62, *63-80,* 84, 93, 96; social, *94-97,* 100, *117-122;* travel, *83,* 85, 88, *89-93,* 108, *109-115,* 116, *117-122;* war, 85, *86-87,* 88, 90, 100, *101-107. See also* Photographers, early; Photographic processes, early
Nudes, 37

O

Orthochromatic film, *138*
O'Sullivan, Timothy H., 89, 90-91; photographs by, *89, 102;* quoted, 91
Over-exposure, 46, *132,* 142-143, 144-145, 152, 165, *168,* 171, *173, 176, 182,* 199, 200

P

Panchromatic film, 138-*139*
Paper negative, in calotype process, 56-57, 62, *70-71*
Particle theory of light, 12-13

Paul VI, Pope, 192, *224-225*
Penny Cyclopedia, The (British), quoted, 55
Persia, 19th-century documentary photographs of, 116, *117-122*
Photographers, early: Brady, Mathew, 58, 85, 88, 95, 100, *101,* 104, 106; Civil War, 58, 100, *101-107;* Daguerre, Louis Jacques Mandé, 50, 52-55, 56, 62, 72, 84; Eastman, George, 59-61, 126; Fenton, Roger, 85-88; Höltzer, Ernst, 116, 118, 120; Jackson, William Henry, 58, *83,* 91-93; Niepce, Joseph-Nicéphore, 51-53, 57; Niepce de Saint-Victor, Abel, 57-58; O'Sullivan, Timothy H., 89, 90-91; Schulze, Johann Heinrich, 50, 51, 54; Stelzner, Carl F., *84-85;* Talbot, William Henry Fox, 56-57, 72; Wedgwood, Thomas, 50-51, 54, 56. *See also* 19th-century photography; Photographic processes, early
Photographic Interface System Computer Language (PISCAL), 232
Photographic News (British), 59
Photographic processes, 19th-century, *49,* 50-61, 62, *63-80,* 84, *85-87,* 88, 92, 100, 102, 114; ambrotypes, *78-79,* 80; calotype, 57, 58, 62, 64, *70-75;* daguerreotypes, 53-55, 57, *62-63, 64-69,* 72, 84, *85,* 91; egg white emulsion in, 57-58; gelatine emulsion in, 59, 60, 61; glass-plates used in, 57-58, 59, 60, 62, *76-79;* heliogravure, 52, 53; negative-positive system, Talbot discovery of, 56-57, 62, *72-73;* roll film invented, 60-61; silhouettes, 50, 51, 56; tintypes, *80;* wet-plate, 58-59, 62, 64, *76-79,* 80, 86, 88, 102, 114. *See also* 19th-century photography; Photographers, early
Photography: aesthetic qualities of light in, 26, *27-46, 215-232;* inventors of, 50-61; light as theme in, 26, *27-46;* negative-positive system of, discovered by Talbot 56-57, 62, *72-73. See also* 19th-century photography
Photons, 12, 13, 128, *129*
Picasso, Pablo, *230*
Polarization of light, 13, *20,* 186
Polarizing filter, *186*
Polaroid film, *160*
Pomeroy, Senator S. L., quoted, 93
Ponti, Carlo, 90
Porter, William Southgate, 69; photograph by, *68-69*
Portrait photography, *125, 147, 156;* artificial lighting for, *182,* 191, *194-199, 204-211, 215, 222-223;* colour, artificial lighting for, *197, 206-207, 210-211, 222-223;* colour, red-eye in, 196, *197;* 19th century, *63, 66-67, 72-74, 78-80,* 85, *92-93,* 95, *99,* 100, *117-122;* Polariod, *160;* slow-speed film used for, 154, *156*
Potassium chlorate, 190

Potassium iodide, 58, 70, 77
Practical Mechanics' Journal, The (British), quoted, 85
Primary colours, 130-*131, 140-141*
Primoli, Count Giuseppe Napoleone, 95, 116; photographs by, *94-97*
Printmaking: exposure corrected in, 165; filter use in, 46; 19th-century methods, 51-52, 62, *63-80,* 84, 93, 96
Prism, 166, *167, 176*
Pushing film, *144-145,* 148, 150
Pyrogallic acid, 58, *77*

R
Radio waves, 12, *14-15*
Rain, *40-41*
Rangefinder camera, 154
Recording film, 150
Red-eye, avoiding, 196, *197*
Reflected-light meters, *166-167,* 168, 172, *176-177,* 178; use of, *174-175*
Reflection: avoiding, in flash photography, *196-197;* of light, *20-21,* 22, 30, *38-39,* 184; use of, in photography, *38-39, 179, 186;* on water, *38-39, 179, 186*
Reflectors, *189,* 191, 202, 203, 204; flash photography without, *195, 210;* flats, *208-209;* umbrella, *210-211;* uses of, *182, 208-209,* 210-*211*
Refraction, of light, *22-23, 40-41*
Renaud, Gary, photograph by, *192-193*
Reproduction methods, 19th-century, 84, 93, 96
Richmond, Virginia, Civil War, photograph of, *106-107*
Riis, Jacob A., 98
Rocky Mountains, 19th-century photography of, *90-91,* 93
Roll film, introduction of, 51, 59, 60-61, 126
Rome, Italy, photographs of, *112, 192*
Rose, Ben, 232, photograph by, *232*
Russell, William Howard, quoted, 86

S
St. Patrick's Cathedral, New York, photograph of, *224*
St. Peter's Cathedral, Rome, photograph of, *192*
Sala, Angelo, quoted, 50
Scattering, of light, *18-19,* 158
Schulze, Johann Heinrich, 50, 51, 54
Semak, Michael, 180, 181; photograph by, *180*
Sensitivity, film, 126-127, *144-145;* black-and-white film, 127, *136, 138-139,* 144; colour film, 127, *136-137, 140-141. See also* ISO film ratings
Sensitivity specks, *128-129, 130*
Shadows, composing with, 26, *29, 33-34, 38, 42-43, 152-153;* control

of, in artificial lighting, *194-196, 204-213;* exposure for, *142-143,* 165, *173, 174-175*
Shutter speed, *165;* flash lighting affected by, *182-183,* 196, 197, 198, 199; to freeze motion, *148;* light-meter readings and, 165, *166-167,* 172, *176. See also* Exposure
Seiff, Jeanloup, 146; photograph by, *147*
Silhouettes, 50, 51, 56
Silk, George, 226; photograph by, *226-227*
Silver bromide crystals, 13, 60, 126, *128-131,* 154; dye formation in film controlled by, 126, 127, *130-131;* film image formed by, 126, *128-131;* light-wave sensitivity of, in film, 127, *138-139;* size of, grain quality due to, 126-127, *136-137,* 150
Silver chloride, 71, 77
Silver density, of negatives, *132-135, 142-143*
Silver iodide, 13, 126; use in calotypes, 70; use in daguerreotypes, 54, 64
Silver ions, *128-130*
Silver nitrate: danger in use of, 64; early photographic experiments with, 50, 56, 58; use in calotypes, *70,* 71; use in wet-plate process, 77
Silver sulphide, 128
Sinar view camera, *64,* 65, *70,* 71
Slavin, Neal, 180, 181; photographs by, *30-31, 181*
Slide film. *See* Transparency film
Slow-speed film, *125,* 127, 136, 146, 152, *154-155;* detail emphasis of, 146, *154-157;* grain quality of, 136, 146, 154, *156;* Kodachrome, *156-157;* for nature photographs, *154-155*
Smith, Adolphe, 96; quoted, 96
Smith, Hannibal L., 80
Snow, *46*
Snyder, Joel, 62, *64-65, 70-71, 76-77;* photographs by, *65, 71, 77*
Social photography, 19th-century, *94-99;* Persian, 116, *117-122*
Sodium thiosulphate, 54, 55, 56, 65
Southworth & Hawes, photograph by, *63*
Spectrum, 130; electromagnetic, *14-15,* 16, *138-139;* laser beam, *cover,* 4, sensitivity of colour emulsion layers to, *140-141*
Speed, film. *See* Film speed
Sports Illustrated magazine, 148, 220
Sports photographs, *148, 216-217, 220-221*
Spot (light) meter, 164, *176-177*
Spotlights, *37, 189,* 191, *202-203, 212-213, 218-219, 222-223*
Staller, Eric, 230; photograph by, *231*
Staller, Jan, photograph by, *46*
Steichen, Edward, 46; quoted, 62
Stelzner, Carl F., 84, 85; photograph by, *85*

Stereoscope, 84, 93, 108
Stereoscopic camera, 84, 114
Still-life photography, *144-145, 156-157*
Stop bath, *131*
Strachey, Lytton, quoted, 96
Street Life in London (book), 96, 98, 99
Strobe, syncopated, *218-219. See also* Electronic flash
Stroboscope, 191
Strong, Henry, 60
Sund, Harald, photographs by, *18-23, 30*
Sunlight, 12, 15; penetration of earth atmosphere by, *16-17, 18-19;* use of, in photography, *18-21, 26-27, 30, 33-34, 36, 38, 41, 44-45, 142-143, 152-153,* 190, *226-227*
Sunrise, *20-21*
Sunset, *18-19, 163,* 164
Super Bowl, 1980, photograph of, *148*
Supplementary light sources. *See* Artificial lighting

T
Talbot, William Henry Fox, 56-57, 72; photographs by, *72-75;* quoted, 56, 57
Texture, light to reveal, *36-37, 175,* 194, 205, *208-209*
Theme, light as, 26, *27-46*
Thersiquel, Michel, photograph by, *32-33*
Thieme, Lars Werner, 44; photograph by, *45*
Thomson, John, 95-96, 98, 116; photographs by, 96, *99;* quoted, 96
Time-Life Photo Lab, 150
Time of day, effect on light, *18-21, 163,* 164
Times, The (London), 86
Tintypes, *80*
Tombs of Cathcarts Hill, The (Fenton), 88
Tone, *138-139;* additional lighting for, *182-183;* exposure for, 178, *179-186;* filter use to change, *184-185;* light-meter readings, 169, *173, 174-175,* 178; limited range of, *180-181;* zone system for, *178-179, 180-181,* 182, 183, 185
Tracings, light, *230-231*
Transparency colour film, 46, *137, 140,* 144, *156-157,* 200, 218, 226, 228; exposure for, *142-143,* 165; print film developer used for, *150-151*
Travel photography, 19th-century, *83,* 85, 88, *89-93,* 108, *109-115;* Persian, 116, *117-122*
Tripod, 191, 198, 214
Twin-lens reflex camera, 214

U
Ultraviolet waves, *14, 16-17, 138-139*
Umberto I, King, 95
Umbrella reflector, *210-211*

Under-exposure, 13, *132, 142, 144-145,* 165, *168-170, 173, 175, 180-181,* 198, 214
Underwater photography, *226-227*

V
Valley of the Shadow of Death, The (Fenton), 88
Van Deveer, David, photograph by, *179*
Victoria, Queen, 85, 86, 88, 96
View cameras, *64,* 65, *70,* 71, *83,* 158, 160, 182, 183, 216, 218
Viewing screen, *167, 176*
Vision. *See* Eye and vision, human
Vittorio Emanuele III, King, 95
Vogel, H. W., 138

W
Waldman, Max, 150; photograph by, *150*
War photography, 19th-century: Civil War, 85, 88, 90, 100, *101-107;* Crimean War, 85, *86-87,* 88
Water, reflections on, *38-39, 179, 186*
Waves: electromagnetic, 12, *14-15,* 16, *138-139;* gamma rays, *14-15,* 17; infra-red, *14-15, 16-17, 138-139,* 158; light, *see* Light waves; polarized light, 13, *20,* 186; radio, 12, *14-15;* ultraviolet, *14, 16-17, 138-139;* X-ray, *14-15,* 12, 14, 17
Weather: effect on lighting, 26, *30-31, 40-41, 46, 180-181;* fog, *180-181;* rain, *40-41;* snow, *46*
Wedgwood, Thomas, 50-51, 54, 56
Western United States, 19th-century photography of, *83, 89-93*
Weston, Edward, 37; photograph by, *36*
Wet-plate photography, 58-59, 62, 64, *76-79,* 80, 86, 88, 102, 114; process of, *76-77*
White, Minor, 158; photograph by, *158-159*
White light, *22,* 24, 184
Wide-angle lens, 4
Wood engraving printing process, 84

X
Xenon gas, 191
X-rays, 12, 14, 17

Y
Yale University, art gallery at, *222-223*
Yankee Stadium, photograph of, *224-225*
Yellowstone, Wyoming, 92, 93
You Have Seen Their Faces, Bourke-White and Caldwell, 98

Z
Zirconium foil, 190
Zone system, 178-*179, 180-181,* 182, 183, 185
Zoom lens, 168, 232
Zuñi Pueblo, New Mexico, photograph of, *83*

Photosetting by G Beard & Son Ltd, Brighton, England
Printed and bound in Italy by Arnoldo Mondadori, Verona

x